£16 -

D0076067

THE BRITISH ARCHAEOLOGICAL ASSOCIATION

CONFERENCE TRANSACTIONS
For the year 1978

IV

MEDIEVAL ART
AND ARCHITECTURE
at Wells and Glastonbury

1981

Previous volumes in the series:
I. Medieval Art and Architecture at Worcester Cathedral
II. Medieval Art and Architecture at Ely Cathedral
III. Medieval Art and Architecture at Durham Cathedral

*Copies of these may be obtained direct from W. S. Maney and Son Limited,
Hudson Road, Leeds LS9 7DL*

ISBN 0 907307 02 7

© The British Archaeological Association 1981

PRINTED IN GREAT BRITAIN BY W. S. MANEY AND SON LIMITED

HUDSON ROAD, LEEDS LS9 7DL

CONTENTS

LIST OF ABBREVIATIONS AND SHORTENED TITLES

in use throughout the volume. See also individual contributions

Archaeol. J.	*Archaeological Journal*
BAA CT	*British Archaeological Association Conference Transactions*
Bilson (1928)	J. Bilson, 'Notes on the earlier architectural history of Wells Cathedral', *Archaeol. J.*, LXXXV (1928), 23–68
B/E	N. Pevsner et al., ed., *The Buildings of England* (Harmondsworth various dates)
Calendar	*Calendar of Manuscripts of Wells Cathedral*, Royal Commission on Historical Manuscripts, Vol. I (1907), ed. W. H. Bird, Vol. II (1914), ed. W. Paley Baildon
Colchester and Harvey (1974)	L. S. Colchester and J. H. Harvey, 'Wells Cathedral', *Archaeol. J.*, CXXXI (1974), 200–14
JBAA	*Journal of the British Archaeological Association*
P.S.A.N.H.S.	*Proceedings of the Somerset Archaeological and Natural History Society*
Robinson (1928)	J. A. Robinson, 'Documentary evidence relating to the building of the cathedral Church at Wells', *Archaeol. J.*, LXXXV (1928), 1–22
VCH	Victoria History of the Counties of England

PREFACE

On behalf of the Association the Editors would like to record their gratitude to the British Academy, the Juno Trust, the Marc Fitch Fund and the Royal Society of Arts (Maltwood Fund) for substantial grants towards the publication of this volume. Their continuing generous support makes the enterprise possible. We are grateful, too, for additional financial help from the Twenty-Seven Foundation, the National Westminster Bank Ltd, and the Cater Memorial Fund. We would also like to thank Mrs Teresa Sladen and Miss Beatrice Rehl for editorial assistance, and Miss Susan Bird for the cover design.

NICOLA COLDSTREAM
PETER DRAPER
Hon. Editors

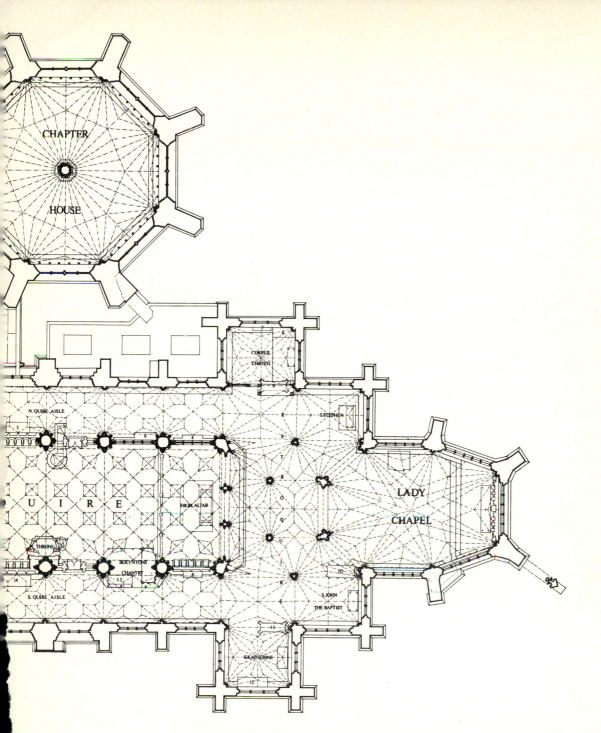

CHAPTER

HOUSE

CORPUS
CHRISTI

N.QUIRE AISLE

S.STEPHEN

Q U I R E

HIGH ALTAR

LADY

CHAPEL

THRONE

BEKYNTONS
CHANTRY

S.QUIRE AISLE

S.JOHN
THE BAPTIST

S.KATHERINE

© *Dean and Chapter of Wells*

RAL CHURCH of St ANDREW
WELLS

HUNTER & NICK ELKINS ④ MAY 1978

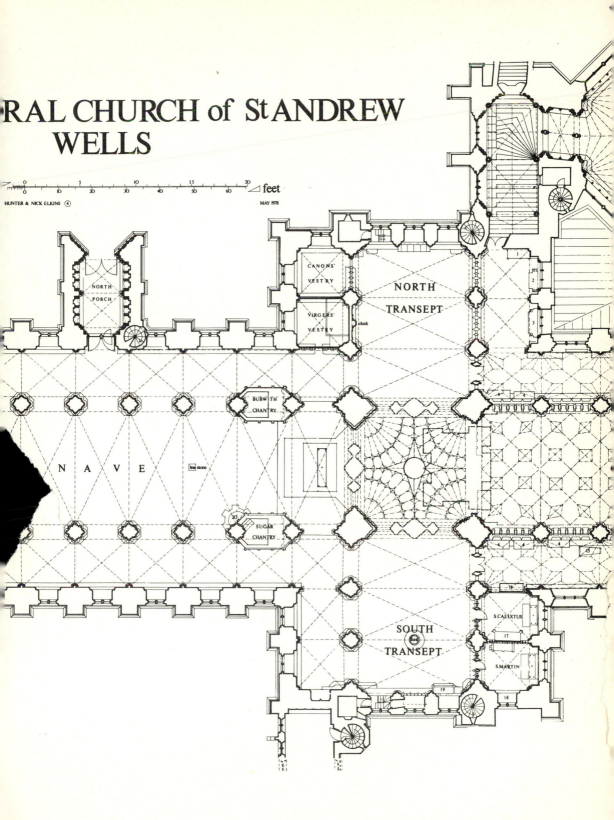

NORTH
PORCH

CANONS'
VESTRY

VIRGERS'
VESTRY

clock

NORTH
TRANSEPT

1

2

3

BUBWITH
CHANTRY

N A V E stone

SUGAR
CHANTRY

20

15

16

S.CALIXTUS

17

S.MARTIN

SOUTH
TRANSEPT

19

18

THE CATHED

SCALE metres

MEASURED AND DRAWN BY DOUGA

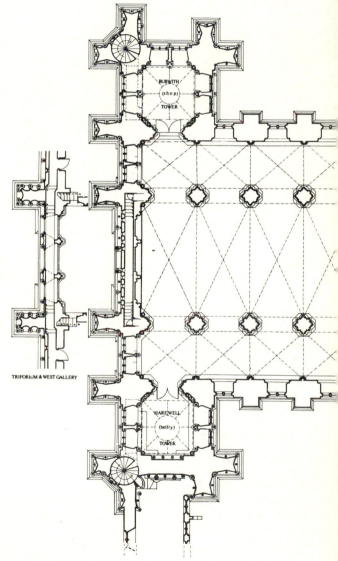

BUBWITH
(shop)
TOWER

TRIFORIUM & WEST GALLERY

HARE WELL
(belfry)
TOWER

The Lady Chapel by the Cloister at Wells and the Site of the Anglo-Saxon Cathedral

By WARWICK RODWELL

'So many attempts have been made to unravel the architectural history of the Cathedral church of Wells, and such conflicting views have been put forth to explain it, that it may seem hopeless now for anyone to get a hearing for an entirely new theory as to its beginnings. Yet I am going to be so bold as to put forth such a theory . . .'.

These were the opening words of a lecture delivered by (Sir) W. H. St John Hope at Wells in 1909. He went on to expound his theory that the foundations of the Anglo-Saxon cathedral lay beneath the cloister garth and east cloister range, projecting even further eastwards into that part of the cathedral close which is known as 'The Camery'.[1] The basis for advancing this theory, which has to all intents and purposes been overlooked by scholars outside Wells for seventy years, was the discovery during excavations in 1894 of the foundations of an ancient chapel which are aligned not with the present cathedral but with the general axis of the Market Place and High Street. The chapel was a building of several architectural phases and its identification as the historically documented 'Lady Chapel by the Cloister' was convincingly established by Canon C. M. Church.[2] He and the excavator of the site, Edmund Buckle, drew attention to the possibility that the earliest phase of the Lady chapel might be equated with the building which Bishop Giso restored and endowed in the mid-11th century.[3]

The contemporary techniques of excavation were not conducive to close dating of the remains, and dates were assigned to the several phases on the basis of historical probability and architectural detail. The earliest foundations were simply termed 'oldest work'. Hope did not use any of the excavated foundations in his reconstruction of the Anglo-Saxon cathedral, but preferred to regard these all as being medieval: he was primarily concerned with the alignment. Thus he was able to 'reconstruct' the plan of the Anglo-Saxon cathedral by simply taking the ground plan of Brixworth Church and superimposing it on the cloister in a position which suited his theory. It is perhaps not surprising that Hope's hypothesis was greeted by his audience with some scepticism, as published remarks show. Today, with our greater understanding of historical topography and early town planning, we can appreciate how sensitive was Hope's assessment of the general topographical outline of the city. Furthermore, in the light of large-scale excavations undertaken in The Camery in 1978 and 1979, we can now confirm that Hope's predictions on the siting and alignment of the pre-12th-century cathedral are correct, even if his speculations regarding the plan are rather wide of the mark.

During some eight months of excavation in 1978–79 a strip of ground *c.*15 m wide, running from the south transept, down the east side of the cloister to the Masons' Yard, was examined (Fig. 1, Pl. I).[4] This took in the greater part of the site of the Lady Chapel by the Cloister, as well as areas of cemetery to the north and south, and facilitated a thorough examination of the archaeological deposits in this crucial area. The various trenches, all of unrecorded extent, of 1851, 1875 and 1894 were relocated; by great good fortune, they were superficial, and the earlier deposits in particular were hardly damaged. The archaeological levels encountered in 1978–79 ranged in date from Neolithic pits to 18th-century garden features. What follows is a summary of the evidence pertaining to the structural history of the Lady Chapel by the Cloister, which began in Period 4 of the excavation chronology.[5]

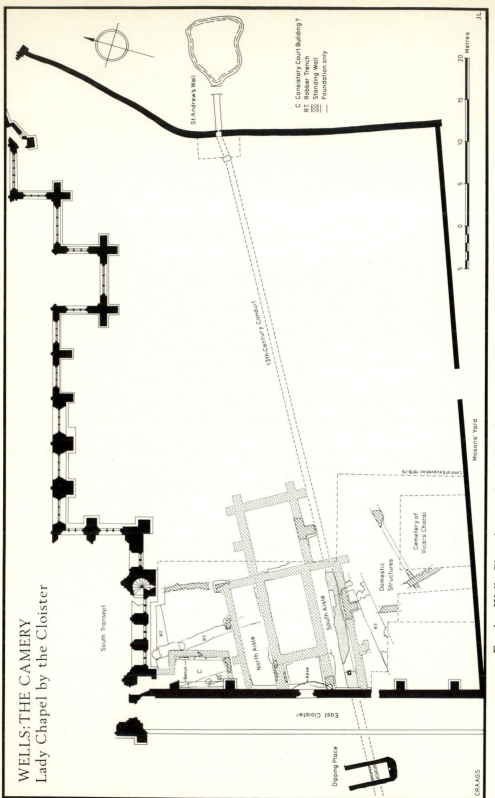

WELLS: THE CAMERY
Lady Chapel by the Cloister

South Transept

St Andrew's Well

C Consistory Court Building ?
R.T. Robber Trench
▨ Standing Wall
— Foundation only

13th-Century Conduit

East Cloister

North Aisle

South Aisle

Apse

Bench

C

R.T.

R.T.

R.T.

Domestic Structures

Cemetery of Vicars Choral

Limit of Excavation 1978-79

Masons' Yard

Dipping Place

CRAAGS

JL

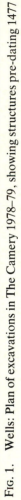

Metres

FIG. 1. Wells: Plan of excavations in The Camery 1978–79, showing structures pre-dating 1477

SUMMARY OF THE ARCHAEOLOGICAL EVIDENCE

PERIOD 4: MIDDLE SAXON

The earliest features of undisputed Christian association are graves of west–east orientation which lie below and to the west of a building of unknown plan, but presumed to be a chapel (Chapel 1, Fig. 2a). Only the west wall, the south-west corner and traces of the north wall are known, giving a width of c.6 m. The west wall overlies a north–south row of five graves, one of which yielded a radiocarbon date of A.D. 730 ± 70. Small chips of Merovingian vessel glass were also found in the backfill of one of the graves. Further west, another grave contained a Frisian *sceatta* of the mid-8th century.

The probable chapel lies c.50 m west of St Andrew's Well, with its axis inclined from north-east to south-west, the deviation from the true east–west being about 21°. At a distance of 15 m to the west of the chapel the edge of a sub-rectangular pit or well was located, and around its inner margin were the remains of wooden stakes. Most of this feature had been destroyed by later buildings and only its eastern edge remained.

PERIOD 5: LATE SAXON I

Chapel 1 was demolished and a new building erected with its east wall directly over the foundations of the west wall of the earlier structure. Chapel 2A was of simple rectangular form, c.11.0 by 6.5 m, following the previous alignment (Fig. 2b). At least partly contemporary with Chapel 2A was a massive curved foundation which was set some 2 m into the natural subsoil. The strength of this foundation (most of which is inaccessible and beneath the east cloister range) implies either great height or a void on the inside of the curve. The latter is more probable, and it is suggested that we have here an eastern apse, with internal crypt, belonging to the Anglo-Saxon cathedral. A cemetery containing men, women and children was developed to the north of Chapel 2.

PERIOD 6: LATE SAXON II

Short link-walls were built to connect Chapel 2A with the apse, and presumably a doorway was created, if none existed, so that direct access from one building to the other could be obtained. It is not certain whether the west wall of the chapel was demolished at this stage or merely breached; the wall is shown solid on Fig. 2c. There is also evidence that an eastward extension was made to the chapel, presumably to create a sanctuary; the form of this is not known but circumstantial evidence might favour an apse rather than a square end (Chapel 2B).

To the south of the chapel is a spread of domestic debris of late Saxon date, which is in sharp contrast to the north side where burials predominate.

PERIODS 7 AND 8: SAXO-NORMAN AND NORMAN

Several phases of building work are represented here, probably extending from the mid-11th to the mid-12th century. The sequence has not yet been fully worked out, and what follows may be subject to amendment. Chapel 2B was completely rebuilt above foundation level (now 2C), and its orientation was twisted slightly towards a truer east–west alignment. The change would scarcely have been perceptible, and the building was still misaligned by 18°.

FIG. 2. Wells: schematic plans to show the development of the Lady chapel by the Cloister:
a. Middle Saxon; b. Late Saxon I; c. Late Saxon II; d. Saxo-Norman and Norman;
e. Early English II; f. Early English III

Chapel 2c was then more or less encased by new buildings to the north and south, their walls following various alignments. On the south there were several periods of building, seemingly related to domestic functions, and on the north was a long, narrow room which appeared to be L-shaped. This has the appearance of an ambulatory; burial was continued to the east of it (Fig. 2d).

Finally, it was probably also in Period 8 that the cathedral apse was demolished and replaced by a square-ended structure. The interpretation of this is problematical since the new wall was not tangential to the axis of the apse but fell on a line which precisely anticipated that of the much later east cloister wall.

PERIOD 9: EARLY ENGLISH I

By *c.*1180 the present cathedral was being erected, the buildings adjoining Chapel 2c had all been cleared away and burial in the area had probably ceased. The chapel itself was however spared.

PERIOD 10: EARLY ENGLISH II

In the last quarter of the 12th century the old cathedral must have been completely demolished too, and its site given over for the new cloister which was to be attached to the south side of the Early English cathedral. Before that cloister was built, however, an underground conduit was constructed across the site of the old cathedral. The conduit had its origin in St Andrew's Well, from which it took an almost straight course westwards to the market place, a distance of 170 m. The conduit passed close by, and parallel to, the south wall of Chapel 2.

The chapel was partly, if not wholly, rebuilt (2D) and joined to the east side of the new cloister (Fig. 2e).

PERIOD 11: EARLY ENGLISH III

Chapel 2D, alone of everything of Anglo-Saxon and Norman date, was spared from demolition, and it began to be enlarged and improved. Aisles were added, both to the north and south, in the mid to late 13th century, and an eastern arm was added, probably about the same time, although this remains essentially unexcavated (Chapel 2E, Fig. 2f).

The interior of the chapel was intensively used for burial in the 13th and 14th centuries, so much so that all traces of ancient floor levels had been dug away and only small areas of contemporary tiled pavement survived. Most of the burials were in stone-lined cists, but one was contained in a stone coffin. It was one of three which can confidently be identified as clerics through the inclusion of mortuary chalices.

PERIOD 14: LATE FIFTEENTH CENTURY[6]

Chapel 2E was demolished, the site levelled and a large new chapel (Chapel 3) of cruciform plan erected. No regard was paid to the retention of features of Chapel 2 and the ancient alignment was thus finally lost. The conduit, which in Period 11 had lain under the floor of the south aisle of the chapel, had now to be diverted to clear the massive foundations of the new building (Fig. 3). This in turn was demolished in the second half of the 16th century, thus ending a tradition of chapels on this site which had existed for some eight hundred years.

INTERPRETATION AND DISCUSSION

In this brief summary of the sequence of structures in The Camery, I have refrained from assigning dates or making historical equations, for these should not be conflated in the presentation of facts. Future excavation and study of the material recovered will certainly refine the archaeologically-based dating of the structural sequence and will add greater conviction to the historical equations which we must naturally seek to make.

Even with this important caveat in mind, I think it will be possible to demonstrate convincingly that all the main structural phases identified in the excavation of this site can be linked with reasonable confidence to historically attested works. Indeed, there is every

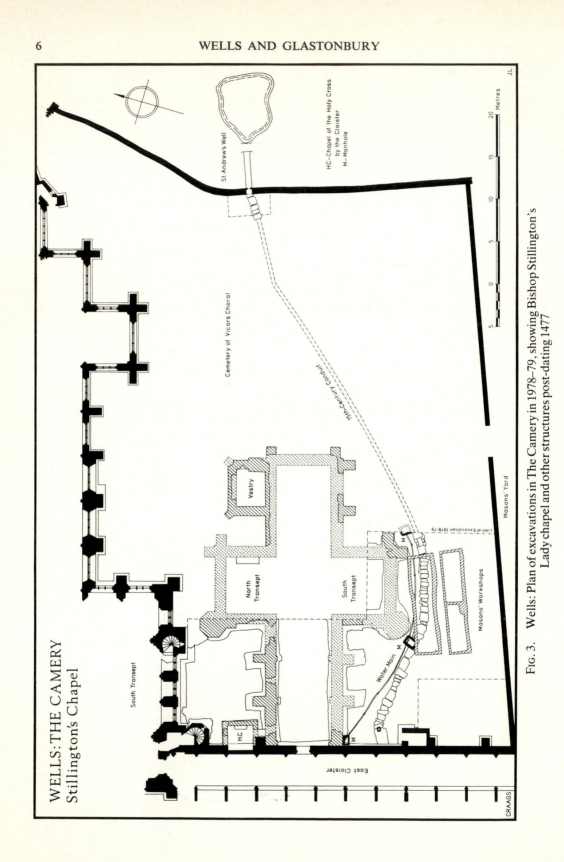

WELLS: THE CAMERY
Stillington's Chapel

St. Andrew's Well

Cemetery of Vicars Choral

15th-Century Conduit

HC—Chapel of the Holy Cross
by the Cloister
M—Manhole

Vestry

North Transept

South Transept

South Transept

Water Main

Limit of Excavation 1978-79

Masons' Workshops

Masons' Yard

East Cloister

H.C.

Metres

CRAAGS

JL

FIG. 3. Wells: Plan of excavations in The Camery in 1978–79, showing Bishop Stillington's Lady chapel and other structures post-dating 1477

promise that this will be a classic case of archaeology and history mutually illuminating one another.

Much of the relevant historical evidence pertaining to chapels in The Camery has been noted by Church and Buckle,[7] and there can be no doubt that all the structures recorded in and after Period 10 were, in succession, known as the 'Lady Chapel by the Cloister'. It seems equally likely that the structures which antedated the erection of the cloister bore the same dedication, but the older description simply recorded the chapel of St Mary as being south of the cathedral. The appellation *iuxta claustrum* came into regular use during the 13th century; even in 1250 we find the precise description: *Capella beatae Mariae quae sita est ex parte australi majoris ecclesie Wellensis.*

There is no reason to suspect that the chapel referred to in 1250 is other than the same chapel of St Mary for which a grant for restoration was enregistered in 1196. Likewise, the same chapel is almost certainly referred to in the grants confirmed by Bishop Robert in 1136, which to the good fortune of the historian, include an endowment to the chapel made by Bishop Giso (1061–88). It is not quite clear whether Giso undertook building works on the chapel, but it is very likely that the endowment was linked to a restoration of the fabric. In archaeological terms, Giso could have been responsible for the works of Period 6. It is also very likely that he was involved in the complex building works of Period 7; in particular, we may equate Giso's well-known benevolence in erecting a dormitory, refectory and cloister for the canons, with that period.[8]

Excavation has shown that to the south of the chapel there were no early burials, only domestic buildings and debris; while to the north the ancient burial ground was cut through for the construction of a non-domestic building in the mid-11th century. Not enough of the plan has been recovered to assert that this was Giso's cloister, but the possibility remains an attractive idea.

In summary, early in its history the chapel of St Mary at Wells seems to have been a detached building standing between the minster (later cathedral) of St Andrew, which lies obliquely beneath the present cloisters, and the 'holy' well which also bore the same dedication. In other words, St Mary's was one element in a line of features, and it occupied a comparable position to that of the chapel of St Mary at Canterbury, which lay just to the east of the great church of St Peter and St Paul.[9]

It is outside the scope of this paper to explore further the subject of the Anglo-Saxon minster and cathedral (the minster was elevated to the status of a secular cathedral in 909), but it should be observed that we have at Wells a substantially preserved example of town planning, probably of the 10th century, in which the ecclesiastical alignment was the key feature. Although rather speculative at present, there are several hints from topographical, historical and archaeological sources of the general disposition of the Anglo-Saxon and Norman cathedrals (Fig. 4).

Finally, it remains only to sketch the outline history of the chapel of St Mary in its later phases. After it had become an adjoined Lady chapel to the eastern arm of the cathedral it was, as we have seen, enveloped in buildings of the 11th and 12th centuries. When these accretions had been stripped away in the 1170s, or possibly in the early 1180s, the chapel would have needed restoration: hence the grant of 1196. It goes without saying that there was little point in restoring the chapel while buildings were being pulled down around it, and equally there would be no point in undertaking work if the chapel itself were due for demolition. Thus by 1196 a positive decision must have been taken to retain this ancient and awkwardly sited chapel. But the excavations have shown that when the Early English cloister was planned and laid out on the ground, the placing of the buttresses and other details clearly envisaged the removal of the chapel. Furthermore, there are hints that the original

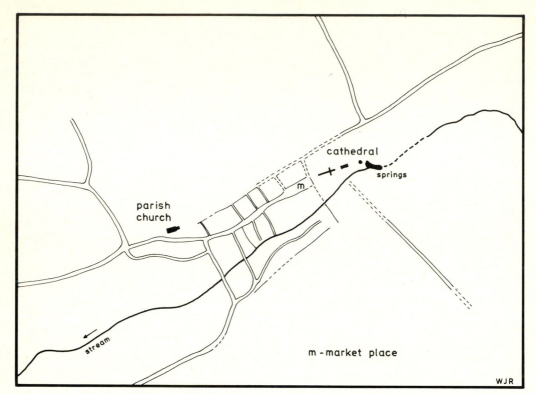

FIG. 4. Wells: simplified plan to show the linear arrangement of religious
buildings and town planning in the late Saxon and early medieval periods

design allowed for the construction of a chapter house on the east side of the cloister, as at
Salisbury.

There was, however, a change of plan, and the decision to retain the chapel of St Mary,
and to bond it into the fabric of the new cloister, came only after the foundations had been
laid. The corollary of this is that the foundations for the cloister must have been constructed
before 1196, which is earlier than had hitherto been supposed. The superstructure may not
have followed for some time.[10]

During the 13th century, interest in the Lady Chapel by the Cloister increased, particularly
for burials and in connection with obits and chantries, and a reference to the addition of an
altar of St Nicholas in 1276 is probably the occasion for the building of the south aisle.[11]
The erection of the north aisle cannot have been far removed in time. The later history of the
chapel is well documented and needs no recitation in detail here: in 1477 it was described as
ruinosa et defectiva and was demolished to make way for Bishop Stillington's replacement,
the cruciform building of Period 14. This chapel, which was completed in 1486, survived
only until 1552 when it was made over to Sir John Gate for demolition, a process which took
many years.[12]

ACKNOWLEDGEMENTS

The Association gratefully acknowledges a grant from the Department of the Environment towards
the costs of publishing this paper.

REFERENCES

1. W. H. St John Hope, 'On the First Cathedral Church of Wells, and the Site thereof', *P.S.A.N.H.S.* (ser. 3), LV, pt. 2 (1909), 85–96.
2. C. M. Church, 'Documents bearing upon late Excavations on the South Side of the Cathedral Church of Wells in 1894', *P.S.A.N.H.S.* (ser. 2), XL (1894), 19–31.
3. E. Buckle, 'On the Lady Chapel by the Cloister of Wells Cathedral and the adjacent buildings', *P.S.A.N.H.S.* (ser. 2), XL (1894), 32–63.
4. Excavations undertaken by the Committee for Rescue Archaeology in Avon, Gloucestershire and Somerset on behalf of the Dean and Chapter of Wells and the Department of the Environment. Full acknowledgements will be made in the final report.
5. Period 1: prehistoric; Period 2: Roman; Period 3: early post-Roman. The remains relating to all these periods are nebulous, but it is clear that a Roman masonry building with glazed windows existed nearby. In view of the proximity of the springs and the western British tradition of 'holy' wells, it should occasion no surprise if a shrine of the Roman period should eventually be located near the cathedral.
6. Periods 12 and 13 are not represented in the history of this sequence of chapels.
7. See notes 2 and 3. Sources are cited in those works and will not be repeated here.
8. For comments on Giso's work, see for example, C. M. Church, *Chapters in the Early History of the Church of Wells* (1894), 3–5.
9. For plans see H. M. and J. Taylor, *Anglo-Saxon Architecture*, I (1965), 136, Fig. 61.
10. If, however, I have correctly identified certain unassociated fragments of vaulting as belonging to the original cloister, a date before *c.* 1200 is implied.
11. See note 7.
12. For the dating see Colchester and Harvey (1974), 200–14; and for a brief account of the excavations of 1978–79, including aspects not touched upon here, see W. J. Rodwell, *Wells Cathedral: Excavations and Discoveries*, 2nd ed. 1980 (Friends of Wells Cathedral).

Proportions in the Design of the Early Gothic Cathedral at Wells

By Barrie Singleton

This paper attempts to analyse the measurements and the system of proportion used in the design of the early Gothic cathedral at Wells. The use of systems employing the proportion of $1:\sqrt{2}$ in medieval architecture is now well established, and a system of this kind seems to have been employed at Wells. However, there appear to have been various ways in which such systems were actually applied, and this problem will be referred to below. It should be remembered that though the $1:\sqrt{2}$ proportion is essentially a geometrical one, being the relationship of the side of a square to its diagonal, arithmetical approximations for it had been known since Antiquity. The pairs of approximations most frequently found are 5:7, 12:17, and 29:41, which are otherwise unlikely combinations of numbers. The pairs can be extended by doubling the first figure. All the combinations so produced, for example 5:7:10:14:20 etc. are related by the $\sqrt{2}$ multiple.[1]

It appears that the cathedral, probably started in the 1180s, was on a new site, so that the building could be a purer realization of its designer's intent than was sometimes the case.[2] The present nave, transepts and much of the three west bays of the choir survive from that building. The upper storeys of these choir bays were modified in the 14th-century rebuilding of the east end. But the original structure of the triforium can be seen beneath the aisle roofs, and much of the original clerestory also remains, visible externally on the south side.

From there it can also be deduced that the square-ended choir had an ambulatory; but it is still uncertain whether an eastern chapel projected from it originally.[3] A different triforium design was introduced in the nave, and the treatment of the main wall behind the nave triforium varies arbitrarily. In addition, a break-line has been observed in the nave, and the decoration of the west front, both inside and out, is different from that of the rest of the building. But despite these changes, there is no sign of any alteration to the basic layout or dimensions of the building, or to the considerations behind them. The cathedral is, in fact, remarkably regular in these elements of its design, and their study is consequently worthwhile.[4]

To begin with the elevation; the heights hardly change between choir, transepts and nave, and were almost certainly meant to be the same. The important levels are the triforium string course, which is the same as the triforium floor; the clerestory string course; the vaulting capitals; the apex of the vaults; and the full height of the side walls. They all seem to be related to each other, and to the level of the capitals of the main arcade. The triforium string varies from 28 ft 5 in. (8·67 m) to 28 ft 11 in. (8·8 m) with the average just above 28 ft 8 in. (8·74 m). The clerestory string varies between 40 ft 3 in. (12·27 m) and 40 ft 8 in. (12·40 m) with the average just above 40 ft 6 in. (12·34 m), which is within an inch of 28 ft 8 in. multiplied by $\sqrt{2}$. But I would suggest the intended ideal heights were 29 ft and 41 ft. This is confirmed by the height of the side-walls on which the roof rests (discounting the later parapet). Having taken measurements throughout the nave and transepts, I calculate this to be approximately 70 ft 5 in. (21·46 m). If 29 ft and 41 ft were the intended heights of the two internal upper storeys, 70 ft 5 in. clearly represents their sum, 70 ft (Fig. 1).[5]

The height of the vault capitals varies between 44 ft 2 in. (13·46 m) and 44 ft 6 in. (13·56 m), which, divided by three, produces the height of the main arcade capitals, which range from about 14 ft 9 in. (4·50 m) in the nave to approximately 15 ft (4·57 m) in the transepts. These

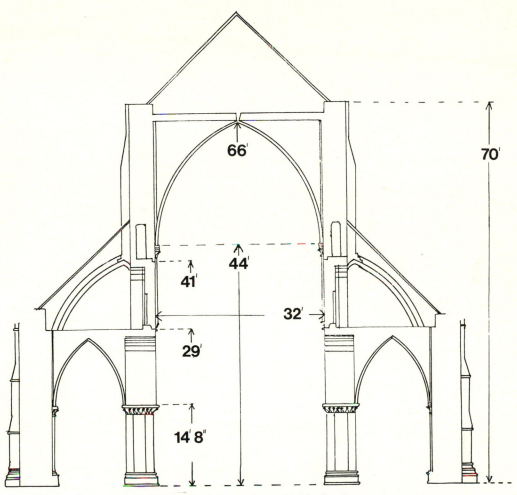

FIG. 1. Wells Cathedral, section, with idealized measurements

two levels are also probably related to the height of the vault apices, whose intradoses are approximately 66 ft (20·12 m) high, though their extradoses are closer to 67 ft (20·42 m). The sense of this seems clearly to be that the vaults are half as high again as the vault capitals. The practice in the rest of the cathedral suggests that these heights were originally fixed in terms of whole feet or simple fractions, and that the vaults were intended to be 66 ft high, the vaulting capitals 44 ft, and the arcade capitals 14 ft 8 in. Thus, in the elevation there seem to have been two separate systems intertwining, as it were, to produce all the major levels.[6]

Happily, the major dimensions of the ground plan appear to be related to at least one of these systems. Just as the elevation remains basically the same in all four arms of the cathedral so do the internal widths of those arms. The narrowest are the transepts, never less than 69 ft 3 in. (21·11 m); the widest the nave, never less than 69 ft 7 in. (21·21 m). In view of the height of the side-walls, these dimensions surely represent an ideal of 70 ft, so that the section of the cathedral was internally a square, being as wide as it was tall (Fig. 2a).

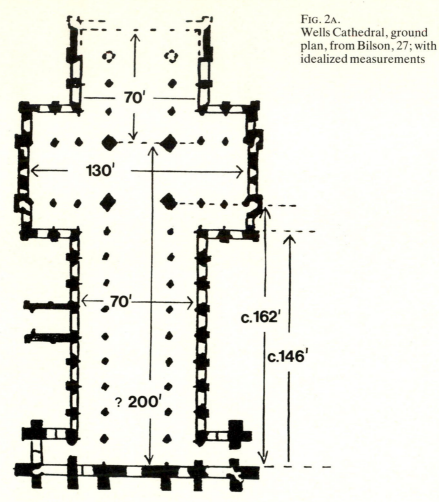

FIG. 2A.
Wells Cathedral, ground
plan, from Bilson, 27; with
idealized measurements

The length of the transepts seems to have been generated from this ideal width. It is difficult to know between which points the transepts were measured. One might think it to have been the wall behind the triplets of the ground storey arcade, but this wall is recessed behind the plane of what is more probably the main wall, as represented in the triforium and clerestory. This plane is also represented on the ground storey by thin pilasters at the extreme north and south edges of the arcading, and it is between these planes that the transept length should be measured (Pl. IIA). This length is approximately 129 ft 7 in. (39·50 m), probably representing an ideal of 130 ft. That being so, each arm of the transept projects beyond the nave by 30 ft, a $\sqrt{2}$ extension, calculated as simple multiples of the 5:7:10 approximations. That is, the width of the nave plus one arm of the transept is $\sqrt{2}$ times the width of the nave. The intended length of the choir is equally clear. The piers which turned its east end were refashioned in the 14th century, but the length of the original choir can be measured from the corresponding responds on the aisle walls, which remain intact. The distance from the centre of the eastern crossing piers to the centre of these — that is, to the centre of the original eastern arcade of the choir — is 53 ft 4 in. (16·26 m) (Fig. 2b).

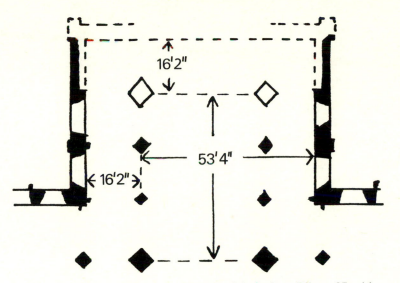

FIG. 2B. Wells Cathedral, ground plan of choir, from Bilson, 27; with
actual measurements

This is precisely the distance across any arm of the cathedral from the inside of an aisle wall
to the centre of the further main arcade, the remaining 16 ft 2 in. (4·93 m) to the other aisle
wall being the width of the aisle measured to the centre of the arcade. The ambulatory round
the east end of the choir would have been as wide as its north and south aisles, and so the
choir measured from the centre of the eastern crossing piers to the inside of its eastern
ambulatory wall, was approximately 69 ft 6 in. By this I again understand 70 ft, so that the
choir, in a sense, was cubic.

The nave would probably have been measured from the inside of its west wall, but its
eastern measuring point is more problematic. It would be consistent with other buildings if
this eastern limit had been to the centre of the western crossing piers. But the length so
produced, about 162 ft (49·38 m), appears to bear no relation to any other major dimension
in the cathedral. Another point of measure, common elsewhere, is to the inside of the
western wall of the transepts. But at Wells this would produce another unrelated measure-
ment of approximately 146 ft (44·50 m). I do not know of a precedent for measuring the
western arm to the centre of the eastern crossing piers, but something can be said in favour
of this at Wells. First, we know it was a point of measure for the choir. Also, measuring to
this point from the west wall of the nave gives a length of approximately 199 ft (60·66 m),
by which 200 ft may be meant, and this would obviously be related to the lengths of 70 ft
and 100 ft mentioned above. Finally, it would be perfectly possible to lay out all the major
parts of the cathedral without a line through the western crossing piers or along the face of
the transept west wall.[7]

The way in which the main widths were divided between main vessel and aisles is best
approached after examining the piers. These have a cruciform core, on the main faces and
in the re-entrant angles of which are attached triple colonettes. The cruciform core was
formed by superimposing two squares whose diagonal lengths are about 5 ft 5 in. (1·65 m),
the first being set diamond-wise, the second at 45° to it (Fig. 3). The points of intersection
were then joined to make a cross and the outer parts shaved off.[8] It is almost certainly the

diagonal length of *c*.5 ft 5 in. which was the important one, for although the distance across the nave between the inner faces of the pier cores is approximately 33 ft 3 in. (10·13 m) it narrows to about 31 ft 8 in. (9·65 m) above the main arcading; and it is, in fact, above ground level that the dimensions of the nave, into which the vaults had to be fitted, are most clearly expressed (Fig. 1 and Pl. IIB). But this distance of 31 ft 8 in. was exactly that between the piers before their protruding corners were shaved off. This shaving-off is probably best thought of as a reduction of the arcade wall to shape it into the piers. The 31 ft 8 in. distance cannot otherwise be found at ground level. Furthermore, if the thickness of the arcade wall is thought of as about 5 ft 5 in., then 13 ft 5 in. (4·09 m) is left for the space of the aisle. The total width of the arcade and aisle would then be $\sqrt{2}$ times the width of the aisle, a proportion which occurs at Norwich, and which may have occurred in the nave at Durham.[9] It may be that ideals of 5 ft 6 in., 13 ft 6 in. and their sum, 19 ft, were intended by these distances. However, what should be noticed here is that whether the distances were intended to be simple divisions of whole feet or more complicated, fractional figures as would be produced by a purely geometrical method of design, they are not related to the arithmetical approximations which have hitherto produced all the major measurements. I do not understand how the 31 ft 8 in. width of the nave was obtained.

It is an arresting coincidence that the 31 ft 8 in. width of the nave is almost twice that of the nave bay lengths which are 16 ft (4·88 m), and it may be thought that this reflects vaulting considerations, since it is easy to calculate the span of the diagonal ribs in a rectangle whose sides are as 1:2.[10] However, the bay lengths of the transept, 14 ft 8 in. (4·47 m), and of the choir, 17 ft 1 in. (5·21 m), are quite different, and clearly demonstrate that at Wells bay lengths were of little importance and had no part in the fixing of the overall dimensions;[11] and that vaulting considerations were independent of the bay design. The fact that the nave vaulting bays are similar rectangles to those at Laon and Bourges, where semi-circular diagonal ribs were still being employed, is either coincidental or the empty leftover of tradition. As has been pointed out with regard to Reims and Chartres, which are similar to

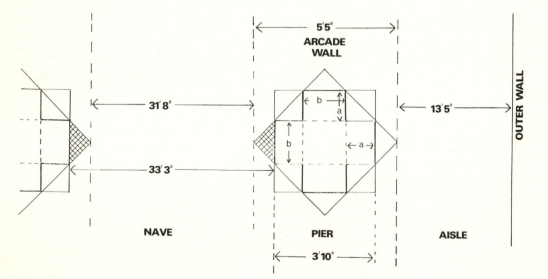

FIG. 3. Wells Cathedral, scheme showing the division of the nave width and the construction of the piers; with actual measurements

Wells in only using pointed arches, the bay forms are no longer dictated by the vaults and the designers have achieved a greater freedom and a technological advance.[12]

Owing to the limited number of monuments which have been examined and published, comparisons and conclusions must be tentative. In general, however, Wells appears to be comparable to the other known buildings. The relationship of vault capitals to vault apices occurs perhaps more often as $1:\sqrt{2}$ than 2:3 as at Wells.[13] But the role of the triforium in bisecting the total wall height and having a $\sqrt{2}$ relationship to both what is below and above can be compared to St Laumer at Blois and, with qualifications, to Noyon cathedral and to the south transept at Soissons.[14] Although the inclusion in the system of the total height of the side wall appears to be rare, it has been claimed for Durham.[15] A desire to build to the square is evident at St Etienne at Caen, Durham and Chartres,[16] and to plan the choir as a square at Ely.[17] To build to the cube is an extension of this, possibly paralleled at Durham. The generation of the transepts from the nave can be compared to practice at Laon and Reims. This list could be extended further, but with little point.

It will be clear that most of the major dimensions at Wells appear to have been fixed by using the established arithmetical approximations for the $1:\sqrt{2}$ proportion. Sometimes, as with the levels of the triforium and clerestory, these approximations appear to have co-incided with an almost exact expression of the proportion. But generally they did not. However, in the division of the nave width they do not appear to have been used, and it could be that there resort was made to a purely geometrical system.

There is clearly a difference in method and result between the two systems. For large dimensions the geometrical method would either have to be scaled up from a smaller drawing or laid out in full scale with pegs and vast lengths of rope which would be manoeuvred about. It might be the method expected for smaller objects. It certainly appears to have been employed for designing the piers at Norwich and Wells. It results in precise relationships but fractional figures. However, exactly such precision through fractional figures has been claimed for all the dimensions at Norwich.[18] The arithmetical method would appear to have been easier to use for large distances, and yet it has been found to underlie certain intricately traceried windows.[19] It results in slightly inexact proportional relationships, but whole figures (of identifiable units of measure), such as is claimed for the major dimensions at Windsor and is common at Wells.[20] Both systems were clearly available to masons, and it may be that they chose between them or combined them in arbitrary fashion rather than following some canonical procedure. Whether there was a move from one method to the other in the course of time, it is not possible to say at the moment.[21] Nevertheless, in analysing buildings for $\sqrt{2}$ proportional systems these two types should be identified and distinguished.[22]

ACKNOWLEDGEMENTS

I am grateful to the authorities at Wells and, in particular, the vergers and Mr L. S. Colchester for granting me great freedom in their cathedral, and for being so friendly, helpful and tolerant. I have benefited considerably from the advice of Dr Kidson. I am indebted to the many people who helped me take measurements, especial amongst whom is Anat Tcherikover.

REFERENCES

SHORTENED TITLES USED

KIDSON (1956)—P. Kidson, *Systems of measurement and proportion in early medieval architecture*, unpublished Ph.D. thesis, University of London, 1956.

— (1975)—P. Kidson, 'The Architecture of St. George's Chapel', *The St. George's Chapel Quincentenary Handbook*, edited by Maurice Bond (Windsor 1975), 29–39.

Fernie (1976) — E. C. Fernie, 'The Ground Plan of Norwich Cathedral and the Square Root of Two', *JBAA*, cxxix, 1976, 77–86.

— (1978 Metrology) — E. C. Fernie, 'Historical Metrology and Architectural History', *Art History*, vol. i, no. 4, 1978, 383–99.

— (1978 St Gall) — E. C. Fernie, 'The Proportions of the St. Gall Plan', *Art Bulletin*, lx, 1978, 583–89.

— (1979) — E. C. Fernie, 'Observations on the Norman Plan of Ely Cathedral', *BAACT*, ii, *Ely Cathedral*, 1979, 1–7.

1. For explanations of the $1:\sqrt{2}$ proportion see Fernie (1976), 77; Fernie (1978 St Gall), fig. 4; Kidson (1975), 32 and 34; and, the most detailed, Kidson (1956) passim, especially vol. i, 116–20. Though I have not discovered systems based on other geometrical figures, for example $1:\sqrt{3}$, at Wells, more complex systems have been claimed for other buildings. See, for example, Kidson (1975). Obviously simple arithmetical proportions, such as 1:2 or 2:3 or 3:4 etc. were used as well as the geometrical ones.

2. Work was certainly under way by 1186; see Robinson (1928), 1–22. A slightly earlier starting date of about 1180 has recently been claimed by Colchester and Harvey (1974). However, the cathedral cannot be dated in isolation from the sort of architectural context that has recently been outlined by C. Wilson, 'The Sources of the Late Twelfth Century Work at Worcester Cathedral', *BAACT*, i, *Worcester Cathedral*, 1978, 80–90. The recent excavations to the east of the cloisters by Dr Warwick Rodwell appear to support Hope's belief that the previous cathedral was to the south of the present building. See W. St J. Hope, 'On the First Cathedral Church at Wells and the site thereof', *P.S.A.N.H.S.*, lv, 1909, pt. 2, 85–96.

3. For all this see Bilson (1928). In view of Bilson's acceptance of Willis's opinion that there was originally a Lady Chapel projecting east of the ambulatory in R. Willis, 'Wells Cathedral', *P.S.A.N.H.S.*, xii, 1863–64, pt. 1, 14–24, and his publication of Willis's plan, it should perhaps be stressed that we have no firm documentary evidence for a chapel in such a position before 1279, and no structural evidence for one at all. See Robinson (1928), 9.

4. The plan and drawings Bilson published in his article are considerably reduced versions of the very fine originals now in the R.I.B.A. Drawings Collection. The cathedral chapter had a new ground plan made in 1978 (p. 1). These are the two best plans I know.

5. There is no record of the floor level having been changed. Mr L. S. Colchester, judging from the apparently unaltered nature of the medieval doors in the cathedral which often reach right down to the present paving, believes that if anything the level may have been slightly lowered, though this seems inherently unlikely. It is perhaps best to consider the level as unaltered. It should be pointed out that the original unit of measure used at Wells appears to have been the standard English foot, which was apparently used at Ely (see Fernie 1979). Consequently, though I give actual dimensions in metres as well as feet, the idealized dimensions are given only in feet.

6. Similar separate but interlocking systems in one elevation have been found at Windsor and Laon. See Kidson (1975), 34–35.

7. It should not be thought that the liturgical divisions of the building would preclude a definition of the nave as extending to the centre of the eastern crossing piers. The divisions used in laying out churches invariably failed to coincide with liturgical divisions. At Wells the pulpitum is thought to have been between the pair of nave piers immediately west of the crossing, which was certainly not an important point of measure. For the pulpitum see W. H. St J. Hope, 'Quire Screens in English Churches etc.', *Archaeologia*, lxviii, 1916/17, 43–110, and Rev. C. M. Church, *Chapters in the Early History of the Church of Wells A.D. 1136–1333* (1894), pp. 322–28.

8. The lengths 'a' and 'b' of the pier core are related to each other as $1:\sqrt{2}$, which is a nice example of how natural and accidental this relationship is to a mason, who is constantly manipulating compasses and regular geometrical shapes.

9. For Norwich see Fernie (1976). I am grateful to Eric Fernie for drawing my attention to this relationship at Wells, and especially for allowing me to read his unpublished analyses of a number of earlier churches. His studies have been a considerable stimulus to my examination of Wells. For Durham see R. W. Billings, *Architectural Illustrations and Description of the Cathedral Church at Durham*, 1843, Pl. iii, where the width of the arcade wall plus the aisle is given as 24 ft 4 in. and the aisle alone as approximately 17 ft 4 in. These dimensions are very close to having a $\sqrt{2}:1$ proportion, and are also close to the 12:17:24 approximations. The arcade wall at Durham is 7 ft wide.

10. A right-angled triangle whose other sides are as 4 to 8 has a hypotenuse very close to 9.

11. It is an interesting speculation that the unbroken triforium of the nave can be seen as more of a reflection of the principles behind the basic design than was the case in the choir and transepts where the triforia are divided into bays. But it is hardly capable of proof.

12. Kidson, ii (1956), 106–07; 159–60; 222.

13. For example, at Durham and Laon.
14. Kidson, II (1956), 197–98.
15. Ibid., II, 69–76.
16. For Caen see E. G. Carlson, *The Abbey Church of St Etienne at Caen in the Eleventh and Early Twelfth Centuries*, Ph.D thesis, University of Yale, 1968. Otherwise see Kidson, II (1956), 62–70 and 189.
17. Fernie (1979), 2.
18. Fernie (1976), passim.
19. I. N. Coldstream, *The Development of Flowing Tracery in Yorkshire c.1300–1370*, unpublished Ph.D thesis, University of London, 1973, pt II, 219–96.
20. For Windsor see Kidson (1975).
21. Compare Kidson, II (1956), 171.
22. There is the further possibility that in addition to the limited number of arithmetical approximations that had been inherited from Antiquity, medieval masons had discovered some of their own. This may be pertinent to the way the nave width was divided.

The Sequence and Dating of the Decorated Work at Wells

By Peter Draper

The building activity at Wells during the late 13th and the early 14th centuries has long been regarded as a very important contribution to the Decorated style in England and even to the development of Late Gothic in Europe. Within a period of about seventy years, between *c.*1270 and *c.*1340, the dean and chapter undertook the construction of a large octagonal chapter house, the heightening of the central tower and an ambitious extension of the eastern arm of the cathedral. Active encouragement was received from the bishops, one of whom, Robert Burnell, doubled the size of the adjacent bishop's palace in the last two decades of the 13th century. However, there has been no general agreement about the dating of these buildings or even about the order in which they were built, although the establishment of as precise a chronology as the evidence will allow is essential if the significance of these works is to be assessed correctly. It is the purpose of this paper to propose a sequence for these works and a chronology which is consistent with the evidence derived from documents as well as that based on stylistic comparison. This will involve a reconsideration of the interpretation which has been placed on the relatively few entries in the Chapter archives concerning the fabric, and an attempt to establish a more secure date for the reconstruction of the east end by relating it to the promotion of the cult of Bishop William de Marchia.

The most influential, and, unfortunately, the most misleading article on the Decorated work at Wells was that published by Dean Armitage Robinson in 1931.[1] In that paper Armitage Robinson argued a starting date for the Lady chapel, and, by implication, for the whole conception of the east end, in the 1290s. He accorded little significance to the document of 1326 where the Lady chapel is described as 'noviter constructa'.[2] Moreover, he argued that the chapter house was not completed until after the Lady chapel had been built. Geoffrey Webb accepted these conclusions and echoes of them are still to be found in the *Buildings of England*.[3] Henning Bock expressed reservations about this proposed sequence for the design of the Lady chapel and the chapter house but he accepted that they were executed simultaneously.[4] Recently, Colchester, reviewing the documentary evidence, and Morris, employing detailed stylistic comparison, have argued that the Lady chapel was not begun until after the chapter house was complete.[5] This view, which is implied in Harvey's biography of William Joy, is very close to that put forward by Canon Church in 1894 and by Professor Willis in 1851.[6]

Willis was the first to propose that the lower storey of the chapter house together with the staircase had been begun about 1260–70 and that the reference in 1286 to the 'nova structura iam diu incepta' was to the chapter house itself.[7] Armitage Robinson accepted the latter hypothesis but modified Willis's proposed dating by suggesting that although the staircase was 'in building about the year 1286', the diagonal tooling evident on the lower eight feet of the whole complex indicated that this had been laid out and commenced before 1220, following Bilson's observations on the occurrence of diagonal tooling on the church.[8] There are many reasons why this conclusion cannot be accepted.[9] It is unlikely that work was started on any part of the complex before the 1260s for it was only in 1263, the bishop and chapter having so far freed themselves from the enormous debt incurred as a result of their litigation at Rome, that the bishop was able to release to the fabric fund the fruits of

vacant benefices which had been granted to him for life. In 1264 the complement of the chapter was finally established at fifty-three including the dean. The construction of the magnificent chapter house was thus a very tangible expression of the newly won authority and independence of the chapter under the zealous leadership of Dean Edward de la Knole (1256–84).[10]

Armitage Robinson's chronology required a break of some twenty years between the construction of the staircase and vestibule and the final campaign on the chapter house, the completion of which he assigned to the year 1319 when the phrase 'in domo capitularis' is used for the first time in the surviving chapter records.[11] There is indeed clear evidence of a change of style at the entrance to the chapter house. The details of the entrance arch and the vestibule up to the height of the capitals, show that they go with the staircase and were built by the masons who were responsible for the chapel in the bishop's palace. This is shown by the obvious similarity of the capitals and bosses in the two buildings and the identity of the mouldings used for the internal mullions of the staircase windows and the windows in the chapel.[12] In each case the forms are more developed in the chapel which must, therefore, follow the construction of the staircase. The transfer of the masons to the new work in the bishop's palace would explain the interruption in the campaign on the chapter house. However, just as the tracery of the staircase is related to that of Burnell's chapel, so a similar close relationship is evident between the tracery of Burnell's hall and that of the chapter house. The apparently simple chronological relationship between these buildings is complicated by the evidence of the masonry which shows that the north-east turret of Burnell's hall was constructed as part of the hall and before the chapel, even though the two buildings are closely integrated at the top of the turret (Pl. IIIA).[13] Yet the style of the tracery has usually been taken to indicate that the hall is later than the chapel. If this is correct it means that Burnell must have interrupted the work on the hall before the north-east turret was finished, and diverted his attention to the chapel before completing the hall itself. It is unlikely that Bishop Burnell would have undertaken a large-scale reconstruction of the palace before c.1280,[14] but we do not know how much of the work was done during his episcopate. If it is assumed that a substantial part was finished by the time of his death in 1292, the significance of the 1286 document must be reconsidered. The supposition that this document marks the start of a campaign which was to include the staircase and the vestibule of the chapter house leaves little time for the subsequent work by the same masons in the bishop's palace. On the other hand, if the chapel is dated earlier, nearer to 1280 — and the style of the chapel is quite consistent with a date in the 1280s (Pl. IIIB) — it means that the staircase must have been constructed well before 1286.

The chronology thus suggested would allow a date in the 1290s for the design of the chapter house with its use of motifs then fashionable in London.[15] This accords well with the traditional attribution of the chapter house to the time of William de Marchia, bishop from 1293–1302, and finds corroboration in the close similarity of the bosses in the chapter house to those bosses at Exeter which can with considerable certainty be dated before 1303.[16] In fact a slightly later date than 1303 for the chapter house vault may be suggested by the presence of bosses which have more seaweed-like forms together with those with very naturalistic foliage (Pl. VIA, B). At Exeter this stylised foliage is found first in the fifth bay of the presbytery where there is an abrupt change from the naturalism of the foliage in the four eastern bays. It may be that the sculptors at Exeter came to Wells, perhaps through the good offices of Bishop Thomas Bytton, who had been dean of Wells and whose family had a distinguished record of service to the cathedral, and that these sculptors then returned to Exeter having changed their style at Wells. A *terminus ante quem* for the completion of the chapter house may be provided by the reference in 1307 to the 'great costs and expenses

which they have incurred and paid in connection with the building of their chapter house', as there are no references to work on the chapter house after this date.[17] Indeed between 1307 and 1315 there is no mention in the Chapter records of any work on the fabric: 1315 marks the start of the next major campaign, the raising of the central tower.

In view of the dates which hitherto have been assigned to the Lady chapel and the eastern extension, it should be noted that up to the completion of the tower in 1322 there is no indication in the surviving records that work was proceeding on any other part of the building. It is clear from the detailed minutes of a meeting of the Chapter called in 1318 to take proceedings against those members who had defaulted on the self-imposed tax to pay for the new tower, that this was the only building work then in progress.[18] In fact, one documentary reference shows that the Lady chapel was still in use in 1319 and there is good circumstantial evidence to suggest that work on the remodelling of the east end was started about 1323/24 after the completion of the central tower. To be interpreted correctly the 1319 reference must be seen in the context of the other documents which refer to this part of the building.

There were two Lady chapels at Wells in the 13th century, and, probably, in the 12th century, for a Lady chapel behind the high altar, whether or not projecting, was almost certainly part of the original design. The Lady chapel to the east of the cloister certainly predated the 12th-century church since it is so much out of alignment with it. This chapel was extensively endowed in the mid-13th century by the Bytton family and was probably remodelled at that time. All that survives is part of the entrance arch, visible on the west side of the east wall of the cloister, and the base of the respond of the south arcade, the profile of which has been convincingly related to some of the bases in the chapter house undercroft.[19] Despite the existence of two Lady chapels there is little danger of confusion for normally they are carefully differentiated when referred to in the documents.

There are several references to the Lady chapel behind the high altar during the 13th century but for the present purpose it will suffice to start in 1298 when a bequest was made to an image of the Virgin in the chapel.[20] It was almost certainly to maintain a light in front of this image that Richard de Chapmanslade left 40d. in 1311, since the chapel is identified as 'where the Salve Sancte Parens was sung',[21] and in a charter of 1318 it is specifically stated that this was sung in the Lady chapel.[22] In 1316 reference is made to an endowment to the 'chapel of the Virgin Mary in the church'. The crucial document is dated 1319 when Bishop Drokensford collates John de Arlesford to the chantry of William de Bytton 'ad altare beate Maria virginis in capella eiusdem retro maius altare'.[23] In 1326 the Lady chapel is described as 'noviter constructa'. It has been suggested that the document of 1319 refers to a chantry in the new Lady chapel which must, therefore, have been complete.[24] However, the chapel is not referred to as new and the document should be construed as a straightforward collation to a chantry for Bishop Bytton which had been established in 1271 by Bishop Bytton II and is mentioned again in 1279 by his executors.[25] Far from giving a completion date for the new Lady chapel the document shows that the old Lady chapel was still in use in 1319.

A comparable misconstruing of documents led Armitage Robinson to conclude that the setting up in front of the choir screen of two altars, one dedicated to the Virgin and the other to St Andrew, demonstrated that by 1306 work had so far progressed on the east end that the Lady altar and the high altar had had to be moved.[26] In fact, the documents cited make it quite clear, as is evident even from the quotations in the article, that the altars had been constructed as chantry altars at which the obits of Bishop Burnell and Bishop Haselshaw, amongst others, were to be celebrated, and near to which the two bishops were buried.[27] The date of 1306 has no significance for the remodelling of the east end.

The geometry of the layout of the ambitious extension to the 12th-century church leaves no doubt that the Lady chapel was an integral part of the undertaking,[28] the ambitious scale of which would lead one to expect that it would be mentioned in the deliberations of the Chapter. The first reference to the 'novum opus' occurs in November 1325 when it is recorded that the bishop had granted half the proceeds of his episcopal visitation towards the fabric of the new church, and that each canon had been made responsible for making his own new stall in the choir.[29] Shortly afterwards the bishop granted an indulgence 'pro novo opere'.

However, as early as June 1324 the dean and chapter were arranging for a petition to be presented to the Pope for the canonisation of their former bishop, William de Marchia, who had died in 1302.[30] There is no evidence that any formal moves to secure de Marchia's canonisation had been made before this, although his local cult had, apparently, become established, for in 1318 oblations at his tomb are listed as one of the sources of income of the fabric fund for the new tower.[31] It is probable that the successful outcome in 1320 of the petition for the canonisation of Thomas de Cantelupe at Hereford inspired the bishop and the canons at Wells to initiate their own petition.[32] The likelihood is increased by the known close association between the bishop of Hereford, Adam de Orleton, a man high in Papal favour, and John Drokensford, for both men were leading members of the faction growing up around Queen Isabella in opposition to Edward II. Indeed, after the battle of Borough-bridge in 1322 Edward wrote to the Pope that he could no longer tolerate the presence in England of the bishops of Hereford, Bath and Wells, and Lincoln.[33] In 1325 the archbishop of Canterbury and eight bishops, including these three, wrote to the Pope in support of the petition[34] and in 1327 the clergy of the diocese granted a tax of one tenth towards the expenses involved in securing the canonisation of de Marchia (as well as to the 'novum opus' of the cathedral), and money was still being collected for the purpose in 1328.[35] The final petition was submitted on 20 February 1329 when Edward III wrote to the Pope and to the cardinals to enlist their support.[36] The prime mover in the affair seems to have been the bishop, John Drokensford, for the petition lapsed with his death in May 1329. In the event, Wells was to be no more successful than Salisbury had been a century before.

The decade of the 1320s was not a propitious one in which to pursue such a petition. The kingdom was in a very disturbed state and relations between England and the Papacy at Avignon were often politically delicate. Three other applications for canonisation from England in this decade were equally unsuccessful and failed even to secure a commission of enquiry. These were on behalf of Thomas of Winchelsea, archbishop of Canterbury 1294–1313, a petition which was actively pursued by Thomas of Lancaster, who himself became the object of a popular cult and of petitions by Edward III in 1327, 1330 and 1331, despite the equally assiduous efforts by Edward's father in 1323 to suppress the cult. It was, of course, Edward II as the object of a cult at Gloucester who was the third candidate to fail to secure any formal recognition.[37] Apart from these considerations, there was also active opposition to the petition on behalf of William de Marchia. He had not been universally loved, and had aroused considerable opposition by his actions as Treasurer to Edward I.

The failure of the petition, however, should not prevent us from recognising the significance of its timing, which may be used as corroborative evidence for dating the start of work on the eastern extension. There can be no doubt of the close connection between the promotion of de Marchia's cult and the 'novum opus', for this is explicitly stated in a Chapter Act of December 1326, where it is recorded that the rectors and vicars of the deanery of Axbridge have granted a tenth of their benefices as an aid to the new fabric, and for honourably placing there the body of William de Marchia of most holy memory.[38] It is, therefore, highly probable that the setting out of the eastern extension at Wells was designed

to make provision for the shrine of de Marchia in the bay behind the high altar.[39] His tomb was, in fact, placed in the south wall of the south transept and is usually dated shortly after the bishop's death in 1302.[40] There is no decisive reason why this date should not be possible although the decorative features differ from those used in the chapter house and such an early date would mean that the tomb constitutes a very precocious use of certain features at Wells. An alternative hypothesis is that the canopy of the present tomb should be dated c.1330, after the failure of the petition for canonisation and the consequent abandoning of the scheme to erect a fashionable shrine at the east end.[41] A number of the features of the canopy, especially the diagonally placed buttresses, the ogee cusping and the concave gables, go perfectly well with the work on the presbytery in the 1330s.

This accumulation of evidence leaves little room for doubt that the starting date for the eastern extension was 1323/24, with the Lady chapel being completed by 1326. The overall sequence of building thus established accords better with the impression gained from the documents that the Chapter organised the separate building campaigns for the chapter house, the tower and the east end, in an ordered and controlled manner, and certainly with less profligacy and extravagance than had been lavished on their litigation with the bishop in the mid-13th century. Even by 1337 the outstanding debt amounted to only £200, the equivalent of only one of several loans undertaken in the 1240s.[42] The documentary evidence, and the evidence to be derived from the fabric, suggest that the eastern extension was constructed in a more or less continuous campaign.[43] The regular coursing of the plinth and the lower part of the wall can be followed around most of the extension with only minor discrepancies. The disturbance to the coursing above sill level at the junction between the Lady chapel and the adjacent chapels shows that the Lady chapel was constructed and completed before work continued on the upper parts of the chapels and ambulatory. The toothings still visible on the western corners of the Lady chapel above the ambulatory vaults, although never used, were probably left in case temporary buttresses were needed before the construction of the ambulatory vaults, which would provide the permanent abutment. They do not indicate that the Lady chapel was built much earlier than the ambulatory and chapels nor that it was part of a different plan. It is possible that the Lady chapel was brought into use in 1326 by screening off the three western arches, even though access to it must have been difficult for many years. The starting date for the Lady chapel proposed here does entail a rapid campaign, but two years had been sufficient for a more elaborate chapel at Glastonbury between 1184 and 1186.

Most of the new work projects beyond the 12th-century church and could have been laid out and constructed on an unencumbered site. A temporary screen would probably have been erected behind the high altar, thus enabling the old Lady chapel to be demolished so that the eastern arcade of the new presbytery could be constructed and the vaulting of the ambulatory could proceed. Whilst the general sequence of construction from east to west can be securely established it should be noted that although the vaults of the 12th-century presbytery aisles belong to the final stages of the whole campaign, there are indications that the windows of these aisles were remodelled before the construction of the windows of the new presbytery aisle.

The evidence is this. The tracery of the windows in the aisles and the eastern chapels of the south transept consists of two alternating designs (Pl. IVA, B). One may be referred to as the vesica design and the other as reticulated. The alternation is regular in the north aisle but in the south aisle there are two vesica patterns adjacent in the second and third bays from the west. The implication of this is that the two western windows were remodelled before the system was established in the north aisle. These two windows are different from all the other aisle windows in the form of their internal and external splays (the third window

from the west shares the same internal splay but externally has the same splays as all the other aisle windows) and in the profile of the external mullions which have a filleted roll added to the chamfer. This form is standard for the internal mullions of all the other windows of the eastern extension including the Lady chapel but excluding the eastern windows of the south transept and the two western bays of the north aisle which share a different form. Finally, the cusping in the eastern windows of the south transept is more elaborate. It is slightly less elaborate in the western windows of the south aisle and is reduced to a standard, simplified form at the east end and in the north aisle. The significance of these subtle but distinct variations is that, as the exceptional features are more elaborate than the standard form, it is highly probable that they were constructed first, particularly as it is evident from the clerestory windows of the choir that the work became progressively more schematic towards the end of the campaign. This interpretation is supported by the irregularity in the alternation of the tracery patterns which could hardly have arisen in a steady campaign from the east.

The question then arises as to whether the renewal of these windows formed part of the 'novum opus' of the eastern extension or an entirely separate undertaking, and if the latter, whether it is possible to ascertain how long before the main campaign it was carried out. One could suggest that the south transept windows were remodelled in the early years of the 14th century in connection with the burial of Dean Husee in St Calixtus's chapel but they must, surely, be later than the work on the chapter house.[44] The patterns of the tracery do not provide any firm basis for dating. The reticulated pattern is found at Bristol, but only datable within much the same bracket that can be established at Wells, and although the vesica shape is found in the vestibule of the chapter house it is there in a decidedly geometrical context with a complete absence of flowing forms. The repertoire of designs at Exeter does not furnish us with any close parallels, apart from the east windows of St Andrew's chapel where there is an oculus in place of the vesica, but these seem to be 17th-(?) century replacements and may bear little relation to the originals. The fact that the vaults of these aisles were not renewed at the same time as the windows, taken together with the peculiarities of the mouldings, argues for a campaign separate from that of the 'novum opus', but if it was much earlier it would betoken a very conservative attitude to tracery design on the part of the masons responsible for the east end, as the two types of design are repeated throughout the work, with the exception of the Lady chapel. Nevertheless, it is worth remarking that at Wells flowing tracery may have been introduced before the fish-scale pattern in the Lady chapel. The evidence of the architectural details suggests that the aisle windows were renewed before the main campaign on the east end but the continuity of some features indicates that there was no great lapse of time between them. The crucial evidence would seem to be the style and technique of the glazing.[45]

This digression does not affect the sequence of the main campaign. The later starting date for the Lady chapel makes better sense of the documented chronology of the chapels, ambulatory and presbytery. The first surviving documentary reference to the chapels is March 1329 when Bishop Drokensford appointed a priest to a chantry which he had founded 'at the altar near which our body . . .'.[46] This presumably refers to the altar of St Katherine in the projecting chapel on the south side where the bishop's tomb was later placed. This chapel is specified in the foundation of a further chantry in September 1329 for which additional provision was made in 1330.[47] At the foundation of a chantry in the corresponding chapel on the north side, the altar of Corpus Christi is described as 'built but yet to be dedicated'.[48]

The demolition of the eastern arcade of the 12th-century presbytery was undertaken just before 1333, for in that year the executors of Dean Godelee were given quittance for monies

C

expended by the late dean 'racione demolicionis ecclesie'.[49] In the same year the Chapter complained that there was at least three years' work to be done.[50] This was to prove an optimistic forecast despite its pessimistic intent, for it was made in reply to the King's request for an aid towards the marriage of his sister. Unfortunately, the surviving records provide no firm dates for the final stages of the presbytery, the remodelling of the 12th-century arcades or the vault. It may be assumed that while these works were in progress the canons moved temporarily out of the eastern arm. The pulpitum would only be erected at the very end when the campaign was almost complete, and the canons of Wells could follow the example of their brethren at Salisbury, Exeter and elsewhere, by moving entirely into the eastern arm. In the 12th-century church the choir had been in the usual position beneath the crossing, with the pulpitum between the first two piers of the western arm.

Compared with the pulpitum at Exeter, or the splendid examples at Lincoln and South-well, the pulpitum at Wells is very disappointing. The detailing is schematic, having none of the subtleties or refinements of the tabernacle work in the presbytery and it gives the distinct impression that funds were short at the end of this remarkable building campaign. It can be shown, however, that the pulpitum was certainly in position before the insertion of the strainer arches into the crossing. There is obvious disturbance to the otherwise regular coursing of the masonry in the north and south bays which would have to have been dis-mantled to provide the necessary access to the crossing piers in order to effect a bonded junction between the piers and the strainer arches. This observation does not help us to date the pulpitum, unless a secure date can be attached to the strainer arches.

Willis seems to have been the first to suggest that the description of the church at the Chapter meeting of 19 May 1338 as 'enormiter confracta' and 'confracta et enormiter deformata' may be taken to indicate the discovery of the ominous cracks which necessitated the insertion of the strainer arches to stabilise the tower.[51] The implications of this hypo-thesis for the chronology of the east end were found to be acceptable and it has now acquired the authority of fact. It should be remembered, however, that the use of hyperbole is not unknown in medieval documents and that in 1333 the Chapter had employed a very similar phrase, 'in tantum est confracta et deformiter diruta', to describe the condition of the church when replying to the King's request for money.[52] Yet in 1337 a tax is levied to expedite the adornment of the church.[53] Furthermore, if 1338 is taken as the starting date, the reference to cartloads of stone for the repair of the tower in 1356 implies a very long campaign, even allowing for the disruption caused by the Black Death and the undoubted difficulty of the undertaking.[54] It may be that the convenience of relating a document to the subsidence of the tower has caused the repair work to be dated too early and, therefore, too much reliance to be placed on an unsubstantiated *terminus ante quem* for the completion of the choir and presbytery. Certainly, the capitals of the additional orders inserted within the arcades of the first bays of the nave and transepts have a distinctly Perpendicular look, but there is nothing to show whether these were inserted as part of the same campaign as the strainer arches or whether they were an earlier, inadequate attempt to prevent further subsidence.[55]

Some consideration must now be given to the implications of this proposed chronology for the stylistic context of the east end of Wells. A number of features, such as the bases of the western piers of the Lady chapel and the pentagonal and triangular piers in the ambula-tory, are so similar to features on the pulpitum at Exeter, securely dated 1317–25, as to establish the closest possible connection beyond any doubt. The traditional date for the Lady chapel has implied that the master mason went on from Wells to lead the team that was responsible for the choir furnishings at Exeter.[56] This relative chronology must now be reversed and the furnishings given priority. The qualities of the Lady chapel, ambulatory

and presbytery at Wells can then be properly seen as deriving from the imaginative use for a full-scale building of small-scale motifs designed for furnishings: an essential characteristic of the Decorated style.

The design of the large traceried windows of the Lady chapel finds its closest parallel in a window in the nave clerestory of Exeter, datable to the 1320s, and in the windows of the nave clerestory at Malmesbury.[57] No date is known for the latter but it seems likely that they were part of the campaign which included the vault. This has bosses with naturalistic foliage indicating a date in the early 14th century at latest, but the rib pattern has been held to depend on Bristol. The possibility remains that the windows at Malmesbury predate the more ambitious application of the design at Wells. The occurrence of a similar pattern in the choir aisles at Lichfield, again undated, suggests a common source rather than a direct sequence.

The style of the figure of Christ in the centre boss of the Lady chapel vault (Pl. VIc) fits convincingly with a date in the 1320s and may be compared to the comparable representations in the glass surviving in the adjacent chapels. The same decade suits the nature of the foliage of the capitals of the vaulting shafts and the type of boss used on this exceptional domed vault. These bosses are quite unlike any of the bosses in the chapter house but resemble those in the vault of the Lady chapel at Ely. The treatment of the boss in relation to the rib is interesting because although the major bosses still overwhelm the intersection of the ribs (Pl. VId), the minor bosses are subdivided so that the smaller elements fit into the angles between the ribs and do not interrupt the main line of the rib itself (Pl. VIe). The handling of the vault at Bristol is not dissimilar in this respect but the idea is less fully worked out and the style of the foliage there bears no relation to that found at Wells.

The Exeter pulpitum provides the source of the vault pattern in the ambulatory at Wells, especially for the use and disposition of the liernes, and even for the style of some of the bosses. Other bosses in the ambulatory remain close to those in the Lady chapel. Despite this variety in style of the bosses, there is a fairly consistent pattern in their use which corresponds to the different types of rib vault employed. The bosses which have still faintly naturalistic foliage occur in the bays which have tierceron vaults with ridge ribs, the two eastern bays of the north and south aisles, whereas the more fully developed Decorated foliage is found in the bays where liernes are introduced, the north and south projecting chapels and the centre bays of the ambulatory (Pl. VII). This pattern may indicate the sequence of construction and it may even represent a change of master directing the work, although the real stylistic division occurs on the line of the eastern arcade of the presbytery. Unfortunately, the evidence concerning the masons does not coincide neatly with the dates which can be established for the fabric.

The chance survival of the record of Thomas the Mason acting as a witness to a charter in 1323 led Harvey to speculate whether this might refer to Thomas Witney, in view of the close connection between the architectural features in the Lady chapel and ambulatory and those to be found at Exeter where Witney is known to have worked.[58] The coincidence of the date of this charter with the date I have proposed for the start of the new work is perhaps too convenient, but it does seem very probable that Thomas Witney was responsible for the overall design of the Wells east end and for the construction of the Lady chapel. However, it is not clear why William Joy took over as master mason, because Witney continued to work at Exeter probably until his death in 1342 when he was succeeded there by William Joy. Nor is it certain when Joy was appointed at Wells, for of the two entries recording contracts between William Joy and the chapter, one bears a date which is no longer legible, although it might be recovered by the use of infra-red photography. The second entry (in the order the contracts were transcribed into the *Liber Albus*),[59] is dated 29 July 1329 and grants Joy

a salary of 30s. 6d. a year whereas in the first entry his salary is stated as 40s. per annum with 6d. per diem for each day that he works on the cathedral.[60] This could be interpreted as a later contract at a higher salary, or, as the original appointment, with the contract of July 1329 constituting an additional salary; in which case Joy could have been in charge earlier than this date. The wording of both entries suggests that Joy had already been employed at Wells, though not necessarily as master mason. The known dates for the chapels flanking the Lady chapel mean that Joy must have been responsible for completing them but he may not have been able to impose his personal style. The really distinctive change of design occurs in the presbytery, especially in the use of the brilliant device of open-work tabernacles to articulate, or rather, to dissolve the wall surface. To William Joy may also be attributed the originality of the presbytery vault, but on the evidence presented here it is less certain that he was responsible for the bold conception of the strainer arches, as they may have been constructed after his death.

The prominent eastern Lady chapel with access provided by a low ambulatory returned behind the high eastern gable places Wells quite clearly in the south-western tradition. Not unexpectedly, in view of the close liturgical connections, the main source of the Wells design is Salisbury.[61] In no other building is the spatial interpenetration of the Lady chapel and ambulatory to be found as it is in these two churches. In both, there are two open arcades between the eastern bays of the aisles and the centre bays of the ambulatory, and more striking is that, despite a more accomplished vaulting technique, which allowed him to dispense with the intermediate piers used in the Lady chapel at Salisbury, the master mason at Wells deliberately set out to recapture and develop the spatial effects resulting from this integration of chapel and ambulatory (Pl. VB). It is this design for the eastern chapel which determines the disposition of the piers in the ambulatory and in both buildings the junction between these piers and the eastern arcade of the presbytery looks decidedly makeshift.

What really distinguishes the Wells design is the unique shape of the Lady chapel. Although common on the continent, the use of polygonal forms for east ends is sufficiently unusual in England to excite particular comment. But there can be little doubt that one of the main reasons for the adoption of this form was to keep the windows of consistent size and to make them more visible from the interior of the church (Pl. VA). By the late 13th century it must have become obvious that there were disadvantages in trying to incorporate elaborate traceried windows into the traditional rectangular eastern chapel: the sequence of patterns had to be disrupted and even the design changed for the much larger window on the east wall, and the side windows only became visible to the spectator standing immediately opposite to them. The Lady chapel at Wells is unique in that the termination does not form part of a regular polygon. The width of the chapel was determined by the dimension of the existing church and the form of the polygon determined by the desire to ensure that all five windows were as large as possible and of the same size so that the tracery, and thus the layout of the glass, could be identical.

There is one other feature which differentiates Wells from the usual form of the east end in the south-west: the projecting chapels to the north and south of the ambulatory. Misleadingly described as eastern transepts, these chapels are not directly connected with that grand feature at Salisbury. In the remodelling at Exeter small chapels were added to the north and south of the presbytery opposite to the entrances to the choir. The southern chapel, probably dedicated to St James, is several times referred to in documents as the 'vestibulum' and it was used as a vestry.[62] Similar chapels were incorporated into the design of Ottery St Mary and there is no reason why comparable chapels should not have been built at Wells. That they were not points to another affiliation for the plan of Wells. A close analogy may be drawn with the east end of Pershore where the disposition of the chapels is very similar. The

obvious advantage of such projecting chapels is to leave the ambulatory unencumbered by altars; in other words, to avoid having to use the chapels as part of the procession path. Assuming that the limited excavations have been interpreted correctly, such chapels also occurred at Malmesbury, where, as in the case of Pershore, the ambulatory had to provide access to a shrine. Hereford provides another example of this arrangement.

It is possible to argue that the double ambulatory at Wells arises simply from the choice of the polygonal form for the west end of the Lady chapel. This determines the position of the western piers of the chapel and necessitates the provision of two more piers to carry the vaulting to the eastern arcade of the presbytery if the height of the ambulatory vault is to be kept low and uniform with that of the 12th-century aisles. However, it must be admitted that the resulting arrangement could have provided a very suitable setting for a shrine, screened off in the centre bays, with the ambulatory allowing access to both the shrine and the Lady chapel and the extra altars being kept conveniently in the projecting chapels. Given the probable starting date for the new work and the known date of the active promotion of de Marchia's cult, it is almost certain that provision for his shrine would have been made in the overall design. The intention to give his body an honourable place in the new work is explicitly stated, but the precise location must remain conjectural. The analogy with Salisbury is not so helpful here for there is no certainty about the intended site for the shrine of St Osmund.[63] It is known that his shrine was placed in the eastern chapel after his canonisation in 1457.

A full discussion of the unique qualities of the design of the eastern extension at Wells is beyond the scope of this paper. The re-examination of the evidence relating to this remarkable undertaking has led to a more complete understanding of its purpose and of the motives underlying its construction. The establishment of a more secure date for its conception and execution will enable Wells to be placed more precisely in a broader historical context.

ACKNOWLEDGEMENTS

Publication of this article has been assisted by a grant from Birkbeck College, University of London.

REFERENCES

SHORTENED TITLES USED

ARMITAGE ROBINSON (1931) — J. Armitage Robinson, 'On the Date of the Lady Chapel at Wells', *Archaeol. J.*, LXXXVIII (1931), 159–74.

BISHOP AND PRIDEAUX — H. E. Bishop and E. K. Prideaux, *The Building of Exeter Cathedral* (Exeter 1922).

CHURCH — C. M. Church, *Chapters in the Early History of the Church at Wells* (London 1894).

MORRIS (1974) — R. Morris, 'The Remodelling of the Hereford Aisles', *JBAA*, 3rd ser., XXXVII (1974), 21–39.

EMA — John Harvey, *English Mediaeval Architects* (London 1954).

References to the documents in the Chapter library are in the standard form: all the documents cited are either numbered charters or are to be found in the Register books, *Liber Albus I* (R. I), *Liber Ruber* (R. II), and *Liber Albus II* (R. III). A calendar of these books was published by the Historical Manuscripts Commission, Vol. I (1907), ed. by W. H. B. Bird, Vol. II (1914), ed. W. Paley Baildon.

1. Armitage Robinson (1931).
2. R. I. 175.
3. G. Webb, *Architecture in Britain: The Middle Ages* (Harmondsworth 1956), 126 and 155; B/E, *North Somerset and Bristol* (Harmondsworth 1958), 289.
4. H. Bock, *Der Decorated Stil* (Heidelberg 1962).
5. Colchester and Harvey (1974), 205; R. Morris (1974), 32–36.
6. EMA, 151; Church, 300–14; Willis's views are also reported in *P.S.A.N.H.S.*, XII (1863–64), 14–21.
7. Ibid., 20.

8. Armitage Robinson (1931), 162–63; J. Bilson (1928), 23–68 esp. 51 seq.

9. Colchester and Harvey (1974), 205.

10. Church, 259–60. The water-holding bases in the undercroft might suggest an earlier date, but this moulding can be found in the later 13th century.

11. R.I.151.

12. Morris (1974), 25. The misalignment between the staircase and the entrance arch to the chapter house is not, therefore, the result of a break in the building campaign.

13. E. Buckle, 'Wells Palace', *P.S.A.N.H.S.*, XIV (1888), Pt II, 73, supported by M. Wood, *Thirteenth-Century Domestic Architecture in England, Archaeol. J.*, CV (suppl), 74–76. The reverse chronology was proposed by J. H. Parker, 'The Bishop's Palace at Wells', *P.S.A.N.H.S.*, XI (1861–62), 153. The decisive evidence is that the chapel wall was constructed to allow some light to an existing window on the turret that would otherwise have been blocked.

14. Morris (1974), 34.

15. R. Morris, 'Decorated Architecture in Herefordshire: Sources, Workshops and Influence' (unpublished Ph.D thesis, University of London, 1972), 114–16.

16. E. K. Prideaux and G. R. Holt Shafto, *Bosses and Corbels of Exeter Cathedral* (Exeter and London 1910), 32 and 88.

17. Colchester and Harvey (1974), 205.

18. R.I.143. The tax was one-tenth on all prebends for five years. The documents relating to the campaign on the tower are listed in Colchester and Harvey (1974), 207.

19. C. M. Church, 'Documents bearing upon the late excavations on the south side of the Cathedral Church at Wells' and E. Buckle, 'On the Lady Chapel by the Cloister of Wells Cathedral and the adjacent buildings', *P.S.A.N.H.S.*, XL (1894), 1–31; W. Rodwell, 'The Lady Chapel by the Cloister at Wells and The Site of the Anglo-Saxon Cathedral', above, p. 5.

20. R.I.128

21. Royal Commission on Historical Manuscripts, 3rd Report (London 1885), 361.

22. Charter 194.

23. *Register of Bishop Drokensford*, Somerset Record Society, Vol. I (1887) as f. 123d (in fact 124a). I am indebted to Mr D. M. Shorrocks, Somerset County Archivist, for his kindness in sending me a full transcript of this entry with the accurate reference.

24. Colchester and Harvey (1974), 205–06.

25. R.III.124; R.I.62.

26. Armitage Robinson (1931), 172.

27. Charter 166; R.I.52.

28. After careful measurement of this part of the building, Dr Peter Kidson and I were able to show that the plan is generated from a point determined by subtending an angle of 45° from the corners of the 12th-century aisles. This line would also pass through the corners of a two-bay projecting Lady chapel. The main dimensions, including the placing of the slender polygonal piers in the ambulatory, show the consistent use of the proportion $1:\sqrt{2}$. For example, the sides of the octagonal Lady chapel are 14 and 20 ft. The details of the geometry will be discussed by Dr Kidson in the Mellon lectures for 1980.

29. R.I.173d; *Register of Bishop Drokensford*, Somerset Record Society, Vol. I (1887), f. 242.

30. R.I.172.

31. R.I.143.

32. A translation was intended in 1321 but delayed until 1349, Morris (1974), 25; G. Marshall, 'The Shrine of St Thomas Cantelupe in Hereford Cathedral', *Transactions of the Woolhope Naturalists Field Club* (1930–32), 41–42.

33. K. Edwards, 'The Political Importance of the English Bishops During the Reign of Edward II', *English Historical Review*, LIX (1944), 311–47 esp. 336.

34. R.I.174.

35. *Register of Bishop Drokensford*, Somerset Record Society, Vol. I (1887), f. 267 and 303b.

36. F. Rymer, *Foedera* (1707), iv, 375.

37. M. R. Toynbee, *St Louis of Toulouse and the Process of Canonisation in the Fourteenth Century* (Manchester 1929), 153, n. 2; A. W. Kemp, *Canonisation and Authority in the Western Church* (London 1948), 118–122.

38. 'in subsidium novae fabricae, et pro corpore recolendae memoriae Sanctissimi patris William de Marchia transferendo ac ibidem honorifice collocando', R.I.165.

39. A suggestion made by W. St John Hope, 'Wells Cathedral', *Archaeol. J.*, LXI (1906), 217 and taken up by F. Bond, *An Introduction to English Church Architecture*, I (Oxford 1913), 92.

40. 1305–10, L. Stone, *Sculpture in Britain: The Middle Ages* (Harmondsworth, 1955).

41. W. St John Hope, 'Wells Cathedral', *Archaeol. J.*, LXI, 217.

42. R.ɪ.200; Church, 267–68.
43. Jean Bony, *The Decorated Style* (London 1979), 39, argues 'a major alteration of plan took place when the walls had been built to a height of five or six feet only, and the first idea may very well have been something like Lichfield with a tall apsidal ending.' The latter suggestion is extremely unlikely in the south-west of England and is, I believe, precluded by the consistency of the geometrical layout (note 28 above) and the sequence of building presented here.
44. For Husee's place of burial see Colchester and Harvey (1974), 206.
45. The earlier date of the western windows of the aisles was suggested by L. S. Colchester, *Stained Glass in Wells Cathedral* (Wells 1952), Appendix B, where he also noted that in these windows, as in the tracery lights of the Lady chapel, there is no trace of the silver stain introduced in the main lights of the Lady chapel and the closely related windows of the adjacent chapels. The aisle windows were, however, glazed in a separate campaign from the chapter house windows as Dr Richard Marks pointed out to me.
46. Charter 240. This charter is in mutilated condition.
47. R.ɪ.181; Charter 226.
48. R.ɪ.179v–180; the intended dedication is mentioned in September 1328, R.ɪɪɪ.278d; Colchester and Harvey (1974), 208 n. 59.
49. Charter 240.
50. R.ɪ.192.
51. R.ɪ.201; R. Willis, *P.S.A.N.H.S.*, xɪɪ (1863–64), 21.
52. R.ɪ.192.
53. R.ɪ.200.
54. BL Arundel MS 2, 18v.
55. Colchester and Harvey (1974), 207; ibid., 208, for the more reliable evidence of the heraldry in the glass of the E. window.
56. Bishop and Prideaux, 52–54.
57. EMA, 298; Armitage Robinson's date for the Wells tracery in the 1290s cannot be substantiated.
58. EMA, 298.
59. The content and compilation of these Register books is discussed in the introduction to the Historical Manuscripts Commission Calendar.
60. R.ɪ.179; R.ɪ.181. The order does not necessarily imply a chronological sequence for the entries in the Liber Albus are not in strict chronological order. Harvey assumed that they had been reversed (EMA, 151) and Colchester and Harvey (1974), 207, cite the undated entry as the dated one.
61. A. Klukas, 'The *Liber Ruber* and the Rebuilding of the East End of Wells', below, p. 30. I am unconvinced by the view that the need for the eastern extension was because 'the narrow spaces of the eastern parts of Exeter and Wells were quite inadequate for the due performance of the elaborated ceremonial of Salisbury' (Armitage Robinson (1931), 167). As extended, the east end of Exeter bears a striking resemblance to the likely form of the 12th-century east end of Wells.
62. Bishop and Prideaux, 112–13.
63. I have discussed the problems surrounding the liturgical layout at Salisbury in 'The Retrochoir of Winchester Cathedral', *Architectural History*, Vol. 21 (1978), 9–10 and n. 35.

The *Liber Ruber* and the Rebuilding of the East End at Wells

By Arnold W. Klukas

The extant east end of Wells Cathedral is the result of a rebuilding campaign which began early in the 14th century. Although architectural historians differ in their chronologies,[1] the architectural programme completed in the 1330s more than doubled the length of the cathedral's east arm. The 12th-century choir of three bays was doubled in length and beyond it was built a two-bay retrochoir with flanking chapels which led into a spacious polygonal Lady chapel. The reason for this rebuilding could not have been simply to achieve aesthetic or technological advancement, since the bay divisions and elevation remained compatible with the older work, nor could the rebuilding have been inspired by the need for a lengthened choir to accommodate an enlarged chapter, since the new choir was not appreciably longer than the 12th-century ritual choir which had extended west under the crossing to the first bay of the nave.[2] What was accomplished by the rebuilding was that all the architectural accommodations for the ritual life of the Chapter (chapter house, choir, Lady chapel, processional path and side chapels) were newly placed east of the transepts totally within the eastern arm of the church. It would seem that such a remodelling would have to have been inspired by a change in the monument's functional requirements, i.e. a change in the liturgical programme used by the Chapter. This idea was suggested by J. A. Robinson, Dean of Wells, in 1931 when he stated: '. . . and here it is to be borne in mind that these great extensions, which were indeed everywhere the order of the day, were not mere displays of architectural genius or ambition; they were the response to a cultural demand. The narrow spaces of the eastern part of . . . Wells were quite inadequate for the due performance of the elaborated ceremonial of Salisbury.'[3] A closer look at the constitutional and liturgical history of Wells should help us to understand the liturgical changes which necessitated the 14th-century remodelling of the cathedral's east end.

Wells was given its first recorded constitution before the Conquest when Giso or Gisa, formerly the chaplain to Edward the Confessor, arrived to become bishop in 1060. Florence of Worcester described Gisa as a Lotharingian, and the *Historia de Primordiis Episcopatus Somersetensis* tells us that he imposed the rule of his native country upon the canons at Wells, requiring them to live in common.[4] As Gisa was a Lotharingian, it is likely that the rule he imposed was the stringent rule of St Chrodegang which imposed a fully monastic existence upon the canons.[5] These customs cannot have taken deep root at Wells, however, because John, Giso's successor, removed his seat to Bath and ejected the canons.[6] When the *cathedra* was finally restored to Wells fifty years later under Bishop Robert of Lewes (1136–66), the Chapter was reconstituted with a charter entitled *De ordinacione prebendarum et institucione commune* (1136–37).[7] Under this charter the life of Wells was to be organized under a dean and precentor. Canons were to serve as treasurer and as subdean, and two were to serve as archdeacons. All the canons were to be endowèd with separate prebends and were also to receive income from a common fund.

There are no direct references to what models Bishop Robert utilized in forming his charter, but from an examination of the Wells statutes called *Antiqua Statuta de officiis cuiuslibet persone ecclesie cathedralis Welln'*, we can conclude that his primary model was the *Institutes of St Osmund*, the earliest statutes of Salisbury Cathedral (*c.*1090).[8] Within the text of the Wells *Statuta*, certainly first composed before 1245, is found, word for word, the

greater part of *St Osmund's Institutes* as well as much of the material found in later Sarum customaries.[9] Bishop Frere explains this close relationship between the Wells *Statuta* and the Sarum *Institutes* as the work of Bishop Jocelin (1206–42): 'It seems impossible to say how much this Wells document represents old traditions and how much was a new incorporation of Sarum ways, but it is probably safe to conclude that already before the thirteenth century the Wells Chapter was constituted on St. Osmund's lines; and though we have no direct contemporary evidence of the fact we may fairly argue backwards that Bishop Robert of Lewes in re-establishing the Chapter in 1136 took Sarum as his model.'[10] The text of the Wells *Statuta* certainly shows that the Salisbury rules of governance were adopted by the Wells Chapter by the mid-13th century.

The close connection between the statutes of Wells and those of Salisbury might suggest a parallel relationship in liturgical observances. At Wells no collection of customs exists from the 13th century, but the earliest extant manuscript, which dates from the 14th century and is bound into the *Liber Ruber*, shows a close relationship to the new customs in use at Salisbury in the late 13th century.[11] The *Liber Ruber* is a manuscript written in a late 14th- or early 15th-century hand. Its text cannot date before 1318 because it includes the Feast of Corpus Christi, which was only introduced at Wells in that year. Nonetheless, the major portion of the text is certainly that of the ordinal required by statute in 1298. Frere sums up the history of the Wells customs in this way: 'There existed at Wells some old and unsatisfactory ordinal which was superseded between 1273 and 1298, after two complaints had been registered, by the adoption of the Sarum consuetudinary, modified to suit the needs of Wells, and called there by the name "Ordinal" after the document which it supplanted.'[12] The text of the *Liber Ruber*, when compared line for line with the Frere edition of *Use of Sarum*, shows the almost complete dependence of the Wells manuscript upon the Sarum Use.

One might wonder why Wells, in Somerset, should so closely follow the observances of a Wiltshire cathedral. In 1256 Bishop Giles de Bridport maintained that 'among the churches of the whole world, the church of Sarum hath shone resplendent, like the sun in his full orb, in respect of its divine service, and its ministers . . .'.[13] The Salisbury canons had become the innovative leaders in worship practices at a time of rapid liturgical change. The order, logic, and adaptability of the Sarum Use made it an appropriate model for other secular cathedrals and for many parish and collegiate churches as well. Indeed, by the end of the 14th century the Sarum Use became the basis for the liturgical regulations of the majority of secular cathedrals, including St David's, Elgin, Glasgow, Dublin, Lincoln, Lichfield, Coventry, Exeter, London, and Wells.[14] The canons of Wells had therefore sought the advice of the leading authorities in liturgical practice and were careful to follow the Sarum rules.

The canonical organization and daily life at Wells are clearly outlined in the *Liber Ruber*. Wells was a cathedral of 'secular canons', an odd combination of words which means that the clergy, or canons, were not monks nor were they under a common rule as were the 'regular canons' (i.e. Augustinians). Secular canons were allowed to live within their own households, usually in the cathedral close, but often they did not remain in residence. Indeed, of the fifty canons at Wells, only fifteen lived in the close in the year 1331.[15] Those canons who were in residence had to appear in their stalls at least once during the day, arriving before the first psalm has ended, if they were to collect their daily stipend. The exception to this seemingly lax regimen was the fortnight every quarter that each canon in residence acted as an 'hebdomadary canon' and was responsible for presiding at all the services. The hebdomadary canon acted as celebrant for the daily High Mass and officiated at all the offices. The actual burden of singing the daily services was taken over by the vicars choral, clerics appointed by the canons to sing the offices in their stead. They were not

allowed to be absent from services, and sat in the rows beneath the canons' stalls with the boys' choir in the forms below them.

The regular day at Wells was not unlike a monastic day, especially for the vicars choral. The day began with Matins at daybreak followed immediately by Lauds, and then private masses were said until the Mass of Our Lady was sung in the Lady chapel at about 9 a.m. The bell for Prime was rung when the Lady Mass was finished and the canons then withdrew to the chapter house for the day's business. Tierce was said while the hebdomadary canons prepared for High Mass at the main altar at about 10 a.m. After High Mass the morning offices ended at about 11 a.m. and the canons retired to their houses for breakfast while the vicars adjourned to their hall. Evensong was sung at about 3 p.m. and on obit days it included Vespers of the Virgin in the Lady chapel, and soon after, Compline was sung. The canons and vicars thus ended their liturgical day at about 6 p.m. after having been in choir about seven hours. On Sundays and on major feasts they were in church for at least an hour more. The Wells calendar included twenty-four days of 'major doubles' (major feast days, like Christmas and Easter) and thirteen of 'minor doubles' (days as important as a Sunday). On each of these feast days as well as on every Sunday the *Liber Ruber* required solemn Matins and Vespers, and processions at High Mass and Vespers. Processions were thus required on at least eighty days of the year!

As we are here most interested in how the new rituals at Wells affected the early 14th-century remodelling of the east end, let us examine in detail some of the processions required by the *Liber Ruber*. On a regular Sunday after Prime the celebrant blessed salt and water for the asperges and entered the choir with his assistants. He then went up to the high altar and sprinkled it with holy water on all sides. Then he aspersed all those in choir in order of precedence and the procession formed: 'First the verger, making way for the procession; then a boy in a surplice, carrying holy water; next the acolyte carrying the cross; and after him two taperers, walking side by side, then the thurifer, and after him the sub-deacon [carrying the Gospels] and deacon all in albs with amices, without tunicles or chasubles; and after the deacon, the celebrant, similarly dressed, but with a silk cope; then the boys and the clerks of the second rank, not two by two but in groups as they are disposed in choir; and then clerks of the higher rank, and those of highest dignity last, in the same order as they are disposed in Chapter, [all] in ordinary habits'.[16] On greater feasts vestments would be worn by the hebdomadary canons, and copes by the rest. The route of the Sunday procession is also clearly specified. They left the choir through the north door and then circled the presbytery with the celebrant aspersing every altar along the way. Then at the south transept door they entered the cloister and stopped to pray for the dead buried in the priests' cemetery. They then made a station at the chapel of the Virgin which was on the eastern side of the cloister, and continued around the rest of the cloister to re-enter the church through the south-west door. They re-formed (the incised circles indicating where the procession re-formed remained until the nave floor was repaved in this century) and proceeded up the nave to the pulpitum where the second station was made before the rood. The fuller details of the Sarum Use specify that on normal Sundays two junior clerks then began the chant from the pulpitum steps. During Eastertide the verse was sung by three clerks of higher rank in surplices, and on major doubles it was sung by three senior clerks in silk copes facing the people from on top of the pulpitum. The procession then resumed, finishing at the choir steps with a versicle and prayer. All in attendance retired to their seats in choir and preparations began for High Mass.[17]

On certain days more elaborate processions were held which followed an extended route including the close as well as the church and cloister. The most important procession was that of Palm Sunday when the procession was meant to represent the triumphant entry of

Christ into Jerusalem. After the asperges on this day, the procession formed and left the choir through the north door and proceeded around the presbytery, out around the cloister and through the west cloister door, into the greater cemetery. There they made their first station and the Palm Sunday gospel was sung. This procession was then joined by a second procession that included a cross, two banners, and two clerks of second rank carrying a feretory containing relics and a consecrated host. After the gospel the cantors began the hymn 'All Glory Laud and Honour', and the two processions combined to move to the second station, and subsequently to the third station where three canons sang another antiphon. Then the procession entered the church under the feretory and pyx which were held over the door by two clerks. The fourth station was made at the rood before the pulpitum and then the procession finished in the choir.[18]

The processions we have examined utilized the entire church interior and operated as preludes to the central acts of devotion in the offices and High Mass. In the eastern arm of the cathedral several smaller processions occurred during High Mass and during Matins and Vespers. For example, during High Mass on major doubles, two cantors in silk copes intoned the gradual and were answered from the pulpitum by three vicars choral in silk copes. As the gradual was sung the principal deacon and sub-deacon processed to the pulpitum to sing the gospel. They were preceded by a cross, a thurifer, and two taperers.[19] During the first Vespers of a saint honoured with an altar at Wells, a procession would form and proceed to the altar of that saint while the choir sang a responsory. The celebrant censed the altar as the choir sang the verse, and then they finished with a versicle and prayer. Normally during Matins and Vespers, only the high altar was censed at the main canticle, but on major feasts there would be two or three thuribles, and the sub-deacons would cense all the altars in the eastern arm of the church.[20]

We could continue and explain Rogation processions, Holy Week rites, Lenten veils, etc., but this would be antiquarian. The real question for the architectural historian is: what does the Sarum Use, and the text of the *Liber Ruber* in particular, require of the architectural formulation of the church? It does seem more than coincidental that the new east end at Wells was laid out soon after the adoption of the statutes which imposed the new Sarum-based ordinal. Liturgical observances had been rapidly evolving throughout the 13th century and the old choir at Wells was not able conveniently to house the Sarum-inspired processions and observances. In this basic observation J. A. Robinson was correct. We have been more specific than he, however, in outlining the particular liturgical observances which the new east end was constructed to accommodate.

Three liturgical observances stand out as particularly important in the development of the east end at Wells. First, the elaborate Sarum asperges procession which we have described required a logical and continuous processional route which would allow the celebrant to asperse each altar in succession without backtracking or otherwise confusing the clerics in procession. Altars could not henceforth be placed at levels or in places which could not be reached in solemn columns of two abreast. The asperges procession thus encouraged a logical arrangement of altars around one continuous processional route. Second, the rubric which demanded that all altars of the eastern arm of the church be censed during the canticles on major festivals added a further reason to arrange these altars around the choir. Of the twelve altars mentioned in the *Liber Ruber* as existing within the cathedral church, all but two were east of the pulpitum and at least six were east of the high altar and partially visible from the choir. This compact arrangement allowed the incensations to be accomplished with a minimum of confusion and time. A third and major Sarum observance which we have not here discussed in detail was the cult of the Virgin.[21] These elaborate ceremonies required a major chapel space to accommodate the daily Lady Mass and Vespers as well as to provide

a dignified climax to the more frequent processions held in Her honour. The new Lady chapel of the early 14th century was large enough to act as a second 'choir' for the canons and vicars choral. Its axial relationship to the main choir accentuated its importance and yet it remained a visually distinct space with its own entrance from the retrochoir. The new east end at Wells was thus a careful architectural accommodation to the full Sarum Use which the canons had adopted at the close of the 13th century. The retrochoir, closely following the Salisbury programme, afforded maximum space for processions and provided an integrated series of chapels close to the choir.

The medieval canons at Wells would probably have found these observations self-evident; today, however, few of us are well-versed in liturgical matters. A liturgical analysis of Wells, or of any other medieval church is essential to any thorough study of the architectural scheme. Both the masons and the patrons wanted to provide a splendid architectural framework for the observance of public worship. The whole cathedral complex, both internally and externally, was part of a consistent and minutely regulated liturgical programme. Whatever technical achievements, personal ambitions, or stylistic innovations might be bound up in the fabric, they do not detract from the primary purpose of the whole. The new east end at Wells was constructed above all else to provide an environment which fully accommodated the observances of the liturgical year.

REFERENCES

SHORTENED TITLES USED

BAILEY, *Processions* — Terence Bailey, *The Processions of Sarum and the Western Church* (Toronto: Pontifical Institute of Mediaeval Studies, 1971).

COLLINS, *Manuale* — A. Jefferies Collins, *Manuale ad usum percelebris Ecclesie Sarisburiensis* (London: Henry Bradshaw Society, 1960).

1. See Colchester and Harvey (1974), in which the dating by previous scholars is clearly outlined. For a reconsideration of the dating of the east end see the article by Peter Draper in this volume, pp. 18–29.
2. This arrangement was outlined by St John Hope in 'Quire Screens in English Churches...', *Archaeologia*, LXVIII (1917), 43 ff. For a discussion of the 12th-century church see Bilson (1928), 23–68.
3. J. A. Robinson, 'On the Date of the Lady Chapel at Wells', *Archaeol. J.*, LXXXVIII (1931), 167–68.
4. Florence of Worcester, *Chronicon ex Chronicis*, ed. B. Thorpe, I (London 1848), 218. The 'Historia de Primordiis Episcopatus Somersetensis', *Ecclesiastical Documents*, Camden Society, VIII (1840), 16, records: 'ecclesiam sedis meae perspiciens esse mediocrem, clericus quoque quatuor vel quinque absque claustro et refrectorio esse ibidem, voluntarium me ad eorum astruxi at instaurationem ...'.
5. Chrodegang, Bishop of Metz, composed a rule for his canons about 755 and it was adopted, with slight modification, by the Council of Aachen in 817. It became the constitution of many chapters in Germany and Lotharingia. It was popular among several mid-11th-century reformers in Britain, i.e. Hereford, York, Waltham, St Paul's in London and Exeter. The Exeter constitution still exists as MS 191 at Corpus Christi College, Cambridge, and has been printed by A. S. Napier, *The Enlarged Rule of Chrodegang*, *Early English Text Society*, 150 (1916).
6. 'Historia de Primordiis Epis. Somersetensis', 22.
7. The charter, transcribed by a later hand, is still at Wells Cathedral bound in *Liber Albus I*. For the text see Church, *Chapters in the Early History of the Church at Wells* (1894). For a discussion of its implications see W. H. Frere, *The Use of Sarum*, I (Cambridge 1898), xxx–xxxi.
8. For the *Institutes of St. Osmund* see Frere, *The Use of Sarum* and Daniel Rock, *The Church of our Fathers as seen in St. Osmund's Rite for the Cathedral of Salisbury*, 4 vols. (London 1849). No manuscript exists from St Osmund's day, nor were the customs in the oldest extant Sarum customary those of St Osmund. The tradition that St Osmund composed the Sarum customs was certainly common in the 14th century, see the 'Chronicle of John of Brompton' (Col. 976, num. 60): 'Hic [Osmundus] composuit librum ordinalem Ecclesiastici Officii, quem Consuetudinarium vocant ...' recorded in Dugdale, *Monasticon Anglicanum*, ed. J. Caley, III (London 1817–30), 375. Such attributions of customs to a worthy founder were common medieval practice. Archdale King, *Liturgies of the Past* (London 1959), 280–326, gives a lengthy discussion of the origins of the Sarum customs.

9. The Wells *Antiqua Statuta* are found in the Wells Cathedral Library bound into the *Liber Ruber*, which is written in a 14th-century hand. It was transcribed at some point in the 17th century, perhaps for the use of Archbishop Laud (*c*.1634), and this transcription is now Lambeth Palace Library MS 729. H. E. Reynolds, in his *Wells Cathedral: its foundations, constitutional history, and statutes* (1881), used the Lambeth transcription as the basis for his printing of the *Antiqua Statuta* text. Reynolds also included a detailed discussion of the text and compared it to the *Sarum Consuetudinary*. W. H. Frere, in *The Use of Sarum*, I, xxx–xxxi, also presents a concise discussion of the close parallel between the Wells *Antiqua Statuta* and the Sarum customs.

10. Frere, *The Use of Sarum*, I, xxxi.

11. For the Sarum customs see Frere, *The Use of Sarum*, II, vii; Collins, *Manuale*, viii–ix. For the Wells text see Reynolds, *Wells Cathedral*, 6–56.

12. Frere, *The Use of Sarum*, II, xxix.

13. Quoted from the Preface of C. Wordsworth, ed., *Ceremonies and Processions of the Cathedral Church of Salisbury* (Cambridge 1901).

14. King, *Liturgies of the Past*, 286–87.

15. See Reynolds, *Wells Cathedral*, 130. In the following material I rely heavily on the excellent explanation of secular cathedral life given by K. Edwards in *English Secular Cathedrals in the Middle Ages* (Manchester 1949), 56–74. The references to the particular Wells circumstances are derived from my reading of the *Antiqua Statuta*.

16. The latin text is found in Reynolds, *Wells Cathedral*, 28, and the parallel Sarum text is found in Frere, *The Use of Sarum*, I, 58. This translation is by Bailey, *Processions*, 13.

17. Reynolds, *Wells Cathedral*, 28: 'et exeat processio per ostium presbiterii septentrionale, et eat circa presbiterium. Sacerdos in eundo singola altaria aspergat. Deinde transeunte processione per ostiū Cimiterii sacerdos cum suis ministris intret Cimiteriū canonicorū aspergendo illud et oret pro defunctis, deinde redeat ad processionem in capella beate Marie Virginis ubi fiat statio. Inde redeant ante crucem in navi ecclesie, et ibi secundam faciat stationem sacerdote cum suis ministris predictis in medio suo ordine stante ita qd puer deferens et accolitus stent ad gradū ante crucem. Deinde precibus consuetis dictis chorum intrent et sacerdos ad gradum chori dicat versiculum et orationem . . .'. The parallel Sarum text is found in Frere, *The Use of Sarum*, I, 58.

18. Reynolds, *Wells Cathedral*, 29: 'In primis exeant per ostiū boriali chori circuens chorū et clastrū et exeant in Cimiterio magno per domū choristarū circuens Cimiterium usqū ad locum prime stationis et ibi legatur Evangeliū . . . ad locum secunde stationis Precentore incipiente Antiphonā fit autem secunda statio ante ostiū ubi pueri cantant *Gloria laus* . . . ad locū tertie stationis que fieri solet ante aliud ostium ipsius ecclesie . . . et ibi intret sub capsula reliquiarū ex transverso ostii elevata, et fiat statio ante crucem . . .'. The parallel Sarum text is found in Frere, *The Use of Sarum*, I, 60.

19. Reynolds, *Wells Cathedral*, 40: 'Lectio ante Epistolam ab aliquibus duobus pro dispositione Cantoris in capis sericis cantetur, et sine intervallo Epistola legatur. Gratia in pulpito in capis sericis a tribus de secunda forma cantetur. Alleluia a tribus de excellentioribus ibidem dicatur. Preterea si Episcopus exequatur officiū omnes ministri in chorū ad prosam cantand′ veniat preter principalem Diaconū et principalem subdiaconū, et ibi moram faciant Diaconi et Subdiaconi cum Rectoribus chori donec principalis Diaconus in pulpito post lectū Evangeliū per chorum redeat. Preterea in processione ad legendum Evangelium crux precedit, deinde Thuribulu, deinde Subdiaconus, deinde Diaconus . . .'.

20. Reynolds, *Wells Cathedral*, 9: 'Incensari debet altare et chorus in omni duplici festo et simplici cum regimine chori ad vesperas et ad matutinas, dū dicitur Magnificat et Benedictus pretera in omni majori duplici extra tempus paschale in singulis nocturnis ad legendam quintam et octavam Lectionē et Te Deū laudam . . .'.

21. From the first quarter of the 13th century onwards the Sarum customs gave greater honour to the Virgin, i.e. full octaves for her Assumption and Nativity as well as added devotions. See Frere, *The Use of Sarum*, II, xv.

Perpendicular at Wells

By J. H. HARVEY

At the opening of the 14th century Wells was dominated by the Court style, influenced by Western fashions: the chapter-house of *c*.1286–1306[1] has tracery virtually identical with that of St Etheldreda, Ely Place, in London (*c*.1290–97), and uses ballflower ornament as early as that of Hereford, though less profuse. The next build, the Lady chapel completed by 1319,[2] can be ascribed to Thomas Witney whose career is documented at St Stephen's Chapel in Westminster Palace and later at Winchester and Exeter cathedrals. He was probably identical with the Master Thomas in charge of the building of the Wells central tower in its original form in 1315–22.[3] Witney was succeeded as cathedral architect in 1329 by William Joy,[4] a master trained in the Bristol style of net-vaulting and enriched nichework, distinct from the proto-Perpendicular of London and Gloucester so soon to become dominant. Joy's work at Wells did not show any direct influence from the London style until, about 1338, he designed the tracery for the great east window of the new presbytery.[5] The division of the window into three by two strong mullions and its straight-sided hexagonal reticulations clearly show the mark of William Ramsey's London innovations in, at most, seven years from his designs for the new chapter-house and cloister at Old St Paul's.[6] It is not unlikely that some contact took place owing to the royal visit of Edward III to Wells in 1332–33. The window is, however, in its lateral lights purely Curvilinear and shows only an imperfect understanding of the new style.

THE VICARS' HALL

The next precisely dated work at Wells is the Vicars' Hall of 1347–48, with flowing tracery and little obvious sign of Perpendicular influence. There is, all the same, use of the double-ogee moulding in the arches to the original staircase-turret on the north side.[7] The existing gateway, fully Perpendicular, is evidently of substantially later date and must have been formed by underpinning the pre-existing first-floor hall during the period of Wynford's responsibility (1365–1405).[8]

WYNFORD AT WELLS

Nothing is so far known of William Wynford before his appearance at Windsor Castle in 1360, already a master and almost at once to become joint architect with John Sponlee, considerably his senior.[9] Wynford, whose family origins were probably at Winford, five miles south of Bristol, was appointed while William of Wykeham was clerk-of-works at Windsor, and it is obviously significant that Wykeham also held the position of Provost of the prebends of Combe in Wells cathedral from 15 December 1363, Wynford being appointed consultant architect to the dean and chapter on 1 February 1364/65.[10] The extent of Wynford's direct responsibility for the cathedral works of the next 40 years does not appear from the few surviving documents, but can be deduced stylistically. We know that he was deeply concerned with the royal buildings at Windsor until Edward III's death in 1377, and thereafter worked on the fortifications of Southampton. From 1379, however, he was in charge of Wykeham's extensive programme at New College, Oxford, and after 1386 designed the sister college at Winchester.[11] The surviving documents at Wells show that the building of

the south-west tower took place mainly in the years 1385–95 and that Thomas Maydestone, one of Wynford's subordinates on the Oxford building, visited Wells at least once, in 1388. Wynford himself visited the cathedral for three days at the end of May 1391 and received the daily 6d. stipulated in his contract of appointment, which had also provided him with a fee of £2 yearly and the use of a house in Byestewall Street, Wells. In 1392–93 the payment of £1 to 'William Mason' by the Communar as his yearly gift for life probably refers to Wynford and may have been in the nature of a supplementary reward for good service to the cathedral. By 1394 Wynford's chief preoccupation was the rebuilding of the nave of Winchester Cathedral, undertaken as a crash-programme for his ageing patron. The hurried nature of Wykeham's work on his cathedral led to some degree of carelessness in construction, evidence of which has been pointed out to me by Mr Wilfrid Carpenter Turner.

There is then a presumption that much of Wynford's work at Wells belongs before 1395, and this agrees with the character of the Somerset churches which are, at least in part, to be attributed to him or to his influence. At Yeovil, where the church was built at the expense of Robert de Samborne, rector 1362–82 and a canon of Wells by 1366, construction had begun before 1382[12] in a markedly Perpendicular style, and the western tower in its system of buttressing and stringcourses closely resembles Wynford's known work on his Oxford and Winchester colleges. The Yeovil parapets, too, are like those used by Wynford at Winchester Cathedral and at Wells on the south-west tower and, internally, at the base of his reconstruction of the west windows of the nave. Wynford's work in the cathedral must also have included the masonry substructure of the famous clock (c.1390) in the north transept.[13]

So far as future development in English style is concerned, Wynford's greatest contribution was certainly his introduction at Wells of the square-topped tower. In some form, spires had been universal in northern Gothic art, and their sudden supersession in England at the end of the 14th century is one of the major phenomena of our highly insular Perpendicular. The spire was, of course, never completely superseded by the square-topped tower; the great stone spires of Chichester and Norwich cathedrals belong to the 15th and that of Louth church to the 16th century. At that time preparations were even made for the addition of a stone spire to the central tower of Durham Cathedral, where it seems significant that the architect was Christopher Scune who had completed the steeple at Louth.[14] Across most of southern England, however, the spireless tower was in fashion soon after 1400, and there remains the problem of its origin.

There is no sign, earlier than the 1390s, of any intention to build spireless towers, yet within a few years Wynford built not only the south-west tower of Wells but also the free-standing bell-tower of New College, Oxford (1396–1400) without any trace of structural provision for spires either of wood or stone. Yet his tower for Winchester College, designed between 1387 and 1393, had been provided in 1395–96 with a tall spire of timber and lead[15] comparable to that of Henry Yeveley's Westminster Palace clock-tower of 1365 as shown in Van den Wyngaerde's drawing.[16] The tower of the parish church at Shepton Mallet, five miles from Wells, was intended to have a stone spire of which some feet were built; this design belongs stylistically to the last quarter of the 14th century, and it is in the highest degree unlikely that abandonment of the spire was due to lack of funds at so prosperous a centre as Shepton. There is no reason to suppose that a spire was ever intended at Yeovil, where the tower may have been one of the last parts of the church to be completed.

It is hard to resist the conclusion that Wynford's sudden adoption of a fundamentally changed aesthetic was due to his appreciation of the horizontality of the earlier front at Wells. The design of Thomas Norreys, who took over the direction of the works at the death of Adam Lock in 1229,[17] had provided for a wide front, twice its height in breadth and with a pair of strong towers placed outside the aisles. Presumably Norreys's elevation,

on a great sheet of parchment, included spires; it would have been preserved in the cathedral tracing-house when Wynford took charge in 1365.[18] By then the Early English style of the original design was obsolete, and in any case required the substitution of a radically new project, up to date in character but in harmony with what had already been built up to the crowning string-course. The immense buttresses for the intended towers demanded an upward extension, but in a flash of inspiration Wynford determined that his towers should echo the four-square *ad quadratum* character of the façade below. His decision must have been made before 1395 and perhaps some years earlier, though probably after the designs for Winchester College with its spired bell-tower had been completed.[19] The spireless and unbuttressed tower at New College, a late addition to the buildings, need not have been set out until 1396, and so came after Wells.[20]

As already mentioned, Wynford reconstructed the interior of the west end of the nave,[21] and seems to have inserted the present entrance gateway to the Vicars' Close beneath the floor of the hall which had been built by 1348. The Close, essentially in its present form, appears also to belong to Wynford's time. He will therefore have had a hand in the erection of this remarkable street, a modified quadrangle, one of the finest as well as the first exercises in urban planning and in uniform terrace housing (see Postscript).

WYNFORD AND THE 'SOMERSET STYLE'

In spite of many points of disagreement between the various attempts to classify the Perpendicular church towers of Somerset (i.e. the medieval diocese of Bath and Wells), it is common ground that the whole family of towers is based on variations upon the theme set by the western towers of the cathedral, which themselves derived in part from the central tower of 1315–22 in its simple form before the alterations of 1439–50.[22] Although documentary evidence for the dating of the parish church towers is scanty, it is certain that among the earliest to be designed are those of Yeovil and Shepton Mallet, with that at Cheddar, a church belonging to the dean and chapter of Wells. The towers of Cheddar and Shepton agree in having slender paired buttresses, contrasting with the solid buttresses at Yeovil. The tall towers of the Cheddar type owe something to the 'classical' western steeples of the Early English period (e.g. Raunds, Northamptonshire), as well as to such central towers as that of Hereford Cathedral; they do not seem to have any predecessors in the region of Bristol.

One of the most characteristic features of the Somerset tower is the high-level change from paired square buttresses to paired pinnacles set 'cater-cornered' at 45°. These diagonally placed pairs of pinnacles are first found on the tower of Wynford's design at Wells, but were evidently adopted by him from the treatment of the eastern chapels of *c*.1330, presumably designed by William Joy.[23] A similar treatment is applied to the pinnacle of the isolated flying-buttress added to support the south-eastern angle of Witney's Lady chapel where its foundations come close to the water-springs of the bishop's pool. This buttress was probably built to Wynford's design. The typical basic variation of the Somerset buttressing system is then due to Wynford's incorporation of the motive in his design for the western towers of the cathedral. The Somerset tower also owes to Wynford's practice the long-panel design of belfry windows, adopted soon after his time for St Cuthbert's in Wells, and much later at Evercreech and elsewhere. The simple supermullioned 'split-Y' tracery of two-light tower windows also derives from Wynford's usage (e.g. the hall at Winchester College) and is found in the early towers at Yeovil, Cheddar and Shepton Mallet. Tracery of this kind was inserted throughout the earlier lancets of the cathedral soon after Wynford's death and is associated with the episcopate of Nicholas Bubwith (1408–24).[24]

THE CLOISTERS AND LIBRARY

It was not until *c*.1420 that the new cloisters in the Perpendicular style were begun, intended from the start to carry a first-floor library over the east walk. The first bays were built by 1424 and the east walk was probably finished by 1433–35.[25] The use of ogee heads to the tracery lights is precocious in Somerset and may be derived from the later bays of the Gloucester cloisters. The west walk was not built until considerably later (*c*.1460–70), and differs somewhat in detail, but is not to a radically fresh design. The south walk, except for its earlier end bays, was filled in between 1490 and 1508. The provision of a library on an upper floor conformed to Wynford's practice at New College and was part of a wave of construction all over England, notably including within a single generation libraries in York, Lincoln, Canterbury, London (Guildhall), Winchester (College), Oxford and Bristol.

THE CLOISTER VAULTS

Although the design of the cloisters is not in itself of outstanding distinction, the vaults belong to that uncommon type where the place of a central boss is taken by a void panel bordered by ribs. Such vaults are characteristic of the West Midlands and the earliest known example seems to be that over the choir of St Mary's, Warwick, probably designed in or soon after 1381 and incorporating also skeleton-ribs as in the contemporary Central European practice of Peter Parler.[26] The Warwick voids are octagons and in the later Beauchamp Chapel (1441–52) alongside are used together with hexagons; the octagonal form was employed in the Hereford cloister in the bay before the chapter-house vestibule, and the type occurs also in the cloisters of Lacock Abbey, Wiltshire.[27] The Wells cloister vaults have quadrilaterals, and similar designs continued to be used at Wells later in the 15th century for some of the vaults of the gates of the Close (Penniless Porch; the Bishop's Eye) and the Chain Gate of 1458–59. Modified versions were used throughout the later walks of the cloisters until the end early in the 16th century.

THE ALTERATIONS TO THE CENTRAL TOWER

The tower of 1315–22 was rendered unsafe by a fire in 1439 and extensive repairs, carried out in 1439–50, greatly changed its appearance. The name of the designer has not so far been discovered, but his work influenced the design of Somerset towers in the direction of enriched tracery and grouped pinnacles. Completion of the alterations in 1450, exactly half-way through the 15th century, conveniently marks the end of early Perpendicular in the region.[28]

THE CHAIN GATE

The unique Chain Gate, linking the Vicars' Hall with the Cathedral by a covered way carried across the road, is an important landmark in architectural design. There was a precedent for the type in a bridge of 1396 at York, linking the Bedern or close of the Vicars with the precincts of the Minster across Goodramgate.[29] The York bridge was of timber and did not produce an architectural type; but its practical purpose, to prevent the vicars from wandering freely in the city streets, was the same.

The details of the Chain Gate, and notably its window tracery, are unparalleled except for part of the nearby house called The Rib.[30] The vault is one of those with the voided bosses found in the cloisters, but there is otherwise little resemblance to any work at Wells or indeed elsewhere. The closest sources would seem to be in southern Warwickshire around

D

Stratford-on-Avon, but so far no other building has been found which can manifestly be attributed to the same designer.

THE CROSSING VAULT, AND BISHOP STILLINGTON'S LADY CHAPEL

Wells Cathedral possessed two of the finest works of late Perpendicular of which one now survives: the vault over the Crossing. This is in precisely the same style of panelled fan-vaulting as the fragmentary remains of the Lady chapel built to the east of the Cloisters for Bishop Robert Stillington in 1477–88.[31] In these years the master mason to the cathedral was William Smyth, presumably the man who took up the freedom of the city of Wells in 1475 and who died in 1490, when he was succeeded by William Atwood.[32] The same details appear elsewhere in the crossing vault of Milton Abbey; at Sherborne Abbey; and on the west front of Crewkerne church. The window tracery of the Sherborne nave is almost exactly repeated in what remains of the west wall of Stillington's Chapel, and belongs to the Bristol tradition exemplified in works of this period at St Mary Redcliffe. The fact that the several fan-vaults are built by different methods, as pointed out by Mr Walter Leedy,[33] emphasises the architectural function of a master such as Smyth. Long before this date it had become normal for designs to be supplied, on sheets of parchment or paper, by distinguished architects who were no longer concerned with the day-to-day supervision of the works on each site. We may suspect from their plurality of employments that Thomas Witney, William Joy and Richard Farleigh already exemplified this modern practice early in the 14th century.[34]

FINISHING THE CLOISTERS

English Gothic, in the strict sense, began at Wells around 1180. Smyth's works, which ended with his death, were among the last of true Perpendicular. By 1490 flowing reticulations were already taking the place of the strong mullion and the sharp angularity of the national style. At Wells there was little left to do, and no opportunity for decadence. The south walk of the cloisters was still unfinished, but it was completed about 1508 under William Atwood. The details differ but slightly from those of the earlier walks and angle-bays and it is evident that Atwood made little attempt to stamp the cathedral works with his personality.[35] To all intents and purposes the Perpendicular of Wells ended with the 15th century.

<div align="center">

POSTSCRIPT ON THE VICARS' CLOSE (see p. 38 above)

</div>

After the substance of this paper had been delivered, works of repair to houses in the Vicars' Close gave an opportunity for archaeological investigation of the fireplaces and chimneystacks of some of the houses. I am indebted to Mr L. S. Colchester and to Dr Warwick Rodwell for pointing out to me changes in the character of the masonry indicating that only the enriched shafted flues had been added in the 15th century, and for telling me of other evidence found in excavations tending to confirm the original character of the stacks. This virtually disproves the old assumption that the houses in their original form did not have fireplaces, and enhances the interest of the Close as a 'modern' exercise in planning and design worthy of William Wynford.

<div align="center">

REFERENCES

SHORTENED TITLES USED

</div>

HARVEY (1950)—John Harvey, *The Gothic World 1100–1600* (Batsford 1950).
— (1954)—John Harvey, *English Mediaeval Architects: a Biographical Dictionary down to 1550* (Batsford, 1954).

— (1971) — John Harvey, *The Master Builders: Architecture in the Middle Ages* (Thames & Hudson 1971).
— (1972) — John Harvey, *The Mediaeval Architect* (Wayland 1972).
WICKHAM — A. K. Wickham, *Churches of Somerset* (Phoenix House 1952).

1. L. S. Colchester in Colchester & Harvey (1974), 205.
2. Ibid., 205–06.
3. Ibid., 207.
4. For Joy, see Harvey (1954), 151; J. H. Harvey in *Report of the Friends . . . of St George's, Windsor*, 1961, 55 n. 3.
5. Colchester & Harvey (1974), 208–09.
6. J. H. Harvey, 'The Origin of the Perpendicular Style' in *Studies in Building History*, ed. E. M. Jope ('1961'; 1962), 139–41.
7. On the double-ogee, ibid., 135, 164; for the mouldings of the Vicars' turret see J. Harvey, *The Perpendicular Style* (Batsford, 1978), fig. 23.
8. Ibid. The character of the gateway, its archways, details and vaulting, is completely distinct from and obviously later than that of the Hall above, though much earlier than the added oriel windows.
9. For Wynford's career see Harvey (1954), 307–10; Harvey (1972), 82–85.
10. *Calendar*, I, 267; for Wykeham's provostship see *Calendar of Patent Rolls 1361–64*, 435; *Calendar*, I, 301–02.
11. A. F. Leach, 'William of Wykeham', in *Encyclopaedia Britannica*, 11th ed. (1910), XXVIII, 677–81; J. H. Harvey in *JBAA*, 3rd ser., XXVIII (1965), 107–28.
12. Will of Robert Samborne, *Somerset Medieval Wills*, ed. F. W. Weaver, Somerset Record Society, XIX (1903), 287–88; the will was made 20 May and proved 12 September 1382.
13. See J. H. Harvey in *Horological Journal*, C, No. 1201 (1958), 654.
14. For Scune see Harvey (1954), 240.
15. Winchester College Muniments 73; the spire appears in the drawing (1463) of the College by Thomas Chandler, reproduced e.g. in A. F. Leach, *A History of Winchester College* (Duckworth 1899), frontispiece.
16. Wyngaerde's drawing is reproduced in *History of the King's Works* ed. H. M. Colvin, I (1963), pl. 24.
17. *Calendar*, I, 35–36; II, 550–52; Harvey 1954, 195.
18. On the drawings used in the construction of Gothic churches see Harvey (1950), 29–36; Harvey (1971), 32–38; pls. 14–18, 20, 22; Harvey (1972), 102–19; pls. 30–33, 42–47, 49, 51–52; J. H. Harvey in *The Connoisseur Coronation Book* (1953), 97–102.
19. Above, note 14.
20. The building accounts for the New College tower are printed in J. E. Thorold Rogers, *Oxford City Documents*, Oxford Historical Society, XVIII (1891), 306–14.
21. For the moulding profiles see J. Harvey, *The Perpendicular Style* (above, note 7), fig. 23.
22. The best accounts of the major Somerset towers are by F. J. Allen, *The Great Church Towers of England* (Cambridge 1932), 11–66; and by N. Pevsner, *Somerset*, The Buildings of England (Harmondsworth 1958), 34–44. See also Wickham, 38–49; and T. D. Atkinson, *Local Style in English Architecture* (Batsford 1947), 95–97, with map.
23. Colchester & Harvey (1974), 208.
24. Mr L. S. Colchester, personal communication.
25. Colchester & Harvey (1974), 209–10.
26. For comparative illustrations of these skeleton-ribs see Harvey (1950), pls. 110, 111.
27. J. Harvey, *The Perpendicular Style* (above, note 7), 183–85.
28. Colchester & Harvey (1974), 210–11; C. Nicholson in *R.I.B.A. Journal*, XIX (1912), 627–28.
29. *Calendar of Patent Rolls 1391–96*, 712. A still earlier precedent, dating from 1335, was the bridge from St Swithun's Cathedral priory at Winchester, leading over the city wall to Mirabel Close (A. W. Goodman, *Chartulary of Winchester Cathedral* (1927), no. 275).
30. A. K. Wickham detected a certain likeness in details of the decidedly later Newton Chapel at Yatton (Wickham, 28).
31. Colchester & Harvey (1974), 211.
32. The William Smyth who took up the freedom of Wells in 1475 (Somerset Record Society, XLVI, 1932, 156) had no stated trade; Atwood, though he succeeded as master mason at the cathedral in 1490, did not take up the freedom until 1498 (ibid., 163).
33. W. C. Leedy, 'Wells Cathedral and Sherborne Abbey', *Gesta*, XVI.1 (1977), 39–44; and see now, W. C. Leedy, *Fan Vaulting* (1980), 212–14.
34. For the architectural functions of the master mason see Harvey (1972), especially 133–36.
35. Colchester & Harvey (1974), 213.

An Interim Note on the Decorated Medieval Tiles at Wells

By Elizabeth Eames

The known decorated medieval tiles from Wells are from five sites: the Lady Chapel by the Cloister, the Bishop's Palace, under the road outside the Deanery, the Corpus Christi chapel in the cathedral, and the gardens of the Vicars' Close. The site of the Lady chapel was excavated and the excavations were published in 1894 by the then Dean, the Very Reverend T. W. Jex-Blake.[1] The tiles found *in situ* were reburied but others recovered at that time are in Wells Museum.[2] Since this paper was read at the conference the site of the old Lady chapel has been extensively excavated under the direction of Warwick Rodwell, whose preliminary report appears in this volume. The tiles reburied in 1894 were uncovered and many more were found but they have not yet been studied. Until they have been fully examined and assessed no worthwhile statement on the tiles in the Lady chapel can be made. The tiles from the Bishop's Palace were found during a limited excavation in the Bishop's Hall carried out by Peter Draper and John Cherry in 1970.[3] In 1890 a few tiles were found under the road outside the Deanery and these are now in Wells Museum. The tiles in the Corpus Christi chapel were published by L. S. Colchester in 1977.[4] I have heard that tiles have been found in the gardens of the Vicars' Close, but I do not know what they were or where they are now.

The tiles known to me fall into two groups: all but a few belong to a recognisable branch of the Wessex school and should probably be dated between 1275 and 1325; the few exceptions belong to a Bristol/Lower Severn group that can be roughly dated to the period between 1480 and 1530.

This later group is represented by some tiles in Corpus Christi chapel and one in Wells Museum said to have been found under the road outside the Deanery. Three designs only are present, published by Colchester as his j, n and o. Each has as its principal decorative motif a shield of arms set diagonally. All these shields are of the tall, straight-sided shape used in the first half of the 16th century, very different from the shape of the shields in the other heraldic designs in the pavement (Colchester's c, d, e, f and g). The arms in design n have been identified as those of William Bird, prior of Bath Abbey from 1494 to 1525.[5] This date accords with the shape of the shield and form of the foliage, and may be accepted as placing this group in the first quarter of the 16th century. The example found under the road in 1890 is decorated with this design. Colchester's design o, the crossed keys and sword for St Peter and St Paul, has been identified as the arms of Bath Abbey and could thus be taken to suggest that this group was designed for Bath, but the third design, Colchester's j, has been identified as the arms of Glastonbury Abbey, so it seems more probable that they were intended for use in several places in the area. It is not known where in Wells these tiles were originally laid; those in the Corpus Christi chapel are not in their original position.

Draper and Cherry recovered forty-seven fragments of tiles but no whole ones during their excavations in the Bishop's Hall. Twenty-eight of these were decorated with designs that are present on a well-known series of tiles that are about 200 mm square.[6] Three designs were represented, all heraldic shields, bearing the arms of England, of Richard of Cornwall and of Clare, all apparently identical with those still present at the south end of the Old Refectory pavement at Cleeve Abbey in Somerset. These were published by J. B. Ward-Perkins as designs 1, 2 and 3 in his account of the tiles of Cleeve Abbey.[7] Both he and Colonel

Bramble, who published a note on the pavement when it was discovered in the 19th century,[8] considered that these arms commemorated the marriage of Edmund, Earl of Cornwall and Margaret de Clare in 1272. These same designs are known from other sites, including Glastonbury, where all three were found during the excavations on the Tor directed by Philip Rahtz.[9] Variants of the designs have also been found, including some at the Nash Hill kiln site[10] and Stanley Abbey[11] and on quarries that were slightly too small at Amesbury Abbey.[12] These Wiltshire variants appear to be derived from the Somerset designs as they have more developed naturalistic foliage beside the shields. It is not known for which site in Somerset the designs were first made; they were probably based on contemporary seals, as was suggested by the Rev. H. W. Pereira who published the heraldry on the Wells tiles beside the seal of Edmund of Cornwall in 1888.[13] It seems probable that they were first made soon after the marriage of Edmund and Margaret in 1272, and it is most unlikely that they were designed after Edmund's death in 1300. The Bishop's Hall at Wells was built for Bishop Burnell some time between 1280 and 1290 and one may suppose that the tiles were contemporary with the building and were made during that decade.

Fifteen of the remaining fragments from the Bishop's Hall are parts of tiles that were about 140 mm square and were decorated with three different designs: addorsed birds set square within a circle, a lion in a circle, and a double-headed eagle displayed. All three are present at Cleeve Abbey, the double-headed eagle being present in the Old Refectory pavement (Ward-Perkins' designs 25, 11 and 4). The addorsed birds and eagle were found in the excavations on Glastonbury Tor and we may suppose that the Bishop's Palace at Wells and some building in Glastonbury once had pavements closely resembling that still present at Cleeve. At Wells four other designs were represented by one fragment each, two of them unidentified, one possibly part of a smaller version of the arms of Richard of Cornwall, of which a number are known, and the last possibly part of the lion in a circle.

Half a tile apparently decorated with the same eagle displayed as that found in the Bishop's Hall was published by Jex-Blake, but the five other designs included in his plan of the tiles found *in situ* in the Lady Chapel by the Cloister are not among those surviving from the Palace; this may be fortuitous as so few are known from that site. The tiles from the Lady chapel now in Wells Museum include examples of Ward-Perkins' designs 5, 20 and 22 from Cleeve; of his plate VIII 3, a smaller version of the arms of Clare, from Glastonbury;[14] and of my designs 5–8 from the excavations on Glastonbury Tor,[15] 11, 13, 16 and 17 from the excavations at Beckery chapel,[16] 31, 48, 49 and 54 from the Nash Hill kiln site,[17] as well as a smaller version of the arms of Richard of Cornwall, a griffon and a lion. There seems little doubt that the Palace and Lady chapel pavements at Wells were closely related, and formed part of this late 13th-century Somerset group.

The tiles in the Corpus Christi chapel present some difficult problems. Fifteen designs were published by Colchester in 1977.[18] He noted that about half of the paved area was revealed in 1976 when Bishop Berkeley's tomb, which had been put on top of the pavement in the 19th century, was removed. The paving remains between the west part of the north wall and the north part of the west wall of the chapel. It is divided into two panels of tiles, set diagonally to the axis of the building, separated by a border consisting of a single row of decorated tiles set square flanked by one row of oblong dark-glazed tiles at each side. A few dark oblong tiles from the edge of the next border are present at the south side of the south panel.[19] The border between the two remaining panels is filled with a row of tiles all decorated with a foliate spray, Colchester's design b, set with the base of the stem at the west. The panel beside the north wall is filled with examples of a four-tile pattern, made up of four elaborate sprays of fleurs-de-lis springing from a central circle, Colchester's design a. This is known from a number of sites including Cleeve Abbey, where it is still present in the

Old Refectory (Ward-Perkins' design 6). At Wells it is used in groups of four surrounded by eight dark oblong tiles with small square yellow tiles at the corners, but all the decorated tiles are arranged with the quarter circle at the west so that they do not form the four-tile pattern for which they were designed. One of the triangular half-tiles near the north-west corner is decorated with a different design, not illustrated by Colchester. It was present on a fragment recovered during Rahtz's excavations on the site of Beckery Chapel, Glastonbury, in 1967–68.[20]

The tiles in the south panel cannot all be in their original position because the late examples are scattered among them, but six rows across the panel at the west end are all examples of Colchester's design c, a small version of the arms of England, also known from Glastonbury (Ward-Perkins' design VIII 1). All are set with the point of the shield at the west. They are very worn and one has apparently been replaced by a plain yellow tile. East of these six rows there is no systematic arrangement of the tiles either in the relationship of the designs to each other or the direction in which they are set. Five complete rows and parts of two more remain in this area of the panel. The tiles are decorated with the remaining designs published by Colchester, his d–h and k–m, as well as the three later designs already discussed. One tile is decorated with a design that is not included by Colchester. It is a Wessex type four-tile pattern of four fleurs-de-lis springing from a circular band, within a spotted open quatrefoil, one quarter of the design being on one tile. It is closely related to one of the designs from the Nash Hill kiln though probably not identical.[21]

Pereira published one other heraldic design of fleur-de-lis which he found on one tile in another part of the chapel, but this is no longer there. In the same paper he wrote: 'In the Chapel of St John the Baptist is a small set of encaustic tiles, which, after having been left in a state of neglect and confusion in some external locality, were some years ago carefully collected and fixed in the floor of this chapel near its western wall'.[22] It is possible that these are the tiles in the disturbed area at the east of the south panel in Corpus Christi chapel, but this was formerly dedicated to St John the Evangelist, not St John the Baptist, whose chapel is at the east end of the south presbytery aisle.

At present I think it likely that the tiles in the north panel, the border and the six west rows of the south panel in the Corpus Christi chapel are in their original position and that they belong to the same group as those in the Old Refectory at Cleeve Abbey and others at Glastonbury and that they date from the last decade of the 13th century, being slightly later than Cleeve because the smaller version of the arms of England at Wells is derived from the larger at Cleeve. The remaining tiles in the south panel have been relaid, probably at some time in the 19th century, with the better tiles remaining from a floor that was contemporary with that in the chapel, from another dating from the early years of the 16th century and possibly from a third of intermediate date; Colchester's design 1 does not belong to the same late 13th-century Somerset/Wiltshire/Wessex group as the rest of the earlier tiles.

From this rather limited evidence it would seem that there was a period of intense activity in the years between 1272, when the 200 mm square heraldic tiles commemorating the marriage of Edmund of Cornwall and Margaret de Clare are likely to have been designed, and 1300 or a little later. During that time the Hall of Bishop Burnell's Palace, the Corpus Christi chapel and possibly the Lady Chapel by the Cloister were paved. At the same period comparable tile paving was laid at Cleeve and Muchelney Abbeys and at more than one site in Glastonbury. It is not known where the tiles were made. Wasters have been recovered during excavations at Glastonbury, suggesting that some were made there[23] but all may not have been made at the same place. The few earlier 16th-century tiles are the only evidence of later tile paving yet known.

REFERENCES

1. Rev. T. W. Jex-Blake, 'The Lady Chapel by the Cloister, Wells', *P.S.A.N.H.S.*, XL (1894), 39 and Pl. 2. For a report on the recent excavations see the paper in this volume by Dr Rodwell, p. 1.
2. I am indebted to Norman Cook for permitting me to study the tiles in the Museum and supplying much helpful information.
3. See the report of these excavations on pp. 52–53 of this volume.
4. L. S. Colchester, 'Floor tiles in Corpus Christi Chapel', *The Friends of Wells Cathedral, Report for 1977*, 16–21.
5. Ibid., 21 n.
6. These are known from sites in Somerset, Gloucestershire and Wiltshire and tiles of this size formed a high percentage of the waste from the kiln site at Nash Hill, Lacock, Wiltshire, excavated under the direction of M. R. McCarthy in 1971. See Elizabeth S. Eames, 'The Tiles', in Michael R. McCarthy, 'The Medieval Kilns on Nash Hill, Lacock, Wiltshire', *Wiltshire Archaeological Magazine*, 69 (1974), 134–45.
7. J. B. Ward-Perkins, 'A Late Thirteenth-century Tile-pavement at Cleeve Abbey', *P.S.A.N.H.S.*, LXXXVII (1941), 39–55.
8. J. R. Bramble, 'Notes on the Recently Discovered Pavement at the Abbey of Old Cleeve, Somerset', *JBAA*, XXXIII (1877), 456–64.
9. Elizabeth Eames, 'Floor Tiles', in Philip Rahtz 'Excavations on Glastonbury Tor', *Archaeol. J.*, CXXVII (1971), 72–78.
10. Eames (McCarthy 1974), 135.
11. Harold Brakspear, 'The Cistercian Abbey of Stanley, Wiltshire', *Archaeologia*, 60 (1907), Pl. LV.
12. Frank Stevens, 'The Inlaid Paving Tiles of Wilts', *Wiltshire Archaeological Magazine*, XLVII (1936), Pl. IV.
13. Rev. H. W. Periera, 'Brief Notes on the Heraldry of the Glass and other Memorials in Wells Cathedral', *P.S.A.N.H.S.*, XXXIV (1888), Pt II, 52–53, and plate f.p.52.
14. Ward-Perkins (1941), Pl. VIII 3.
15. Eames, 'Floor Tiles', *Archaeol. J.* (1971), 73.
16. Elizabeth S. Eames, 'The Floor Tiles', in Philip Rahtz and Susan Hirst, *Beckery Chapel, Glastonbury, 1967–8* (1974), 66–70.
17. Eames (McCarthy 1974), 139 and 142.
18. Colchester, 'Floor Tiles in Corpus Christi Chapel' (1977), 17.
19. An undated manuscript plan of Wells Cathedral, drawn by John Carter at some date between 1761 and 1817, includes a rough indication of the presence of this pavement. (British Library, Department of Manuscripts, Add. MS 29943, John Carter, *Architectural and Monumental Drawings, 1761–1817*, Vol. 19, f. 124.) I am indebted to Christopher Norton for bringing this to my notice. This sketch shows three panels separated by narrow borders running west–east. The south panel is incomplete on its south side. All extend a few feet only from the west wall. A tomb against the north wall overlies part of the north panel, which does not extend as far as the east end of the tomb. This might be Bishop Berkeley's tomb but may be that of Bishop Bubworth. His tomb is shown in another sketch by Carter occupying a position against the north wall of this chapel but apparently further east. (B.L. Dept of MSS, Add. MS 29932, being Vol. 16 of the same work, dated 1794 f. 45). The south panel in Carter's drawing is no longer present, but the area under the tomb is now revealed.
20. Eames (Rahtz & Hirst 1974), 25 no. 17.
21. Eames (McCarthy 1974), 138 no. 26.
22. Pereira, *P.S.A.N.H.S.* (1888), 52.
23. Eames, 'Floor Tiles', *Archaeol. J.* (1971), 76.

Medieval Carpentry and Ironwork at Wells Cathedral

By Jane Geddes

In the fields of carpentry and ironwork Wells cathedral is outstanding because it preserves many early examples of objects which later became commonplace. As the objects are so diverse, it is difficult to relate them to a single theme, but, in general, their progressive nature may be contrasted with the extreme conservatism in the surrounding district.

The carpentry to be considered is found on various doors in the cathedral. The construction of large church doors evolved to a certain extent during the middle ages, but once a stable formula was found, little further development took place. The final, most satisfactory, solution was a portcullis frame made with massive rectangular members forming a dense grid of small squares. A typical example is found in the Pyx Chamber, Westminster (Pl. VIIIA), installed shortly after a robbery there in 1303.[1] This type of sturdy construction is found on almost every well-made 14th- or 15th-century door. The earliest surviving major cathedral doors are at Durham. They were made for the north and south doors of the nave between 1128 and 1133.[2] In spite of their enormous size, they are only held together by three ledges wedged in a groove across the back of the doors, without any frame or even any nails.

In the years between the construction of these doors at Durham and Westminster, many experiments took place to provide an improved solution. The most inventive period seems to have been at the end of the 12th and beginning of the 13th century. The earliest surviving example of a heavily braced church door is at Ripon where a diamond lattice is used. It hangs in the north transept, a part of the building erected by Bishop Pont l'Eveque, 1154–81.[3] Another type of framed door, with three saltire braces, is found in the north transept at Lincoln (Pl. VIIIB). This part of the church was built in the same campaign as the chapter house, which is first mentioned *c*.1220–30.[4] The magnificent west doors of Peterborough cathedral, 1193–1200, contemporary with the inner section of the west front,[5] are gracefully framed to match the twin entrances on the exterior. Within the two lancets formed by the frame is the carefully carved lattice brace. A similar construction is used on the doors of the Ely galilee, built between 1198 and 1215 under Bishop Eustace.[6]

In all these early examples it should be noted that the frame members are widely spaced compared with the dense portcullis at Westminster, and that they are carefully carved or moulded, in contrast to the rough angular beams of later work. It was during this period of experiment that the earliest surviving portcullis frames were made, for the north doors of the nave at Wells (Pl. VIIIC). This part of the building was completed after about 1190 and before Bishop Joscelyn fled abroad during the Interdict from 1209–13.[7] Here it should be observed that the styles and ledges (vertical and horizontal members) are slender and neatly chamfered like other contemporary work, and the squares are still relatively large. Already on the west doors of the nave, probably ready for the 1239 consecration, the squares are proportionally smaller (Pl. VIIID).[8] It is possible that a new master carpenter was employed when work was resumed after the Interdict, and this accounts for the change in door construction. Hewett has observed a decisive change in the joinery of the roof before and after the building break by the north porch, which supports this assumption.[9] The inner door of the chapter house undercroft, built in the 1250s, has a similar construction to those of the west front (Pl. IXC).[10] So, already by the 1250s, the design of the portcullis frame had become standardised at Wells, although it did not become widespread elsewhere for another 50

years. Other later examples in the cathedral are at the entrances to the choir from the ambulatory, *c*.1325,[11] and at the foot of the chapter house staircase.

A further turning point in carpentry can be seen in the use of roves at Wells. Roves are small plates of iron placed under the head of a nail to prevent the wood from splitting. They are still used frequently in the construction of clinker built boats. In the 12th century, roves used on doors invariably had long claw like arms which clasped the ledge on the back of the door. Examples are found at Stillingfleet, North Yorkshire, Staplehurst, Kent and from the 11th century at Hadstock, Essex. By the 14th century roves had changed to square or diamond-shaped washers, merely cushioning the nail head but never clasping the ledge. Late medieval examples are found on the north door of Southwell nave and the door from the nave to the cloister in Gloucester cathedral.[12] The outer door to the undercroft of the Wells chapter house is also constructed with roves of the washer type (Pl. IXD). It is simply cross boarded with vertical planks on the inside and horizontal on the outside. A similar construction of cross boarding with flat roves is used on the larger door of Bishop's Gate in the Norwich cathedral precinct. The Norwich door is carved with the rebus of Bishop Lyhart, 1461–83.[13] This construction, together with the scanty, severe ironwork, suggests the Wells undercroft outer door is a 15th-century addition. It must have been installed to improve security, as the earlier door has little provision for locks.

The transition from clasping roves to flat washers can actually be seen on the Wells doors, and it corresponds with the building break by the north porch. On the north doors of the nave, made before 1209, the roves distinctly clasp the ledges as in the 12th-century examples. (Pl. VIIIc). On the west doors, *c*.1239, the lozenge-shaped roves alternately clasp the ledges and act as washers (Pl. IXA). On the chapter house undercroft door of the 1250s, the roves are much shorter and serve only as washers (Pl. IXB).

One other item of carpentry at Wells deserves mention, as it seems to be a very early example of its kind. This is the cupboard with drawers in the muniment room of the Vicars Choral. Dr Eames, in her study of medieval furniture, considers it to be the earliest surviving armoire with drawers in England.[14] Such armoires are first mentioned in French accounts around 1430 where they are described as *laiettes* for keeping letters and charters. Dr Eames assumes the cupboard was made specifically for the muniment room, whose construction she dates to 1457. In fact the muniment room has no exact documentary date, but Mr Colchester argues convincingly that it was probably built around 1420.[15] The north window in the muniment room has exactly the same perpendicular tracery as the windows of the nave and south transept. The latter must have been installed before one of them was blocked by the construction of Bubwith's library in 1425. In addition, there is a boss in the vault under the treasury, a square with elongated points, which is repeated in the east cloister. Bubwith's will of 1424 refers to the east cloister as already built.[16] Thus, while it is likely that the cupboard with drawers was built for its present location in the muniment room, both may have been constructed as early as 1420.

It is not only the carpentry at Wells which is precocious; some of the ironwork is equally advanced. The inner door of the chapter house undercroft is covered with imaginative stamped scrollwork (Pls XA, XIA, B). The scrolls and short clusters of leaves and flowers spring from three strap hinges. They do not cover the whole width of the door but leave a gap of about 40 cm along the opening edge. Each strap is crossed in the middle by a short moulded bar. On the top and bottom straps, a short foliage cluster and long scroll spring from the bar. On the middle bar there is no sign of the foliage cluster, not even in the form of nail holes (Pl. XIB). In fact, for the sake of symmetry, there should be two long scrolls on the upper side of the central strap. The two opposing scrolls at the top of the door are randomly placed and end in the sort of tapers usually made to slip under a strap (Pl. XIA).

They look as if they were intended for the hanging end and raised bar of the central strap. The short length of the straps and the misplaced scrolls from the central strap suggest that the ironwork was designed for a taller, narrower door.[17]

The terminals of the scrolls are covered with tiny stamped flowers and leaves. Stamped ironwork is produced rather like the impression of a seal on wax. A case-hardened iron die is carved with the required pattern, and a hot iron bar is hammered into it. This technique, familiar to coin makers since Antiquity, was first applied to iron in the early 13th century. The earliest surviving example in England is on the doors of St George's Chapel, Windsor, built between 1240 and 1249.[18] Although some of the terminals at Windsor were experimental, the orthodox vocabulary of rosettes, trefoils, cinquefoils and asymmetrical leaves was also used. These are also commonly found in stained glass and manuscripts. The orthodox patterns at Windsor were closely copied at Merton College, Oxford, in the hall built between 1274 and 1277,[19] and such patterns continued to be used frequently in ironwork for the next seventy years. However, the smith at Wells seems to have been unaware of the orthodox forms, and invented his own square rosette, a rather insignificant circular rosette and a type of quatrefoil, none of which can be found elsewhere. There are two possible explanations for this: the relative isolation of the Wells smith, and the early date of the ironwork. The distribution of surviving stamped ironwork, all made from c.1250 to 1350, shows that it is mainly concentrated east of a line from York to Oxford.[20] The Wells hinges are probably close in date to the earliest example at Windsor (1240–49), although they do not look alike. At Wells, work was resumed on the upper part of the chapter house in 1286, when the work was described as 'long since begun'.[21] The undercroft where the door hangs was built in an earlier campaign, and contains bar tracery first used at Westminster chapter house in c.1249.[22] The stamped hinges, even if not specifically made for the undercroft, were probably installed there during the 1250s. Unfortunately this attractive technique was not adopted by Somerset village smiths, or if it was, no examples have survived.

The next development of ironwork at Wells became so popular that it continued to be employed in the county from the 14th to the 16th centuries. When stamped work was at its peak, around 1300, simpler imitations began to be made using thin sheets of iron cut with chisels into various leaf and flower terminals. This type of cut-out design is used on the hinges of the doors leading from the ambulatory to the choir. They were probably installed when the newly finished choir was being furnished (Pl. XIc). The choir stalls were ordered in 1325 but were still not paid for in 1337.[23]

Characteristic features of this type of ironwork are the central ogival lobe with nibbed point, and hollow or cupped weld covers. Perhaps of the same date are the clusters of cut out leaves added to the door at Priston. The only difference between these and later examples is that the later iron bars are much thicker. (It seems to be a general trend that iron straps on church doors became thicker as the middle ages progressed: many 12th-century bars are 3–5 mm thick while in the 15th century, for the same size of door, bars are 7–10 mm thick). Other examples in this group are in the remote Somerset churches of Raddington (Pl. XId) and Winsford. Their terminals are not very well developed, but the hollow weld covers are used. Both these sets of hinges are in parts of their buildings constructed in the 14th century. The doorway of North Curry suggests that its lost ironwork was probably 15th century.[24]

The hinges on the west doors at Butleigh are probably 14th century. Similar cut-out rosettes on a sculptured mid-14th-century portal are used at Brampton, Oxfordshire. At Sharpham Park (Pl. XIe) the hinges have all the characteristics of earlier cut-out work, such as the nibbed lobes, hollow weld covers and so on, but they are probably 16th century. Sharpham Park was the private manor of the abbots of Glastonbury, and was built by Abbot Richard Beare between 1493 and 1524.[25] The simplest hinges in this group, at Moor

Lynch, now on a new door, may be of the same date as Sharpham Park, because the terminals are attached to equally angular stems. Presumably because their curvaceous appearance relates them to the Decorated style in architecture, the hinges at Meare have been attributed by Pevsner[26] to the original church dedicated in 1323 (Pl. XB). This would make them roughly contemporary with the simple hinges in Wells choir. However, they resemble the nearby hinges at Sharpham Park much more closely and are therefore likely to be contemporary with the nave in which they hang, built by Abbot Selwood of Glastonbury between 1456 and 1493.[27] This cut out ironwork with curvaceous stems and ogival leaves may be called the ironwork equivalent of the Decorated style. Its persistence, with so little change from about 1330 to 1520, gives some indication of the conservatism of Somerset smiths.

A sign of even greater conservatism is the persistence in Somerset of a basically Romanesque design up to the late 17th century. At Wedmore, the magnificent Early English portal was carved by masons from Wells but, as the studs indicate, the door was replaced in 1677 (Pl. XC). The main decoration consists of lobed terminals surrounded by clusters of tendrils coiled like springs. Such tightly scrolled terminals are also found at Low Ham, a remarkable Gothic survival-revival building, completely rebuilt by Edward Hext (Pl. XIIA). His work began before 1623 and the church was consecrated in 1669.[28] This type of ironwork falls into a category I have called 'lobes and tendrils' which flourished particularly at the end of the 12th century.[29] The scrolled bars at Cuddesdon, Oxfordshire, were made around 1200 and are basically the same design as at Wedmore (Pl. XIIc). There are two main differences between the early and late work: first, the 12th-century lobes have straighter sides whereas the Wedmore lobes are ogival and nibbed; second, the 12th-century spirals have a circular profile and are loosely curled, whereas at Wedmore and Low Ham they have a rectangular section and are tightly scrolled. The fashion for tight tendrils with a rectangular section began in the 15th century. The earliest examples I have found are in Denmark, for instance at Kavslunde, dated by inscription to 1489 (Pl. XIID).[30]

The final outstanding item of ironwork at Wells is the railing around the tomb of Bishop Beckynton (Pls XIIb, XIIIA, B). Thomas Beckynton did not die until 1464, but in 1449 he was congratulated on getting his tomb ready.[31] In 1451 Beckynton requested the mayor and corporation to pray at his chantry in return for his gift of a water supply to the town;[32] and in 1452 he dedicated his altar.[33] The railings have elaborately moulded corner posts linked by ornamental transoms. One of these is crenellated and the other has an openwork design of small crosses (Pls XIIIA, B). The crests of the rails themselves are made from sheets of iron, cut into crosses and leaves which project in four directions. The crest motif of crosses and leaves, together with a variation of the openwork crosses below, is found on another set of railings, at Farleigh Hungerford (Pl. XIIIc, d). They were made for the tomb of Sir Thomas Hungerford (d.1398) and his wife Joan Hussey (d.1412). The Beckynton and Hungerford railings are remarkably similar in design and execution, besides being geographically quite near to one another. It is therefore hard to believe that the Hungerford railings were complete by the time Joan died, thirty-nine years before Beckynton's railings were made. Both these railings were, after all, prestigious commissions, quite different from the rustic parish work discussed previously. Unaware of the documentary sources, Starkie Gardner supposed both sets were made after Beckynton's death in 1464.[34] Positive documentary proof has yet to be located, but there is an indication that the Hungerford railings might have been erected by Thomas's son Walter, in 1449, making them more or less contemporary with Beckynton's ironwork. Joan's will of 1411 establishes that she wished to be buried 'in the chapel of Saint Anne in the parish church of Farleigh Hungerford, next to the grave of my husband'.[35] In 1441 her son Walter founded a chantry for his family in the

church.[36] In 1445 the chantry licence was reissued because Walter converted the whole church, situated within his castle walls, into a private chapel and a new parish church was built outside in the village.[37] Walter's will of 1449 shows continuing concern for the souls of his mother and father. It contains instructions for the monks of Bath to celebrate the obits of his parents. Furthermore he writes, 'I will that if anything be deficient either in the foundation endowment or statutes of the chantry I have founded at Farleigh Hungerford . . . that an accomplishment thereof be made with all speed and whatever ornaments are wanting . . . I desire they be supplied by my executors'.[38] Walter died in 1449, and perhaps it was at this time that the Hungerford railings were erected, to complete the ornaments of Walter's chantry. This could explain the similarity between the Hungerford railings and those of Thomas Beckynton made between 1449 and 1451.

REFERENCES

1. G. G. Scott, *Gleanings from Westminster Abbey* (Oxford 1863), 290.
2. J. Geddes, 'The Sanctuary Ring of Durham Cathedral', *Archaeologia* (forthcoming); C. A. Hewett, *English Cathedral Carpentry* (London 1975), 90.
3. J. T. Fowler, ed., 'Memorials of the church of SS Peter and Wilfred', *Surtees Society*, 74 (1882), 97.
4. J. F. Dimock, ed., *The metrical life of St Hugh, Bishop of Lincoln* (Lincoln 1860), 37.
5. *VCH, Northamptonshire*, II (1906), 441; Hewett, *English Cathedral Carpentry*, 94.
6. *VCH, Cambridgeshire and the Isle of Ely*, IV (1953), 56; Hewett, *English Cathedral Carpentry*, 94, thought the Galilee was built in the 1250s and therefore believed the counter-rebated boards on the door to be reused. The VCH argues convincingly for the erection of the Galilee under Bishop Eustace, 1198–1215, and both the frame and boards appear to be contemporary with the building.
7. Colchester and Harvey (1974), 203; Bilson (1928), 68.
8. Robinson (1928), 14.
9. C. A. Hewett, 'The notch lap joint in England', *Vernacular Architecture* (1973), 18.
10. Colchester and Harvey (1974), 205.
11. Ibid., 208.
12. Stillingfleet: P. V. Addyman and I. H. Goodall, 'The Norman Church and Door at Stillingfleet', *Archaeologia*, CVI (1979), 96; Gloucester: Hewett, *English Cathedral Carpentry*, 102.
13. Ibid., 100; J. A. Repton, *Norwich Cathedral* (1965), 34.
14. P. Eames, 'Medieval Furniture', *Furniture History Society*, XIII (1977), 40, 250–51.
15. I would like to thank Mr Colchester for his very generous and constructive advice. The information about the muniment room is entirely his contribution. Eames, 'Medieval Furniture' (1977), 251, quotes a variety of sources, none of which produces the 1457 date. However *VCH, Somerset*, II (1911), 167, refers to Beckynton's executors building the Chain Gate in 1457. Even this is incorrect as the Chain Gate was built in 1459–60: H, C. Maxwell Lyte and M. C. B. Dawes, eds., 'The Register of Thomas of Beckynton', *Somerset Record Society*, 49 (1934), 338.
16. Colchester and Harvey (1974), 210.
17. The present dimensions are 163 × 245 cm. A more appropriate size of door for the ironwork would be about 114 × 260 cm. Unfortunately I cannot find a major doorway of such dimensions in the cathedral.
18. H. M. Colvin, ed., *The History of the Kings' Works*, II (London 1963), 868–69; M. Ayrton and A. Silcock, *Wrought Iron and its decorative use* (London 1929), 18.
19. The hinges are on the dining-hall door. The college moved to Oxford in 1274 and the hall is first mentioned in 1277. *VCH, Oxfordshire*, III (1954), 97.
20. J. Geddes, *English Decorative Ironwork 1100–1350*, unpublished Ph.D. thesis, University of London (1978). Except for the Wells door, the only other western survivor is the aumbry at Chester cathedral, but the latter may have been made at York.
21. Colchester and Harvey (1974), 205.
22. Ibid; N. Pevsner, *South West Somerset* (Buildings of England, Harmondsworth 1958), 298.
23. Colchester and Harvey (1974), 208.
24. Drawing by J. Buckler in Somerset Museum, Taunton. Courtauld Institute negative, 764/50(26).
25. *VCH, Somerset*, II (1911), 94.
26. B/E, *South and West Somerset* (1958), 234; A. K. Wickham, *Churches of Somerset* (1952), 33.
27. His initials are carved on the fabric of the nave.

28. *P.S.A.N.H.S.* (1925), Notes, p. xxxviii-xxxix.
29. J. Geddes, Ph.D. thesis (1978), 99–106.
30. M. Mackeprang, 'Fyenske jaernbundne kirkedorer fra Middelalderen', *Aaboger for Nordiske Oldkyndighet og Historie* (1943), 1–30. The earliest door in this series is from Indslev, made in 1465. Spiral tendrils are also found on the Somerset church door at Huish Episcopi. The doorway is Romanesque but the door has a late medieval portcullis frame. Welds on the iron straps explain why there are different types of spiral at each end. It would seem that the tight spiral terminals are contemporary with the door, probably 15th century, and the simpler terminals at the hanging end of the straps are later repairs.
31. G. Williams, ed., 'Official Correspondence of Thomas Beckynton', *Rolls Series*, 56 (London 1872), 264.
32. *Calendar*, 433.
33. 'Register of Beckynton', *Somerset Record Society*, 49 (1934), i, 175.
34. J. Starkie Gardner, *Ironwork*, i (London 1927), 105.
35. W. H. Nichols, *Testamenta Vetusta* (1826), 181.
36. *Calender of Patent Rolls*, Henry VI, 1441–46 (PRO 1908), 36.
37. Ibid., 327.
38. Nichols, *Testamenta Vetusta*, 257.

Excavations in the Bishop's Palace, Wells

By JOHN CHERRY and PETER DRAPER

The Great Hall added to the Bishop's Palace at Wells by Robert Burnell is, undoubtedly, amongst the most important secular buildings of the late 13th century.[1] Unfortunately, the impressive ceremonial hall was not easily adapted to suit the circumstances of the bishop in the mid-16th century and in 1552, presumably at the petition of the bishop, the king granted leave 'to take down the Great Hall now standing and to grant the same away'. Although it was not demolished immediately, the building fell into decay and was brought to its present condition in the 18th century when part of it was deliberately pulled down in order to make the ruin more picturesque.[2] Enough remains, however, to determine the main features of the building and with the useful though brief account by William Worcestre it can be said with certainty that the Hall was divided into nave and aisles.[3]

To our knowledge no excavation had ever been carried out to see if any evidence remained of the original form of the arcade piers. This could be a matter of more than local significance as the Hall was an elaborate and prestigious building for a leading figure at the Court, and at the time of its construction, the West Country was making an important contribution to the development of the Decorated style. There is also the possibility that Burnell's Hall was one of the sources for the remarkable design of the choir of St Augustine's Bristol, where the curious arrangement of the aisle vaults and the use of transomed windows have been related to practices current in secular buildings.

It was with the intention of looking for evidence of the bases of the arcade piers that in 1970 we undertook a trial excavation of three trenches, each four feet square. On the likely assumption that the width of the aisles would be half that of the nave, the first trench was dug fifteen feet from the north wall on the presumed site of the north-east pier. It was excavated through deposited earth, rubble and tile to a depth of three feet where an irregular stone slab was found. We were unable to determine its thickness but it showed no trace of having been cut to form an architectural element. No evidence was found of any cut stone which might have formed part of the base of a pier in this or in the second trench on the presumed site of the next pier to the west. Here a layer of hard-packed chalk was found at the same depth as the slab in the first trench. A third trench was dug on the central east–west axis of the Hall to see if there was any indication of a stone or tiled floor. Only disturbed earth, rubble, chalk and fragments of tile were found but the layer of hard-packed chalk at the same depth as in the second trench provided a strong indication that this was the original floor level. This is borne out by the fact that the external plinth of the north wall is now almost entirely buried (Pl. IIIA). It would seem that the site has been very systematically cleared of all cut stone and from our limited investigation it was not possible even to verify the probability that the piers had been of stone.

Of the fragments of medieval tiles found, most of the identifiable designs were identical with tiles found at Cleeve Abbey and Glastonbury. They included examples of Glastonbury Tor group I, nos. 2 and 3 (Cleeve nos. 2 and 3), Glastonbury Tor group II, no. 4 (Cleeve no. 1), Glastonbury Tor group III, nos. 6 and 7 (Cleeve nos. 4 and 25), and Cleeve design no. 11. These tiles have been discussed by J. B. Ward Perkins who dates groups I and II between 1272 and 1300, and Mrs E. Eames who suggests that groups I, II and III were designed for Cleeve Abbey in the 1280s and that tilers from Cleeve Abbey were later employed at Glastonbury.[4] These close parallels indicate that the tiles were contemporary

with the building of Burnell's Hall and the dating is consistent with the suggestion that the Hall was substantially complete by the death of Robert Burnell in 1292.[5]

REFERENCES

1. M. Wood, *Thirteenth-Century Domestic Architecture in England*. Supplement to *Archaeol. J.*, cv (1950), 74–76.
2. E. Buckle, 'Wells Palace', *P.S.A.N.H.S.*, xxxiv (1888), 89–90.
3. 'Memorandum quid aula episcopatus Wellensis continet per estimacionem circa 80 gressus super navem et duos elas'. William Worcestre, *Itineraries*, ed. J. H. Harvey (Oxford 1969), 208–09.
4. J. B. Ward-Perkins, 'A Late Thirteenth-Century Tile Pavement at Cleeve Abbey', *P.S.A.N.H.S.*, LXXXVII (1941), 39–45; E. Eames in P. A. Rahtz, 'Excavations on Glastonbury Tor, Somerset, 1964–6', *Archaeol. J.*, cxxvii (1971), 72–78. The tile fragments have been deposited in the Wells Museum.
5. P. Draper, 'The Sequence and Dating of the Decorated Work at Wells', above p. 19 and n. 14.

The Liberty, Wells

By D. S. BAILEY

In the topography of Wells the designation 'The Liberty' has two distinct applications. First, it is now the name of a road which connects New Street and St Andrew Street, thus forming part of the main A371 road to Shepton Mallet. Second, 'The Liberty', or more precisely 'The Liberty of St Andrew', denotes the 'extra parochial township'[1] which lies outside both the ancient parishes of St Cuthbert ('In' and 'Out') and the modern parish of St Thomas. It is an area of about forty acres, shaped like an irregular diamond, with the cathedral situated in its south-eastern part. Sometimes we find 'The Liberty' used in a rather vague sense, to denote the immediate environs of the cathedral.

The road called 'The Liberty' divides naturally into two unequal lengths (Fig. 1). The eastern portion, running northward from St Andrew Street to make a right-angled junction with the western portion, was known from medieval times until the middle of the 17th century as Mountroy Lane,[2] and sometimes as College Lane; it appears on William Simes's map of Wells (1735) as 'The Liberty', and on the map of the manor of Canon Grange (c.1825)[3] as 'Back Liberty'.[4] The other, western portion, running eastward from New Street, has also been known by a variety of names. In recent time it was 'North Liberty', and on Simes's map it appears as 'The Back Liberty'; in 1683 it is referred to in a chapter minute as the road 'commonly called College lane'.[5] In certain 14th-century documents[6] it is named 'Canons' street [*vicus canonicorum*], showing that it was then, as it was to remain for the next six hundred years, principally a street of canonical houses. The designation 'College lane' reminds us that both sections of The Liberty once led to the college of St Anne and St Catherine, which stood at the junction of these roads. This college or *hospitium* provided accommodation for the chantry priests who ministered at altars in the cathedral. It was founded in pursuance of the will of Bishop Ralph Ergum, who died on 10 April 1400.[7] The college building probably incorporated a house in which the grammar school of Wells was held, and which had belonged at the beginning of the 13th century to Adam Lock, one of the masons concerned with the building of the nave of the cathedral. The existence of this college was terminated in 1547 by the act for the dissolution of the chantries,[8] and it then passed into lay hands, eventually becoming a private dwelling house. In 1755 it was purchased by Charles Tudway of Wells, who demolished it; on the same site a Bristol builder, Thomas Paty, erected for Tudway at a cost of more than 4871*l*. a large mansion, known now and for many years past as 'The Cedars', from the plantation of cedar trees on ground opposite the house. This mansion remained in the possession of the Tudway family until 1926, when it was leased to, and subsequently bought by the Wells chapter for the use of the Wells Cathedral School, the modern successor of the grammar school which had been held in a house on the same site in the 14th century.

This early school house was the middle house of a row of three, of which the western one became a canonical house. It stood on the west side of 'The Cedars' and judging by the frequency with which it changed hands, seems never to have been regarded as a desirable residence, probably because it was not maintained in a sufficient state of repair. It was pulled down in 1863, and no trace of it now remains.

One of the essential qualifications for admission as a residentiary canon was possession of an official house in which to live and dispense hospitality. At Wells such houses were of two kinds: those belonging to, and in the gift of the bishop of the diocese, and those belonging to and in the donation of the chapter. The former were usually given to officials such as

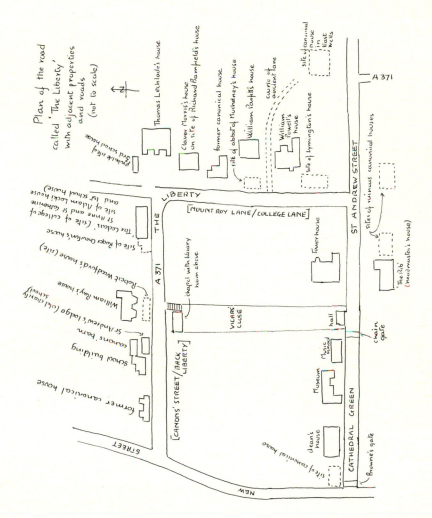

Plan of the road
called 'The Liberty'
with adjacent properties
and roads
(not to scale)

Fig. 1

E

archdeacons, or to canons whom the bishop wished to have at his side, or on whom he desired to confer a favour by rendering them eligible for election to residence by the chapter. The houses belonging to the chapter were collated upon canons[9] who were approved as 'fit and proper'[10] persons for election as members of that society.

Canonical houses were normally granted for life or, in earlier times, for so long as the canon in question desired to keep residence. There are, however, instances in the 16th and 17th centuries of grants by the chapter for a term of years (usually forty), or for lives. His canonical house formed part of a residentiary's benefice; it was sometimes termed a prebend.[11] He might not alienate it, but custom sanctioned its being leased. So we find grants of canonical houses to other canons, either residentiary or non-residentiary, and even to lay persons, made by residentiaries and sometimes by the chapter or by the bishop, in the case of houses which were redundant for the time being. It was also traditional for residentiaries, in order of seniority by election, to have the right to move into a vacant capitular house.

The tenant of a canonical house was required to maintain it in good repair at his own expense, although in medieval times there are records of the cost of repairs being met occasionally by the chapter. Every year, on St Jerome's day (30 September) when the officers of the chapter for the ensuing year were appointed, two overseers of houses were elected to inspect the chapter's canonical houses and to assess the cost of any necessary repairs, which the tenants were obliged to carry out before the next Michaelmas. There is no evidence of any similar arrangement in the case of the bishop's houses. There is no record of action being taken against defaulters, and the condition into which some houses were allowed to fall suggests that there was some negligence or laxity on the part of either overseers or tenants. The tradition of life tenure and of moving to vacant houses, and the responsibility of tenants for repairs undoubtedly explain why so many of the canonical houses belonging to the Wells chapter fell into a dilapidated condition.

For the capitular canonical houses the tenants paid what amounted to nominal rents. These rents have a certain interest in that they remind us of the circumstances in which the chapter acquired its houses. In the 13th and 14th centuries a cleric or layman, having obtained a house or land on which a house had been built, would grant such property to the chapter and St Andrew, stipulating that it should never be alienated, but always collated upon a residentiary canon, who in some cases would pay annually a certain sum of money to help provide for the celebration of the benefactor's obit. Although the observance of obits was discontinued at the time of the Reformation, the escheator continued to collect these obituary rents, which formed part of the capitular revenue.

The history of the vanished house situated on the west side of 'The Cedars', to which reference has already been made, well illustrates what has been said about the chapter's canonical houses. After some rather complicated transactions, provision was eventually made that the house should always be held for life by a canon, who was to pay to the communar an annual rent of 10s. which would be divided among the canons and vicars choral present at the obit of Roger Chewton, who had obtained the house in 1236. More than three centuries later it was collated upon a residentiary, Thomas Jury, who for several years paid the prescribed obituary rent of 10s. He then went to live in one of the bishop's canonical houses (Tower house), of which the holder had been granted a royal licence dispensing him from the obligation of residence in order to study abroad; Archdeacon Archer, writing at the beginning of the 17th century, surmises that Jury changed houses because that collated upon him 'was now much out of repair'.[12] It did not remain unoccupied, however, for Jury leased it to a layman, Thomas Matthew. In 1574 it was again granted to a layman, this time by the chapter, Jury having died, and other lay tenants followed, not without protest from one member of the residentiary chapter. In 1749, after a hundred years of lay tenancy, it

became again a canon's house. In the following sixty-eight years seven residentiaries held the house; one effected some alterations and pulled down part of it, but most of the tenants seem to have been dissatisfied with the house, and availed themselves of vacancies elsewhere to move to more acceptable premises. Ultimately a lease of the house was taken by the owner at the time of 'The Cedars', and shortly afterwards it was demolished.

Here we see the persistence of an unrealistic obituary rent; a canon exercising the customary right to grant a lease of his canonical house, while he takes up residence in another; the chapter alienating a house from its proper purpose by making grants to lay persons; and finally, a succession of canons as tenants who seem to have had little interest in their house and its maintenance, its deterioration in their hands, and its eventual loss to the chapter.

West of this canonical house is another, built by William Ray. It stands well back from the road, having been erected behind an older house which fronted on to the street. Little is known of the history of this earlier house, beyond the names of a few tenants, but probably about 1670 it was collated upon Treasurer Richard Busby, a notable headmaster of Westminster school. Dr Busby received from the chapter a grant of 30*l.* to enable him to make good the damage which the house had sustained during the Civil War. Other residentiaries were given much larger sums, which suggests that Busby's house was in reasonably good repair. In 1733 the house was collated upon its last tenant, Treasurer Robert Woodford, who held it for thirty years, apparently without doing any repairs. At his death the building was found to be in poor condition. William Ray, to whom it had been granted, drew up a schedule of dilapidations which was confirmed by 'certain honest and expert workmen', showing that the house was unsafe, and needed rebuilding. Mr Ray, therefore, instituted a suit in the Court of Arches against Woodford's executors, who seem to have been reluctant to contribute to the cost of repairs. The suit alleged that the ruinous and decayed condition of the house was due to Woodford's delay and neglect, although the profits of his residentiary canonry were sufficient to enable him to maintain the building in good repair. The total estimated cost of necessary repairs amounted to over 313*l.*, and although it is not known whether Ray succeeded in his suit, the old house was judged to be beyond repair, and the stone from it was doubtless used in the construction of the new house behind it.

Both Woodford's and Ray's houses were described at various times as situated on the east of the canons' barn. This was a medieval building, said to have been 'an exceeding early example of Early English'.[13] To the original structure comparatively modern additions had been made. This ancient barn was incorporated into the new building of Wells Cathedral School, which was opened in 1884. Originally it was a tithe barn of the dean and chapter, but it also served as a hall where the courts baron of the manor of Canon Grange were held. Later it was held by the lessees of the rectory of St Cuthbert's in Wells.

The land between the canons' barn and the road was granted by the chapter about 1720 for a substantial fine to a philanthropic citizen of Wells, Philip Hodges, who built thereon a house, now known as St Andrew's lodge, to serve as a charity school (this was the original of the Wells Blue school). St Andrew's lodge was used recently as a canonical house.

On the west of the charity school building and of the canons' barn, lies another canonical house, the present structure of which dates mainly from about 1700, but incorporates some 15th-century portions. We know nothing of its earlier history, save the names of its tenants. It was always occupied by residentiaries until recently, when it served as the residence of the cathedral organist; like other capitular properties in The Liberty, it is now leased to the Cathedral School.

At 'The Cedars' The Liberty turns sharply south, and as we have mentioned, this eastern portion was known formerly as Mountroy Lane. It was so called because it led up to an area of high ground on the north side of the cathedral, known locally as the Mountroy. On the

eastern part of this high ground were situated the holdings of certain prominent lay landlords, such as Walter Downhead and the Cardevill family. These holdings, and the houses built upon them, passed by the stages described above in the course of time into the hands of the chapter, yielding to the escheator regular revenues in the form of obituary rents. One such property, standing opposite the east end of 'The Cedars', and well back from the road with a spacious court in front was known, from an early occupant, the vicar choral Thomas Lechlade, as 'Lechlade's [later corrupted into 'Lichfield's'] house'. At one time it served as a residence for the dean, when Dean Goodman was deprived of a dwelling owing to the alienation of the deanery under Protector Somerset. In general it was used as a canonical house, though on occasion the chapter granted it to lay tenants.

On the south of Lechlade's house lay another canonical house, which had originally belonged to Richard Bamfield. The two houses were joined at the turn of the 17th century. This was another house which came into lay hands; at the end of the 17th century the lease was acquired by a Wells physician, Claver Morris. On the site he proceeded to build a new house; it was completed in three years at a cost of 807*l*. 14*s*. 6¾*d*., and has been described as 'a telling example of domestic architecture in Somerset'.[14] This fine house was never used as a canonical house, though in 1829 the chapter resolved, in view of its suitability for this purpose, not to grant any further lease of it to lay persons. Ten years later, because it seemed then unlikely that the house would be needed for a residentiary, the chapter rescinded its former act, and further grants were made to laymen and one to a non-residentiary canon. Several of the lay tenants who followed Dr Morris were family connections of his. Eventually this house also came into the possession of the Cathedral School.

The next house of interest south of Claver Morris's house is large and stands back from the road. It is designated in a conveyance of 1821, 'the house formerly belonging to the abbot of Muchelney'.[15] This description, though incorrect, shows how persistent tradition can be. The house in question was newly built about 1820 by the chapter clerk, William Parfitt, who, like William Ray some seventy years earlier, erected his new house behind a much older one. The older house, in Parfitt's case, was the one known as the lodging of the abbot of Muchelney, which the map of the manor of Canon Grange shows as fronting on to the road.

By virtue of a donation made in 1201 the prebend of Ilminster was annexed to the abbacy of Muchelney, and the abbots became *ex officio* canons of Wells cathedral. Personal reasons apart, it is not clear why they had, or wanted, a lodging in Wells, for they were not bound to reside, and their commitment to the monastic establishment over which they presided would preclude their seeking admission as residentiaries. However, it seems that the abbots secured from the chapter a grant of land on which they built the house. It soon became dilapidated, for it was repaired in 1447 at the charges of the chapter, not of the abbot. In 1469 the house was described as formerly ruinous and virtually destroyed; it was then restored by Treasurer Hugh Sugar at his own charges. He then arranged a grant by the abbot to the chapter 'for the use and profit of the vicars choral', and to make provision towards his obit. By this arrangement the house became virtually the property of the college of vicars choral, who sub-let it. So the situation stood, until some centuries later the house was acquired by Mr Parfitt, who built his new dwelling at the rear.

On the south of the abbot's house lay a large piece of ground belonging to the chapter, part of which was known in the 14th century as 'La Purihey'—probably a pear orchard. In the centuries which followed there were various buildings on this site. The one that principally concerns us was a canonical house known as 'Lymington's house', from one of the early tenants, the vicar choral, Hugh Lymington. This house also fronted on to Mountroy Lane, and ultimately passed into lay hands. At the beginning of the 17th century the house and the land pertaining to it were granted to Edward Powell, son of William Powell,

archdeacon of Bath, apparently to facilitate his father's design of building a new house to the north-east of Lymington's house. In its construction, stone was used, taken by permission of the chapter from the ruins of Stillington's chapel, on the east side of the east cloister. William Powell's new house was finished by 1610, and having been restored in 1970, serves as the dean's lodging.

Between the houses of the abbot of Muchelney and Hugh Lymington there ran at one time a lane which gave access from Mountroy Lane to a canonical house in East Wells, which has now disappeared. This house was one of those in the gift of the bishop. Other similar houses lay nearer the cathedral. One stands on the north side of St Andrew Street; it is distinguished by a tower which rises at the northern end of the building, hence the name 'Tower house' by which it is known locally. It is sometimes designated the 'house of the master of the fabric',[16] legend asserting that the purpose of the tower was to facilitate the supervision of the workmen engaged in the building of the cathedral. This belief is quite unfounded; in fact the house was the official residence of the precentor. The master of the fabric in medieval times was generally a vicar choral; moreover, his duties did not include oversight of workmen.

On the opposite side of the street stood three more houses in the patronage of the bishop. Nearest the cathedral is a 15th-century canonical house,[17] now occupied by the headmaster of the Cathedral School. East of this house lay two others, of which nothing now remains; they were ruinous in the 18th century, and their dilapidation is attributed to neglect and depredation during the Civil War and the Interregnum. As late as the beginning of the 19th century these ruinous houses were often collated upon canons by the bishop as a qualification for election to residence.

On the west of Tower house is the Vicars' Close (or Close Hall, to give it its traditional name). In his description of the Close, which is no longer literally a close, being open at both its north and south ends, Pevsner endorses a general misunderstanding by referring to it as a street.[18] It is nothing of the kind, of course, but an elongated college quadrangle. We have here a 14th-century college — the College of the Vicars Choral, with its chapel, and library room above, at the north end, and its hall at the south end, over the entrance gate, and on the east and west sides of the quadrangle the chambers of the fellows of the college. Some chambers were later united to form houses.

On the west of Vicars' Close stands a reconstruction of a 13th-century house, which now serves as the Music School of the Cathedral School. It is often referred to as the 'Archdeacon's house',[19] but there is no evidence that it was the official residence of the archdeacon of Wells. The last such dignitary to hold it was Polydore Vergil in the first part of the 15th century, while William Peirs, archdeacon of Taunton, lived in part of it at the end of the 17th century. Although Nicholas of Wells, who originally gave this house to the Church in the 13th century intended that it should always be assigned to one of the canons, bishops often leased it to laymen. About 1800 it was being used as assembly rooms, and thereafter as a brewery. At the end of the 19th century it was acquired by Wells Theological College, and converted into a library and lecture rooms. In the course of conversion for the purposes of the college, the south elevation, which resembled that of the dean's house, was completely altered.

On the west of the house last described is the Wells Museum. This is often called the 'chancellor's house', though it was never the official residence of the chancellor either of the cathedral or of the diocese. The present building is said to be originally Tudor,[20] but there is evidence of a canonical house in the gift of the bishop on the site in the middle of the 15th century. The designation 'Chancellor's house' may have arisen from the fact that in the 15th century the original house was occupied by a succession of cathedral chancellors, while in

the 16th century it was held by Chancellor Roger Edgeworth. Like other canonical houses, this one passed into lay hands, and in the 19th century was used by the Cathedral School it was then obtained by the trustees of the Museum.

Next to the Museum on the west is the deanery, or dean's house as it was customarily named. The original house was rebuilt, modified, and enlarged by Dean Gunthorpe (1472–98), and altered and repaired with material taken from the bishop's palace by Dr Cornelius Burges in the time of the Commonwealth. For a while during the 16th century it had been used as an episcopal residence when Protector Somerset had appropriated the bishop's palace. It was one of the houses for which the chapter was responsible, and except at the Reformation and during the Commonwealth, never alienated until recently when, being found inconvenient as a dwelling and excessively costly to maintain, the chapter sold it to the diocese for use as administrative offices.

Moving towards Browne's gate, a 15th-century tower-gate built by Bishop Bekynton, which preserves the name of Richard Browne, a shoemaker who dwelt in an adjoining house, we pass the site of another canonical house in the gift of the bishop of the diocese, which has totally disappeared. To this house Dean Goodman moved from Lechlade's house, because he could not get possession of the dean's house.

One canonical house in the patronage of the bishop remains to be dealt with. It stood where the town hall stands and no trace of it remains. The original house was appropriated by Bishop Bourne in the reign of Queen Mary. He purposed to establish therein a school for the education of boys in preparation for ordination to the priesthood of the church of Rome, but though some of the scholars received minor orders, Bourne's design was frustrated by Mary's death and his own deprivation in the religious changes which followed, and the house became again a canonical residence. After the Restoration it became the centre of some controversy. Its tenant before the Civil War was William Peirs, whom we have already met in connection with the so-called 'Archdeacon's house'. During the troubles, Dr Cornelius Burges, the distinguished Presbyterian divine, who became minister of the cathedral church on the abolition of the dean and chapter, purchased this house along with other capitular and episcopal properties. Burges then sold it, and it was converted into a court for the holding of the quarter sessions. When Peirs recovered it at the Restoration he repaired it and at a cost of some 700*l*. 'converted it again into an habitable house'. Judge, then, of his feelings when 'since the kinges restauracion . . . a greate market house [was] built before the dore of this canonicall house, which hath drawne the market from other partes to the very dores of this house, to the great annoyance of the said house'.[21] On account of this inconvenience Dr Peirs went to live in Tower house, of which he took a lease from Dr Sebastian Smith, the persistently non-resident precentor. Meanwhile he let the house in the market place. In the opinion of Bishop Creyghton, between whom and Peirs relations seem to have been somewhat strained, Peirs's abandonment of his canonical house called into question his capacity for keeping residence. Creyghton, therefore, summoned him to the palace and, in the presence of two of his fellow residentiaries, censured him and suspended him from his ecclesiastical functions, for violating the fundamental statutes of the cathedral. Dr Peirs declared his intention to appeal to the Court of Arches, and stated a case for legal opinion. The question was never resolved, and Creyghton died soon after. Peirs seems to have resumed his archidiaconal and capitular responsibilities and duties without hindrance. As tenant of the canonical house in the market place, he was followed by Edwin Sandys, archdeacon of Wells, who, with the consent of Bishop Mews, pulled down the house and built on new foundations another, fit for a canon residentiary. Eventually Sandys' house was sold to the Mayor and Corporation of Wells for a consideration of 700*l*., and on the site the present town hall was built.

In 1286 King Edward I granted permission to Bishop Robert Burnell to surround the churchyard and the precinct of the canons' houses with a crenellated stone wall.[22] The course of this wall is nowhere defined, and the area which it enclosed was certainly not coterminous with the 'extra parochial township' of the Liberty, but much smaller. It is possible that the area enclosed by the wall was designated 'the Liberty', but there is no medieval evidence for this; nor is the significance of the term set forth in any document. From time to time various explanations have been advanced. J. H. Parker suggested that 'Liberty' referred to the privilege of being allowed to keep residence in a house situated outside the crenellated wall,[23] but this seems improbable. It is more likely that it relates to exemption from liability for secular dues, and from certain kinds of secular jurisdiction. Such exemption does not obtain, of course, today, and in recent time inhabitants of the Liberty were liable to charges for the maintenance of highways and bridges, and also for a poor rate, one of the houses belonging to the manor of Canon Grange and situated in St Andrew Street being used as a poor house. Offences under the ecclesiastical law, such as adultery and fornication, and infringements of the statute law relating to attendance at worship and reception of the Holy Communion, if they concerned persons dwelling within the bounds of the Liberty, were triable by the chapter, sitting as a court of law in the chapter house. In fact, the Liberty became virtually the 'parish' of the cathedral. According to a well established tradition, residence in the Liberty is now regarded as a qualification for baptism and marriage in the cathedral. Despite the jurisdiction exercised by the chapter within the Liberty, this area contained properties other than those belonging to the chapter's manor of Canon Grange; it also included the bishop's palace, and properties which belonged to the bishop's manor, to the college of Vicars Choral, and to the Mayor and Corporation, and to others. Thus it was an area defined by jurisdiction, and not by tenure of property.

REFERENCES

1. J. Collinson, *History of Somersetshire*, III (Bath 1791), 405.
2. The word occurs in a variety of spellings: Monterie, Montre, Muntorie, Mountery, Mountry, etc.
3. Somerset Record Office, DD/CC 10878.
4. In various deeds of collation to canonical houses, St Andrew Street is also designated 'Back Liberty'; in Simes's map this name is also given to the western arm of The Liberty.
5. *Calendar*, II (1914), 452; cf. charter 849, ibid., 716.
6. Winchester Coll. MS 19402 (1307); *Calendar*, I (1907), 249 (1341), 276 (1375–76).
7. See R. V. Sellars, 'The Chantry College in the Mountry of Wells', in *Report of Wells Natural History and Archaeological Society*, 50–51 (1959–60), 5–17.
8. 1 Edwd VI c. 14.
9. 'Canon' is used here and throughout in its strict sense as denoting a member of the capitular body, and not in the dubious modern sense as denoting only a residentiary.
10. *Idoneus et habilis* in the Charter granted by Queen Elizabeth I to the dean and chapter of Wells in 1591.
11. See e.g., Somerset Record Office, DD/WM, box 3, 1/204.
12. Wells Cathedral Library, E. Archer, *Long Book*, f. 50.
13. See *Report of Wells Natural History and Archaeological Society*, 1873, 42.
14. B/E, *North Somerset & Bristol*, 327.
15. Wells Cathedral Library, Chapter Act Book 1817–1832, 197.
16. Cf. J. H. Parker, *The Architectural Antiquities of Wells* (Oxford and London 1866), 25 and pl. XXIII.
17. Ibid., 22 and pl. XXI, designates this the house of the choirmaster or precentor, why, it is not clear, unless it had been confused with Tower House.
18. B/E, *North Somerset and Bristol*, 319.
19. Ibid., J. H. Parker op.cit., 20.
20. B/E, *North Somerset and Bristol*, 319.
21. Wells Cathedral Library, Documents Series III, box 4, 230.
22. *Calendar*, I, 532.
23. J. H. Parker, op.cit., 25.

Three Irish Buildings with West Country Origins

By ROGER STALLEY

INTRODUCTION

In 1882 George Edmund Street, writing in the sumptuous volume published to celebrate his restoration of Christ Church Cathedral in Dublin, commented that 'the architecture of Glastonbury and Wells had an extraordinary influence not only in the south of England and in Wales, but equally throughout the Irish pale and even beyond its circuit'.[1] As far as Ireland is concerned, Street exaggerated the specific influence of Wells and Glastonbury, but in general terms the close relationship between Irish Gothic and the West Country is not in doubt. These links reflect the pattern of settlement in Ireland following the Anglo-Norman invasion of 1169–70. By the early years of the 13th century vast numbers of Anglo-Normans had migrated to Ireland and a substantial proportion of them came from towns and villages in the Severn valley.[2] It is in this area, the Severn valley and its hinterland, that the chief sources of early Gothic in Ireland are to be found.

THE START OF ENGLISH INFLUENCE: CORMAC'S CHAPEL AT CASHEL

Long before the invasion of 1169–70, English ideas had been infiltrating Ireland, and the first Irish building to deserve the title Romanesque is thoroughly impregnated with English architectural forms and sculptural motifs. This is Cormac's Chapel at Cashel, begun in 1127 and consecrated in 1134 (Pl. XIV).[3] The chapel was probably designed for a small Benedictine community, dependent on the Schottenkirche at Regensburg,[4] a link which may explain the Germanic appearance of the square towers, flanking the chancel arch. The small scale of the building and the high pitched roof of stone were inherited from traditional Irish practice.[5] Indeed the steeply angled roof may be derived from the wooden churches for which Ireland had been famed since the days of Bede.[6] In all other respects the chapel was revolutionary in an Irish context. The external wall arcades, the corbel table, the string courses of billet, the scalloped capitals, the extensive use of chevron and the whole system of arches in several orders, were all imported from England. For many of these features specific parallels can be found in the West Country. The superimposed rows of engaged shafts, which so attractively articulate the façades of the chapel, recall the arrangement on the chancel walls at Milborne Port. The tympana of the north and south doorways, carved with animals in low relief, also have counterparts in Somerset and Dorset, as at Lullington and Stoke-sub-Hamden. The south doorway at Milborne Port provides a further parallel, though there the two affronted lions are carved with more precision and skill than the rather clumsy animals at Cashel.[7] The various forms of chevron, used extensively in the decoration of the chapel, can also be traced to the West Country without difficulty (Pl. XIV).[8] Almost all the ornament of Cormac's Chapel, therefore, has a familiar English look, and it would be easy to imagine that one was looking at a church in the shadow of the Mendips or close to the waters of the Severn. In the gable of the north porch there is a detail that could almost be the signature of a West Country master mason, the presence of large floral bosses filling empty patches of wall. Such bosses were used in the lavish reconstruction of the choir of Sarum Cathedral, carried out by Bishop Roger between 1125 and 1139, and a fine frilly rosette from the gable of a roof or porch can be found among the surviving fragments of the

cathedral.[9] Henceforth they became a leitmotif of the West Country school, as defined by Brakspear.[10] Those at Sarum and Cashel are ancestors of the elaborate foliage bosses later used to decorate the gable of the north porch at Wells.

The ornate interior of Cormac's Chapel also reveals a clear English ancestry. The wall surfaces are broken up with blind arcades, both jambs and arches being furnished with chevron or geometrical ornament. In the small square chancel the upper arcades are formed with continuous mouldings, devoid of capitals, a technique which became widespread in the West Country towards the end of the 12th century, though rare around 1130.[11] The chancel is covered by a simple ribbed vault, with roll moulded soffits clearly indicating an English origin. In contrast, the vault of the nave is not so obviously English. It consists of a barrel vault, with a series of transverse arches, tightly spaced (Pl. XIVc). These arches are not moulded and they rest on short half columns, engaged to the wall. There are few prototypes for this method of construction in England. Francoise Henry has pointed out a parallel in France,[12] and barrel vaults with regular transverse arches are certainly very typical of French Romanesque. But there is one church in Wales which has a vault remarkably similar to that employed at Cormac's Chapel. This is the priory church at Ewenny (Pl. XVA). Here the western bays of the chancel are barrel vaulted, and, as at Cashel, there are a series of transverse arches, which rest on short pilasters engaged to the wall. It is true that half columns had been used in this position at Cashel, but otherwise the arrangement is analogous. Even more remarkable is the treatment of the final eastern bay at Ewenny, where a ribbed vault is substituted for the barrel. While this allowed slightly higher windows in the side walls, it is hard to avoid the impression that the ribs were meant to serve as a cross shaped baldacchino immediately over the altar. It will be recalled that a similar change took place at Cashel, with a small ribbed vault being used in the chancel in preference to the barrel vault of the nave. Ewenny is situated near Bridgend, not far from the shore of the Bristol Channel, so once again the evidence suggests that the sources of Cormac's Chapel lie in the West Country. The date of the chancel at Ewenny is not known with certainty, though it is usually dated after 1141 when the church was made into a priory.[13] If so, it cannot be the direct source for Cashel. Many of the details at Ewenny, capitals, bases, string courses of chevron, are so similar to Cormac's Chapel that it is hard to believe many years separate the construction of the two churches.

There is one ingredient in the decorative repertoire of Cormac's Chapel that is undeniably French in origin. This is the line of heads in full relief which frame the chancel arch (Pl. XVB). The heads are placed parallel to the curve of the arch, except near the top, where their arrangement suddenly becomes radial. Francoise Henry has pointed out the striking parallel with the sculpture of Bellegarde-du-Loiret (Loiret), east of Orléans, where, as at Cashel, the heads are placed in a hollow groove.[14] Arches carved with human and animal heads are so much a feature of western France that it is hard to deny that this is the ultimate source, but there is at least one church in England which employed the same technique. This is at Prestbury (Lancashire).[15] Unfortunately, the Romanesque doorway here has been rebuilt and the sculpture is badly weathered. Small heads in *ronde bosse* appear on the hood moulding, and originally there was the same change from parallel to radial placings, though the arrangement was muddled when the doorway was reconstructed. Although Prestbury is not far from the west coast of England, it scarcely seems a likely source for the sculpture at Cashel. The heads at Prestbury may have been derived direct from France, but it is equally possible that the same technique was used on other English doorways, long since destroyed.

There is one other sculptural detail in Cormac's Chapel where the same problem occurs, namely a western French device which also has parallels in England. This is the capital with a monster head in the act of swallowing the shaft on which it rests, to be found in the north-

east corner of the nave. This 'column swallower' has a pronounced twist to its upper jaws which relates it to a whole series of such capitals in western France, as at Civray, Echillais and Fenioux. They are also widely distributed in the south of England, and a close parallel for the Cashel monster occurs in the porch at Elkstone (Gloucestershire). This has been dated to the 1160s[16] and so, as with Ewenny, a potential source for Cashel turns out to be later in date. In the case of the column swallower, however, there is evidence that it was used in the decoration of Old Sarum Cathedral, which might have provided the inspiration for both Cashel and Elkstone.[17]

Whatever the exact source for both the column swallower and the arch with human heads, both are fundamentally western French ideas. Like English sculptors in the second quarter of the 12th century, it seems that masons in Ireland were coming under the influence of western France, either directly or indirectly. Later in the century, French ideas were even more marked in the decoration of churches in the south-west of Ireland, and they are clearly evident at Clonmacnois, Clonfert and Dysert O Dea.[18]

This discussion of some of the motifs and ideas used in the building of Cormac's Chapel serves as a prelude to the question of who actually built it. The chapel contains such a medley of ideas that it is not easy to determine the origin of the master mason in charge. The roof of stone, with its distinctive corbelling technique, has a long Irish ancestry, though never before had the technique been executed with such fine quality ashlar (Pl. XIVA). Was the roof designed by an Irish mason, or an English mason who had been asked to copy local methods? The decoration of the chapel is so predominantly English, that it seems certain that English-trained masons were involved in its construction. Stylistic analysis of the various capitals and corbels, many of them carved with considerable sophistication, may one day indicate the exact home of the sculptors responsible. French elements in the design are probably best explained by the use of pattern books and the transfer of motifs from workshop to workshop, rather than presupposing a visit to France by one of the masons. The links with France do not seem extensive or specific enough for that. This leaves the problem of the two square towers beside the chancel arch. Hitherto the Irish had been normally satisfied with round towers completely detached from the church, and the square towers at Cashel, neatly integrated into the architectural form of the building, were without precedent.[19] While the possibility of English intermediaries cannot be ignored,[20] Germany remains by far the most likely source of the scheme. Two such towers had been erected beside the chancel of St James at Regensburg, and it seems perfectly possible that the Benedictine monks, arriving at Cashel, requested a similar arrangement in their new church.

Despite its German and French connections, Cormac's Chapel remains overwhelmingly English in style and ought to be considered an integral part of Romanesque art in the West Country. Although started over forty years before the Anglo-Norman invasion, this contact between England and Ireland is not difficult to explain. During the course of the 12th century, a vigorous reform movement took place within the Irish Church, and several of its leaders looked to England for aid and guidance.[21] King Cormac MacCarthy, founder of the chapel at Cashel, was a supporter and patron of the movement. One of his bishops, Malchus, bishop of Waterford and Lismore, had been trained as a monk at Winchester, and Malachy, archbishop of Armagh, the most successful of all the reforming prelates, made at least two journeys down the length of England from the Scottish border.[22] Coming from a land where monumental architecture was unknown and where most churches were no more than single chambered oratories, such men must have been enormously impressed with the scale and complexity of Norman building. The surprising fact is not that there was English influence in Ireland, but rather that it made no impact on Irish architecture before 1127. The ecclesiastical contacts with England began at the end of the 11th century, and it was in 1096 that

Malchus came to Ireland from Winchester.[23] Equally surprising is the fact that English influence on Irish architecture was limited chiefly to decorative ideas. The internal length of Cormac's Chapel is a mere 14.31 m, and it has no aisles or transepts. Apart from the churches erected by the Cistercians, few Irish Romanesque churches were complex pieces of architecture.[24] Indeed there seems to have been an Irish prejudice against large scale buildings as if they seemed extravagant. When Malachy of Armagh began to lay foundations at Bangor for a church 'like those which he had seen in other regions', he met with a vigorous local protest, one of his opponents exclaiming 'We are Irish not Gauls'.[25] While innate conservatism might explain this hostility, lack of resources and the undeveloped economic structure of the country were other factors which deterred architectural enterprise.

It would be wrong to suppose that Cormac's Chapel is a typical example of Irish Romanesque. It is an exceptional building, with English ideas almost unadulterated by local characteristics. There is only one other church built before 1169 which displays such marked West Country features in a pure form. About forty miles north of Cashel are the remains of the ancient monastery of St Cronan at Roscrea.[26] Only the west gable survives from the former monastic church, but this is sufficient to show that about 1140–50 the monks had quite pretentious architectural ideas. The main doorway, decorated with two orders of chevron, is surmounted by a steep gable. Within the gable are the weathered remains of what was once no doubt a large figure of Christ. Flanking the sculpture are two West Country rosettes. The whole composition mirrors the arrangement used on the north doorway at Lullington, a fine Romanesque village church near Frome in Somerset. The Lullington doorway is known to have been constructed by Sarum masons, and it is possible that Sarum Cathedral itself was the origin of the design.[27] As with Cashel, the question arises whether English or Irish masons were employed. There are several hints of Irish workmanship; the jambs of the doorway lean inwards and some of the engaged shafts are cut in a very shallow, and typically Irish fashion. Perhaps this is a case of an Irish mason who had travelled abroad.

The English features of Roscrea and Cashel were gradually absorbed by local builders and mixed with traditionally Irish motifs, Viking designs and further western French ideas, to form an eclectic but nonetheless distinctive Irish style. By the end of the 12th century, when the magnificent gabled doorway was added to Clonfert Cathedral, English forms had become almost totally submerged.[28] The tangent gable, now acutely pointed, and the chevron design can ultimately be traced back to England, but far more conspicuous are the numerous traditional motifs, including a jungle of interlace and large bosses, the latter copied from high crosses of the eighth or ninth century. Clonfert is one of many Irish churches with Romanesque sculpture carved long after the first Anglo-Norman incursions. Delightful examples of Hiberno-Romanesque are to be found at Tuam (after 1184),[29] Killaloe (c.1200)[30] and Ballintober Abbey (1216–24),[31] which demonstrates that the English invasion did not lead to the instant demise of Irish carving, as some historians have assumed. There was a substantial period of coexistence between native and newly imported English styles, lasting as long as fifty or sixty years.[32] In this there is an analogy with the Norman invasion of England in 1066 and the Saxo-Norman overlap, though it is a parallel which cannot be pushed too far. The invasion of Ireland in 1169–70 was quite different in its organisation from that of 1066. It was not a systematic campaign led by the king, but rather a series of separate attacks led by individual feudal entrepreneurs. It was also much slower in its progress. Not until 1235 did heavy English settlement begin in Connacht and extensive parts of the west of Ireland were never conquered at all. While intensive English settlement was taking place in Leinster and along the east coast, it is no surprise to learn that, west of the Shannon, Irish sculptors were carrying on much as before.

THE ENGLISH CONQUEST AND ITS EFFECTS:

1. *Waterford Cathedral*

However long Hiberno-Romanesque lingered in the west, it was inevitable that the Anglo-Norman settlement would eventually change the whole character of Irish architecture. Before 1169 the occasional English mason may have found his way to Ireland, but by the early years of the 13th century dozens of English trained craftsmen were settling in the country. Before the invasion English ideas were absorbed into a native style; afterwards, English styles were imported wholesale. As in England after 1066, the new rulers of Ireland tried to install their own bishops wherever possible, though it was a slow and intermittent process. By about 1230 ten of the thirty-four Irish sees were held by Anglo-Normans, and in at least six of these the appointment of an Anglo-Norman led to the rebuilding of the cathedral.[33] The best known is the eastern limb of Christ Church Cathedral in Dublin, constructed soon after the appointment of John Comyn as archbishop in 1181, but an equally interesting example of the same process was the remodelling of Waterford Cathedral.

Unfortunately the medieval fabric of Waterford Cathedral was destroyed two hundred years ago. In 1773 it was claimed that the old building was 'unsafe for the purposes of public worship' and so it was demolished at a cost of £150.[34] This was a tragedy, since the cathedral was one of the three most sophisticated Gothic churches in Ireland. Plenty of information about the old cathedral survives, and a brief account of it was published in the Clapham memorial volume of the *Archaeological Journal*.[35] This description, written up from notes after Clapham's death, is incomplete and in some places misleading.

There is a short account of the cathedral made before its demolition by Charles Smith in 1746,[36] and Ware's discussion of the bishops of Waterford, published in 1739, is accompanied by a valuable plan of the building (Fig. 1), as well as two exterior views.[37] Six further drawings of the cathedral are preserved in the National Library of Ireland,[38] evidently unknown to Clapham (Fig. 2 and Pls XVIA, B). There are also two 18th-century oil paintings, one of which provides the only known illustration of the interior (Pl. XVII).[39] Finally, there are a few stone relics from the building: two foliage capitals, a 16th-century window head, a number of 13th-century moulded stones and the foundation of one of the main piers, which can be examined by squeezing through a grating in the floor of the present cathedral. Although a plan of this pier was published in the Clapham memorial volume, it was inaccurate in its details.

The earliest parts of the building were the four western bays, constructed sometime in the second half of the 12th century. Substantial square piers supported an arcade of round arches, with round headed windows in the clerestory above. There was no triforium. The next four bays represented either a remodelling or an extension of the early 13th-century and formed the choir. This terminated in a straight wall, though the aisles continued to the east into the third section of the cathedral. This was an aisled chapel of four bays which served as the church of the Holy Trinity. To judge from the irregular roofs and the changes in wall thicknesses shown on Ware's plan (Fig. 1), this chapel may have been, at first, a single-aisled structure projecting east from the rectangular ambulatory. Such a scheme invites comparison with the supposed plans of the east end of Wells Cathedral and Glastonbury Abbey.[40] The solid wall between the choir and ambulatory is unusual, so much so that it was probably the result of Bishop Hugh Gore's alterations between 1660 and 1691.[41] This included a 'modern and elegant' altar which may have blocked the arch or arches at the east end of the choir. The arch in this position at St Patrick's Cathedral, Dublin, is also known to have been blocked at this time.[42]

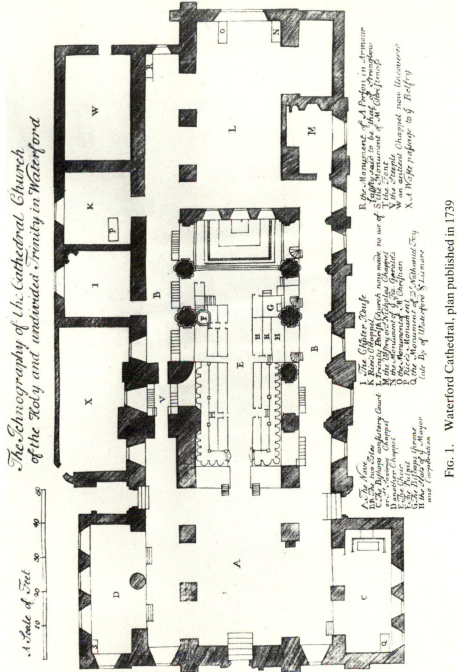

FIG. 1. Waterford Cathedral, plan published in 1739

During the later Middle Ages a series of chapels was erected along the flanks of the cathedral. The two at the south-east corner, one of them dedicated to St Nicholas, were probably the first additions, since the drawings show 13th-century style lancets (Pl. XVIA). The chapel which projected from the west end of the south aisle served as the consistory court and was probably erected in the 15th century, to judge from its curvilinear tracery. Along the north side of the cathedral were three further chapels and a small chapter house, though the eastern chapel was already derelict by 1739. All these additions probably date from the 15th century.

Our knowledge of the interior is almost solely dependent on the 18th-century painting (Pl. XVII). The picture shows the cathedral looking west from the high altar. Much of the architecture is obscured by relatively recent furnishings, which include box pews, an imposing episcopal throne and galleries placed at the west end of the chancel. The 13th-century piers were obviously complex in form, with the main shaft rising unbroken to support the vault ribs. The adjoining shafts supported a giant order, which embraced both main arcade and triforium. The soffits of the main arches were decorated with roll mouldings on their outer angles, but not in the centre, an economy which is typical of Irish Gothic.[43] A string course terminating in foliage bosses separates the arcade from the triforium. It is unclear whether the three arches of the triforium opened into a wall passage or whether they gave direct access to the aisle roofs, but the clerestory definitely had a passage. The painting shows the clerestory windows with a single rere-arch, leaving a large expanse of bare wall each side. The openings were flanked by nook shafts, one of which is shown with a ring. The original ribbed vault had either collapsed or had been dismantled, though the springers are clearly shown by the artist. The date of the original vault is confused by a piece of documentary evidence from the 16th century, for Bishop Nicholas Comin and Dean Robert Lumbard are said to have 'adorned the choir and chapel with an arched or vaulted ceiling'

FIG. 2. Waterford Cathedral, exterior from the north, drawing in the
National Library of Ireland

in 1522.[44] This may refer to the panelled ceiling shown in the painting, though it is noticeable that this extends into the nave as well. It is possible, though unlikely, that stone vaults were erected in the 16th century, but this hypothesis does not affect the question of whether the 13th-century choir was vaulted. The pier forms leave little doubt that a vault was intended and probably erected as part of the original building. In the background of the painting an abrupt change of design is apparent where the choir joins the earlier nave.

The surviving pier helps to confirm the details of the painting (Fig. 3). It is peculiarly irregular in plan, but this lack of symmetry is explained by its location. This was the pier which separated the two campaigns of building in the cathedral, and clearly the 13th-century arcades were not quite aligned to their 12th-century predecessors. The pier was not the result of casual workmanship, for it is very precisely executed. The irregular design was deliberate.[45] The remaining piers of the choir can be reconstructed by doubling the eastern half of this surviving pier. It provides for large, triple filleted shafts on the main axes, each of them separated by two smaller, single filleted shafts. The bases are waterholding, with standard 13th-century profiles. The pier is constructed of oolitic limestone, quarried at Dundry, near Bristol, a stone used extensively in 13th-century Ireland.[46]

Exterior views of the cathedral are dominated by the square tower, which rises above the north aisle at the point where the 13th-century work begins. Clapham assumed that the tower was built at the same time, but the drawings in the National Library show windows with ogee heads (Fig. 2). The tower could have been a 14th- or 15th-century addition. From the outside there was little to differentiate the two phases of building; all the clerestory windows were furnished with twin lancets. It is likely that the windows of the 12th-century nave were altered to correspond to those of the choir. The combination of twin lancets on the exterior with a single rere-arch inside might seem unusual, but it is a feature also found at Dunbrody, a Cistercian abbey a few miles away. Three of the windows in the south choir aisle are distinguished by having transverse gables above (Pl. XVIA); a curious arrangement, but one with precedents at Abbey Dore.[47] A round-headed doorway led into the south aisle of the nave. This was designed with several orders, and the supporting shafts appear to have been provided with rings. The west doorway was a relatively simple affair, though it belongs to the 13th-century remodelling rather than the original building (Pl. XVIB). It had at least three orders, the two inner ones apparently with continuous mouldings. The large traceried window above, like that in the façade of Trinity church, was a 15th-century insertion.

Almost all the characteristics of the 13th-century choir have a convincing West Country pedigree. The theme of the giant order was obviously taken from Glastonbury, where there were prototypes for the three arched triforium and the clerestory passage. The two surviving stiff leaf capitals have the same tall elegant proportions of many of the Glastonbury capitals.[48] The similarities between the buildings are striking and help to support G. E. Street's belief in the powerful influence of Glastonbury (though in fact it is unlikely that he knew about the design of Waterford). These general comparisons should not, however, obscure the many differences of detail. Waterford was a later work and consequently there was no chevron decoration. The triforium arcades were pointed and lacked the trefoil heads of Glastonbury. The string course below the triforium was finished with ornamental bosses before it reached the giant enclosing arch, and it did not turn upwards as part of a continuous order. This part of the design is more closely related to the string courses inside the north porch at Wells and the Elder Lady chapel at Bristol. The arrangement of the clerestory at Waterford, with its single arch, also has no detailed connection with Glastonbury. The master mason who produced the design of Waterford was certainly familiar with Glastonbury, but there is no proof that he was recruited from the same workshop. The details are more advanced and to judge from style, Waterford was designed at least two decades later. The main shafts on the

surviving pier, with their triple fillets, look decidedly up-to-date compared with the plain rolls and pointed bowtells of Glastonbury.[49]

Unfortunately there is no documentary evidence to prove the date of the choir. It was an unsavoury period in the history of the see of Waterford, with two bishops being excommunicated and one murdered.[50] Building is unlikely to have commenced before 1200, when the first Anglo-Norman was appointed as bishop. The dean and chapter of the cathedral are first mentioned in a letter of Innocent III in 1210, and they are said to have been endowed by King John with land worth 400 marks in order to support twelve canons and

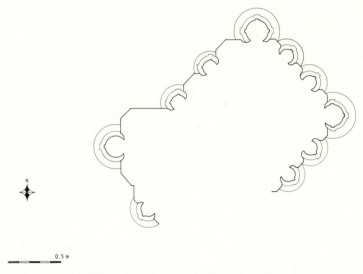

0.5 m

FIG. 3. Waterford Cathedral, plan of surviving pier

twelve vicars.[51] King John visited Ireland in 1210, the probable year in which the grant was made. From the evidence available, it appears that about 1210, or just before, Waterford acquired a normal cathedral establishment. With this increase in the number of clergy attached to the cathedral, more room would have been required in the choir, which explains the decision to construct a new east end. A starting date of c.1210 thus fits both the documentary and the stylistic evidence.

Although advanced in matters of detail, the elevation of Waterford choir looks archaic for the early 13th century. The basic idea was borrowed from Glastonbury without any obvious attempt to modify or improve it, and the design cannot claim to be much more than an uninspired derivative. Admittedly there was a lacuna in West Country architecture at this time, between the first Gothic buildings of the 1180s and the mature Early English works of around 1220, at Salisbury, Worcester and Pershore. The architecture of Waterford was certainly not original enough to fill the gap. Unfortunately, similar comments could be made about most Early Gothic architecture in Ireland. Few churches emulated the scale and sophistication of major English cathedrals and only three were elaborate enough to include a triforium and an ambulatory in their designs. Major ribbed vaults were equally rare. Irish Gothic was thus a simplified version of West Country Gothic, reproducing details rather than major architectural forms. Kilkenny Cathedral, for example, was a large church, as befitted one of the major towns of Anglo-Norman Ireland, but its plan did not include an

ambulatory, its elevation was devoid of a triforium and no attempt was made to vault its spacious choir and nave. Yet the design was inspired from England and the west doorway, of about 1280, is an updated version of its counterpart at Wells, complete with west country foliage bosses.[52]

The most obvious explanation for the simplicity of Irish building is that resources were too limited to allow grandiose architecture. But this is not the whole answer. A major problem was that the diocesan structure of Ireland was too fragmented, with the result that the potential endowment of Irish cathedrals was divided among thirty-four claimants. It is also true that Ireland rarely attracted the top craftsmen from England. To an established master mason, Ireland, with its limited resources and unstable politics, was not a particularly inviting place. The prevailing view of the Irish, to judge from the jaundiced views of Gerald of Wales, was not encouraging either — a barbarous and 'filthy people, wallowing in vice'.[53]

2. *The nave of Christ Church Cathedral, Dublin*

There is one honourable exception to this generally uninspiring picture of Irish Gothic architecture. The nave of Christ Church Cathedral was an outstanding design and its architect deserves to be ranked among the finest architects produced by the west of England. He was by no means the first West Country mason to work at the cathedral. The choir and transepts had already been reconstructed between 1186 and 1200 in a style with obvious affinities to buildings in the Bristol Channel area.[54] A group of nine historiated capitals are related to contemporary sculpture at Wells and Glastonbury, and the architectural details all derive from the west of England or South Wales. The design of the elevation, however, is singularly clumsy and inept, and there is an extraordinary contrast in quality between this late Romanesque composition and the early Gothic nave.

In its present form the nave is largely the work of George Edmund Street (Pl. XVIIIA). When he began his restoration in 1871, it was in a depressing and semi-ruined condition.[55] The vaults had fallen long before, in 1562, bringing down with them the whole of the south arcade. The north aisle windows were blocked and the 13th-century west façade totally obliterated. It is to Street's credit that he restored the nave to its original form, taking care to reproduce original mouldings whenever he could. His book of moulding profiles survives and each drawing is labelled 'ancient' or 'modern' depending on whether he had found 13th-century masonry.[56] In engineering terms his restoration was a magnificent achievement. Although the north wall had been pushed several feet out of vertical in the collapse of 1562, he managed to replace the stone vaults, without dismantling the wall. The piers of the north arcade were seriously decayed and these were rebuilt with new masonry, while the arches above were supported on a massive timber centering. Street proclaimed that he would not remove a single ancient stone unless it was essential.[57] In fact, the restoration was not achieved without sacrifices. The third and fourth piers originally lacked banded shafts, but in the interests of Victorian homogeneity, Street provided them. He moved a door in the north aisle one bay east and another in the south aisle two bays west. He blocked the triforium and clerestory passages with concrete in order to sustain his new vault and he added flying buttresses for the same reason. These alterations notwithstanding, the present appearance of the nave is now much closer to its original appearance than at any point between 1562 and 1871. The north elevation, apart from the piers, is genuinely medieval and this includes several capitals.[58] Enough medieval masonry remained at the east end of the south elevation to show that it followed the same form, so Street's reconstruction here was justifiable.

F

The nave consists of six bays, the whole of the western bay being an addition of 1234 (Fig. 4b).[59] A groin-vaulted crypt extends below the entire building with the exception of this final bay, an unusual feature to find as late as the 13th century. Presumably the crypt was an attempt to provide extra space, for the cathedral is relatively short, its length being restricted by the location in the centre of the city. Much of the crypt was already erected when the architect of the nave arrived. Its stylistic details conform to those in the Romanesque transepts and some of the piers are not vertically aligned with those in the nave above. The start of work on the nave itself is probably to be dated to about 1216 and the first five bays were certainly finished by 1234.[60] Most of the building was carried out during the episcopate of Henry of London (1212–28), one of the most active and political of Dublin's bishops.

(a) five eastern bays (b) western bay

Fig. 4. Dublin, Christ Church Cathedral, mouldings of nave arcade after G. E. Street

At first sight the relatively low arcades, the massive squat piers and the profusion of soffit mouldings recall the design of Wells Cathedral. In fact the roots of the Christ Church design lie further north in Worcestershire, as numerous parallels testify. The foliage capitals, many with protruding heads, are so closely matched by those in the village church at Overbury that the same sculptor must have been responsible.[61] Overbury is situated six miles north-west of Tewkesbury and the advowson of the church belonged to Worcester Cathedral. There are also similarities of detail with Worcester Cathedral itself. One of the main vault capitals of Christ Church, now stored in the crypt, has a foliage design remarkably close to one of the few original capitals in the Lady chapel at Worcester. Moreover the curious way in which the main vaulting shafts at Christ Church are recessed into the wall is a mannerism which the two churches have in common, though it also occurs at Pershore, Llandaff and St David's. The soffit rolls of Christ Church with their abundance of fillets and deep hollows (Fig. 4a) recall the similarly exuberant work in the Lady chapel arch at Pershore (c.1220).[62]

There are elements in the design which give the nave of Christ Church a decidedly French tinge. The individual bays are clearly separated and defined by a shaft which rises unbroken from floor to vault, a feature by no means *de rigueur* in Early English. As well as accentuating the bays it helps to impart a measure of verticality to the composition. The two superimposed passageways at both triforium and clerestory level are related to those buildings grouped

together by Jean Bony in his article entitled 'The Resistance to Chartres'.[63] Although found in a number of early Gothic buildings in England, the presence of a genuine triforium passage is of course far more characteristic of France. Finally there is the integration of the triforium and clerestory, with continuous shafts linking both storeys. The earliest surviving example of this arrangement is in the choir of St Remi at Reims and its subsequent development in France is well known.[64]

The linkage at Christ Church has in the past been associated with St David's Cathedral, Llanthony Abbey and Pershore,[65] though the relationships are not as simple as is often assumed. In structural terms these buildings are very different. The nave of St David's has no floor to the clerestory and the upper parts of the wall comprise two skins, totally separate from each other. At Llanthony there was no triforium passage except in the western bays and at Pershore the clerestory and triforium are so completely integrated that triforium arches were omitted (Pl. XXA). Christ Church is a more accomplished and pleasing version of the theme. The genesis of this part of the design is complex, involving both the eastern arm of Worcester Cathedral and possibly the original design of Lichfield choir.

The outer bays of the Lady chapel and eastern transepts at Worcester are particularly important (Pl. XVIIIB).[66] For these outer bays there is no aisle and consequently no justification for a triforium. The two upper storeys were therefore combined and tall lancet windows inserted. The rere-arches of these triple lancets are divided into three horizontal levels. The lower two correspond to the engaged shafts which are divided half-way by banding. The upper level, which is not so high, corresponds to the arches themselves, the centre arch being stilted well above those at the sides. This composition, when viewed on a two dimensional plane, is almost identical to that used in the upper half of the elevation at Christ Church. The exterior façades of the eastern transepts have a similar design and show the same preoccupation with vertical flow and unbroken lines of shafting (Pl. XIXA).[67] The cliff-like façade of Worcester Cathedral and the absence of low eastern chapels have often been compared to churches in the north of England.[68] The choir façade of Whitby Abbey presents a good parallel. Its appearance is similar to that of the eastern transepts at Worcester, with superimposed groups of lancets linked by continuous vertical shafts. It is clear that this unified approach to design was not restricted to one area of the country.

The 13th-century choir and transepts of Lichfield Cathedral have long been regarded as part of the 'West Country school' (Pl. XIXB).[69] The low massive piers, with their groups of triple shafts recall those at Wells and Pershore, and the relative lowness of the arcades, which gives great emphasis to the intricately moulded soffits, is reminiscent of the same two buildings. The upper parts of the fabric were remodelled in the 14th century and the original design is far from clear. There was a passageway at triforium level, and on the rear wall of the triforium, simple pointed arches opened into the aisle roofs. In the transepts more of the 13th-century arrangements remain, including the formeret arches, which are supported on pairs of shafts *en délit*. These rest on a ledge at the base of the triforium, and they effectively unite the upper levels of the elevation. The inner plane of the wall is completely open with no sub-arches below the formeret, but whether this was always the case is open to doubt. The most logical arrangement would have been to divide the space into three.[70] If so, the original design must have been similar to that at Pershore, where there are no individual triforium arches, nor is there a passage at clerestory level (Pl. XXA). The evidence suggests the same was true at Lichfield.[71]

The English background of the integrated triforium and clerestory at Christ Church is thus complicated.[72] The design produced by the Dublin master mason was obviously not the result of a sudden flash of genius, but the crystallisation of ideas which had been circulating for some years in the west of England. At its most general level the desire to combine the

upper parts of the elevation into a unified design is the product of similar thinking to that which produced the giant order, by which the lower two storeys were united. The solution evolved in Dublin is particularly striking because of its resemblance to contemporary French design. Of all the English attempts to combine the triforium and clerestory, that at Christ Church has the strongest French flavour. It is unlikely that the architect had any direct knowledge of French buildings, though it is not impossible that information about Arras Cathedral, St Remi at Reims or Notre-Dame-en-Vaux at Chalons-sur-Marne had filtered through to the West Country. The design is emphatically English, with its thick wall structure, its heavy shafts of dark jurassic limestone and the cusping used on the centre arch of the clerestory. It was almost certainly the result of a separate English evolution.

If the nave of Christ Church was begun about 1216, it preceded the new choirs of both Pershore Abbey (*c.*1223) and Worcester (1224), which makes its originality all the more remarkable. In stylistic terms, the work at Worcester is evidently later, as can be judged from the complex pier forms, and the more elegant proportions of the building. Despite the analogies, there are so many features of Worcester which find no echo in Christ Church, that it seems certain that the architect of Dublin Cathedral set sail across the Irish Sea well before 1224. Christ Church thus takes its place as the major West Country design of the decade 1210–20, simultaneously looking back to Wells and Lichfield, and forward to Pershore and Worcester.

Another informative aspect of Christ Church lies in the proportions of the elevation, which appear to be based on a straightforward and coherent system. The main dimensions are as follows:[73]

Average width of bay	16 ft 2½ in.
Height to the top of the abacus of the pier capitals	12 ft 0 in.
Height to the floor of the triforium	24 ft 4 in.
Height to the string course below the clerestory	32 ft 8 in.
Height to the top of the abacus of the clerestory capitals	40 ft 9 in.
Height to the top of the formeret[74]	48 ft 6 in.

The width of the bay was apparently used in generating the other dimensions. Multiplied twice it produces the level of the clerestory, and multiplied three times the total height of the building.[75] Divided by $\frac{3}{4}$ it gives the height of the main capitals. The triforium string course serves as a median line, though the string itself is about 9 in. below the floor of the triforium passage, which appears to be the actual mid-point. The main features of the design are thus related by simple ratios of 1:2, 1:3, 2:3 and 3:4 etc. The unit of 16 ft 2½ in. may seem arbitrary, though it is close to the perch at 16 ft 6 in., which may have been the theoretical starting point. If a rod, roughly equivalent to the perch, was employed, it was probably subdivided into four, since units of about 4 ft 0½ in. can be detected throughout the elevation. As a common denominator, when multiplied by 4, 3, 6, 8, 10, and 12 respectively, approximations to the measurements given in the table are obtained. What makes the proportional system of Christ Church especially interesting is its relationship to that employed in the choir of Worcester Cathedral. There, a unit of 4 ft 6 in. determined the main lines of the elevation, used in multiples of 4, 7, 10 and 14. As at Christ Church, the base of the triforium acts as a median line.[76] This similarity of approach re-inforces the connections between Dublin and Worcester.

The reason for links with Worcester are not hard to explain. The main sea routes from Ireland to England centred on the Bristol Channel, whence there was easy access to Worcester via the river Severn. Many citizens of Dublin came from Worcester and the cult of

St Wulstan was popular in the city. Indeed Dublin possessed a relic of the saint and Archbishop John Comyn (1181–1212) played a major role in ensuring his canonisation. After Bristol, Worcester would have been an obvious place to search for highly trained craftsmen.[77]

In contrast to Waterford Cathedral, Christ Church is not, as far as one knows, a straightforward copy of something that already existed in England. The architect succeeded in combining a number of ideas which were in circulation in the West Country, and he did so in an imaginative and harmonious way. Unfortunately for his reputation, his schemes were carried to fruition in a backwater of Europe and they remained unnoticed by English medieval architects. If the nave of Christ Church had been built in England, it might well have had a decisive influence. Not until the building of the nave of York Minster (1291–1343) did an English architect produce such a felicitous combination of triforium and clerestory, and that was after a lapse of fifty years (Pl. XXB). This 'lack of influence', coupled with the heavy restoration of the medieval fabric, has encouraged the neglect of Christ Church by architectural historians. The nave design may have been irrelevant for the future of English architecture, but that should not affect our judgement of its quality. Although less than fifty feet high and a mere six bays long, it was a masterpiece.

CONCLUSION

The three buildings considered in this article illustrate different aspects of the process by which English methods were adopted and exploited in Ireland. Some important distinctions between the buildings emerge. In one case, Waterford Cathedral, there is a prototype in England from which most of the broad architectural themes were derived. The situation at Christ Church, Dublin, was not so straightforward. Previously thought to be related to Wells, Llanthony, Pershore and St David's,[78] it is clear that the design emanated from workshops in and around the city of Worcester. In contrast to Waterford, there was no general prototype, and the design represented a new and imaginative step forward in West Country architecture. It is likely that the origins of the third major Early English building in Ireland, St Patrick's Cathedral, Dublin, are even more diffuse, but discussion of its sources must await the publication of Dr Rae's meticulous survey of the fabric. All of these early Gothic buildings use stone quarried from Dundry, and it is clear that sizeable teams of English masons were involved in their construction. Before the 1169–70 invasion, West Country influence was more spasmodic. Cormac's Chapel stands isolated as a relatively pure example of English Romanesque, and, while English ideas did exert an influence in Ireland, not least in the development of chevron ornament, Cormac's Chapel is one of the rare instances where one can be certain of the presence of English craftsmen. Although most of the sources of the chapel lie in the West Country, there is no English Romanesque monument which embraces all its major features. Parallels can be found across a broad area covering Somerset, Hampshire, Dorset, Gloucestershire and the coast of South Wales, and the design thus appears to be an eclectic gathering of West Country motifs.

A particularly striking feature of the sources of all three Irish buildings is the geographical association with the Bristol Channel, revealing its importance as a commercial and artistic route, both before and after the invasion. The masons responsible for each of the three buildings were almost certainly recruited from towns and villages either on the banks of the river Severn or not many miles from it. It is possible that unknown personal relationships, particularly among the clergy, may also have played a part. Nonetheless, there is a clear geographical consistency in the distribution of the English sources which implies that physical proximity and ease of communication were the crucial factors determining the recruitment of Irish labour forces.

In terms of quality of design, only the nave of Christ Church Dublin can be regarded as outstanding, and it forms a worthy addition to the achievement of West Country masons. Cormac's Chapel is of interest primarily for sculptural reasons, not least for its role as a catalyst in the development of Hiberno-Romanesque. Some of its features, for example barrel vaulting with transverse ribs and the use of arches with continuous mouldings, are relatively rare in surviving buildings of the first half of the 12th century. In this respect the chapel adds to our knowledge of West Country design. Waterford Cathedral, though more difficult to assess, deserves attention as an interesting, if provincial, reflection of the power and prestige of Glastonbury Abbey. In contrast, the design of Wells Cathedral had no successors in Ireland. Some of its sculptural and architectural ideas were copied,[79] but there was no attempt to reproduce the main lines of its elevation. Whether this was the result of deliberate choice or mere accident remains unclear.

ACKNOWLEDGEMENTS

I should particularly like to thank the following people for the help they gave me in preparing this article: Mr John O'Callaghan, Dr Edwin Rae, Dr Peter Kidson. Publication has been assisted by a grant from Trinity College, Dublin.

REFERENCES

SHORTENED TITLES USED

BRAKSPEAR (1931) — H. Brakspear, 'A West Country School of Masons', *Archaeologia*, LXXXI (1931).

GWYNN AND HADCOCK (1970) — A. Gwynn and R. N. Hadcock, *Medieval Religious Houses; Ireland* (London 1970).

HENRY (1970) — F. Henry, *Irish Art in the Romanesque Period* (*1020–1170 A.D.*) (London 1970).

LEASK, I (1955) — H. G. Leask, *Irish Churches and Monastic Buildings*, I, *The First Phase and the Romanesque Period* (Dundalk 1955).

LEASK, II (1958) — H. G. Leask, *Irish Churches and Monastic Buildings*, II, *Gothic Architecture to A.D. 1400* (Dundalk 1958).

STALLEY (1979) — Roger Stalley, 'The Medieval Sculpture of Christ Church Cathedral, Dublin', *Archaeologia*, CVI (1979), 107–22.

STREET AND SEYMOUR (1882) — G. E. Street and E. Seymour, *The Cathedral of the Holy Trinity commonly called Christ Church Cathedral, Dublin* (London 1882).

WORCESTER CATHEDRAL, BAACT (1978) — *Medieval Art and Architecture at Worcester Cathedral*, BAACT, 1978.

1. Street and Seymour (1882), 108.
2. In the case of Dublin, the origin of many of its citizens can be assessed from rolls of names drawn up at the end of the 12th century and in the first half of the 13th, *Historical and Municipal Documents of Ireland A.D. 1170–1320* (ed. J. T. Gilbert, 1870), 3–48.
3. The dates are given in several of the Irish annals, Henry (1970), 170. The suggestion that Cormac's Chapel was the first Romanesque building to be constructed in Ireland was made by A. C. Champneys, *Irish Ecclesiastical Architecture* (London 1910), 132, and the point has been substantiated by L. de Paor, 'Cormac's Chapel: The Beginnings of Irish Romanesque', *Munster Studies, Essays in commemoration of Monsignor Michael Moloney* (Limerick 1967), 133–45. Cormac's Chapel has also been discussed in detail by Leask, I (1955), 113–20.
4. The links between Cashel and Regensburg have been discussed by several writers: D. A. Binchy, 'The Irish Benedictine Congregation in Medieval Germany', *Studies* (June 1929), 194–210: A. Gwynn, 'Some Notes on the History of the Irish and Scottish Benedictine Monasteries in Germany', *Innes Review*, V (1954), 1–23: Gwynn and Hadcock (1970), 104–05; Henry (1970), 170. All these accounts contain errors. The crucial source, hitherto known only through faulty copies, has now been published by P. A. Breathnach, *Libellus de fundacione consecrati Petri, Die Sogenannte Regensburger Schottenlegende, Untersuchung and Textausgabe* (Munchener Beitrage zur Mediavistik und Renaissance Forschung) (Munich 1977). Dr Breathnach has established a number of previously controversial points. The

monastery of St James at Regensburg was founded in the 1090s, not in 1110, and there were three recorded visits by its monks to Ireland in the 12th century. The first was by Isaac and Gervasius, plus two others of lesser degree, Conrad the carpenter and a man whose name cannot be deciphered (it is not William, as suggested by some writers). They came to Cashel between 1127 and 1137 in order to collect money for their monastery at Regensburg, and their visit could have coincided with the building of Cormac's Chapel, 1127–34. The second and third visits to Ireland were made by abbot Christian MacCarthy, around 1148, and abbot Gregory. Unfortunately there is no firm information about the monastic rule followed by the monks at Cashel, but it seems almost certain that they were Benedictine. There were Benedictines on the Rock of Cashel in the 13th century (*Calendar of Documents Relating to Ireland*, ed. H. S. Sweetman (London 1875–86), II, 1252–84, nos. 1361–62 and III, 1285–92, no. 745) and it is likely that they were introduced in 1127. The successive visits to Cashel by monks from Regensburg make St James the most likely mother house, though there is no proof. It should be stressed that in contrast to England, Benedictine monks were a rarity in Ireland (I am grateful to Dr Breathnach for advising me on the whole of this problem).

5. Leask, I (1955), 27–41.
6. Ibid., 5–9.
7. Tympana carved with animals in low relief are quite widespread in England, and Francoise Henry quotes further parallels at Ribbesford (Worcestershire) and Kencott (Oxfordshire), Henry (1970), 173–74. A lion similar to that at Cashel graced the tympanum at the Cluniac abbey of Thetford, R. B. Lockett, 'A Catalogue of Romanesque Sculpture from the Cluniac Houses in England', *JBAA*, XXXIV (1971), Pl. XIV.
8. It is worth noticing that relatively elaborate types of chevron appear in the north porch and they are advanced for 1127–34. In contrast, the chevron employed in the wall arcades of the nave is surprisingly primitive. It is almost as tentative as that used in the south transept at Pershore, where chevron makes one of its first appearances in the West Country.
9. R. A. Stalley, 'A Twelfth Century Patron of Architecture: a study of the buildings erected by Roger, Bishop of Salisbury', *JBAA*, 3rd ser., XXXIV (1971), 71, 75.
10. Brakspear (1931), 1–18.
11. They can be found occasionally before the second half of the 12th century, as at Gloucester Cathedral and Milborne Port. See C. Wilson, 'The Sources of the Late Twelfth Century Work at Worcester Cathedral', *Worcester Cathedral*, BAACT (1978), 82.
12. Henry (1970), 172.
13. C. A. Ralegh Radford, *Ewenny Priory, Glamorgan* (London, H.M.S.O. 1952), 5.
14. Henry (1970), 175. See also F. Henry and G. Zarnecki, 'Romanesque Arches decorated with Human and Animal Heads', *JBAA*, 3rd ser., XX (1957), 18–19.
15. I am grateful to Mr T. A. Heslop of the University of East Anglia for bringing this to my attention.
16. The date was suggested by K. J. Galbraith, 'The Sculptural Decoration of Malmesbury Abbey', unpublished M.A. thesis, University of London (1962), 181. She also gives a list of column swallowers in England, p. 191.
17. Stalley, 'A Twelfth Century Patron', 78.
18. Henry (1970), 157–65. The dates given here for Dysert O Dea and Clonfert are not acceptable. The doorway at Dysert O Dea must have been carved in the years around 1150–60 and Clonfert sometime between 1170 and 1200.
19. A few Irish churches had round towers integrated with the fabric, M. Stokes, *Early Christian Architecture in Ireland* (London 1878), 82–83.
20. Eastern towers flanking the apse are said to have formed part of the 12th-century design of Hereford Cathedral, B/E *Herefordshire* (1963), 148, 150. There is also some evidence that they were found at Llandaff. Two chapter seals, showing quite different views of the cathedral, depict such towers and E. W. Lovegrove was inclined to believe they must have had some basis in fact, E. W. Lovegrove, 'The Cathedral Church of Llandaff', *JBAA*, 2nd ser., XXXV (1929), 89–90.
 Such towers are a familiar feature of Romanesque churches in Germany and the Rhineland. Those at St James Regensburg are typical. They are clearly earlier than the main body of the church which dates to the mid-12th century, and they were probably erected soon after the foundation in the 1090s (cf. 4 above).
21. The Church reform movement in Ireland has been discussed by many writers on Irish ecclesiastical history. A useful modern survey is that provided by J. Watt, *The Church in Medieval Ireland* (Dublin 1972).
22. The journeys were made in 1140 and 1148; on both occasions Malachy was on the way to Rome, H. J. Lawlor, *St. Bernard of Clairvaux's life of St. Malachy of Armagh* (London 1920).
23. Gwynn and Hadcock (1970), 91, 100.

24. The nave of Waterford Cathedral and the cathedral of Limerick are the two major Romanesque buildings outside the Cistercian order. For Limerick see Leask, II (1958), 45–47.
25. Lawlor, *Life of Malachy*, 61.
26. The church is discussed by Leask, I (1955), 126; de Paor, 'Cormac's Chapel', 136–37; Henry (1970), 175.
27. Stalley, 'A Twelfth Century Patron' 76, 79.
28. Leask, I (1955), 137–42, and Henry (1970), 159–62.
29. Leask, I (1955), 153–54; Henry (1970), 168. For the date of Tuam see Stalley (1979), 108.
30. Leask, I (1955), 151–52 and Henry (1970), 166–67. The doorway at Killaloe has been carefully analysed by Dr T. Garton, who in a forthcoming study establishes the date at about 1200.
31. Leask, II (1958), 63 and R. A. Stalley, *Architecture and Sculpture in Ireland* (Dublin 1971), 110–16.
32. I have discussed the overlap in more detail in Stalley (1979), 107–08.
33. Ibid., 107.
34. R. H. Ryland, *The History, Topography and Antiquities of the County and City of Waterford* (London 1824), 145.
35. A. Clapham, 'Some Minor Irish Cathedrals', *Archaeol. J.*, CVI (1949), supplement, 30–33.
36. C. Smith, *The Ancient and Present State of the County and City of Waterford* (Dublin 1746), 173–80. Smith's account was repeated verbatim by P. Luckombe, *A Tour Through Ireland* (in 1779) (London 1780), 37. Luckombe's tour was fraudulent as far as Waterford was concerned. He described the medieval cathedral which had been demolished six years before his supposed visit.
37. *The Whole Works of Sir James Ware concerning Ireland*, ed. W. Harris, 2nd ed. (Dublin 1764), opposite 525.
38. National Library of Ireland, TX 1977 (2–7).
39. The paintings used to hang on the walls of the vestry at the north-west corner of the cathedral, but since the recent union of the dioceses of Waterford and Ossory, they have been moved to the Bishop's Palace, Kilkenny.
40. The exact form of the 12th-century plans of Wells Cathedral and Glastonbury Abbey has long been the source of disagreement, but the existence of a rectangular ambulatory is accepted by all authorities. See Bilson (1928), 28; Robinson (1928), 18–22.
41. Clapham, 'Minor Irish Cathedrals', 33, and C. Smith, *Waterford*, 175.
42. J. H. Bernard, *The Cathedral Church of St. Patrick* (London 1903), 14, 16 and 60.
43. Compare for example the nave arcades in the Cistercian Abbeys of Dunbrody and Graiguenamanagh.
44. Smith, *Waterford*, 175.
45. The plan used to illustrate Clapham's article is highly misleading since it falsely assumes that this irregularly planned pier was the norm throughout the east end.
46. D. M. Waterman, 'Somersetshire and Other Foreign Building Stone In Medieval Ireland c.1175–1400', *Ulster Journal of Archaeology*, XXXIII (1970), 63–75.
47. The relationship with Abbey Dore was pointed out to me by Peter Draper.
48. Capitals with such tall proportions are by no means restricted to Glastonbury. They can be found in parts of Wells and Hereford Cathedrals, but those most closely comparable to Waterford are to be found at the west end of Llandaff Cathedral, for example the north capital of the west window of the nave. This must belong to the first quarter of the 13th century, Lovegrove, 'The Cathedral Church of Llandaff', 82. In Ireland, similar capitals can be found in Christ Church Cathedral Dublin, on the first free-standing pier from the west. These capitals are unique in the cathedral and they are quite different from those used in the rest of the nave arcade. As the nave was lengthened to the west by one bay in 1234, the capitals belonged to the responds against the original west wall of the cathedral, and as such they may have been among the first parts of the nave to be executed, probably around 1216 (see n. 60 below).
49. Triple filleted shafts have often been regarded as a mark of the late 13th century, as for example in F. A. Paley, *A Manual of Gothic Mouldings*, 6th ed. (London 1902), 39 and H. Forrester, *Medieval Gothic Mouldings: A Guide* (London and Chichester 1972), 31. In Ireland they can be found in the eastern parts of Graiguenamanagh Abbey, started in 1207, in the choir of Abbey Knockmoy, founded in 1190 and begun soon after, and in the nave of Christ Church Cathedral Dublin, 1216–34.
50. F. M. Powicke and E. B. Fryde, *Handbook of British Chronology*, 2nd ed. (London 1961), 334, Gwynn and Hadcock (1970), 100.
51. Ibid.
52. Stalley, *Architecture and Sculpture in Ireland*, 77–78.
53. Giraldus Cambrensis, *Topographia Hiberniae*, trans. J. J. O'Meara (Dundalk 1951), 90.
54. Stalley (1979), 109–16.
55. For the pre-restoration condition of Christ Church see the following: Street and Seymour (1882), R. B. McVittie, *Details of the Restoration of Christ Church Cathedral, Dublin* (Dublin 1878); T. Drew, 'Street as a Restorer', *Dublin University Review* (June 1886), 518–31: W. Butler, *Christ Church Cathedral,*

Measured Drawings of the Building prior to Restoration (Dublin 1878); W. Butler, *The Cathedral Church of the Holy Trinity Dublin* (London 1901); *Dublin Builder*, XIII, nos., 275 and 286 (1871), XIV, no., 296 (1872), XXIII, no. 513 (1881). There are several illustrations of the nave before 1871 of which the most valuable is a photograph in the Lawrence collection, National Library of Ireland.

56. This book is kept in the chapter room of the cathedral.
57. Street and Seymour (1882), 73–74.
58. Stalley (1979), 116–18.
59. Ibid., 116.
60. Ibid.
61. Ibid., 116–18.
62. Roger Stalley and Malcolm Thurlby, 'A Note on the Architecture of Pershore Abbey', *JBAA*, 3rd ser., XXXVII (1974), 113–18.
63. J. Bony, 'The Resistance to Chartres in early thirteenth-century Architecture', *JBAA*, 3rd ser., XXI–XXII (1957–58), 35–52.
64. R. Branner, *St. Louis and the Court Style in Gothic Architecture* (London 1965), 20–23. Branner points out that after the initial experiments with linkage *c*.1170–85, no further examples are known from north-east France between 1185 and its subsequent use in the hemicycle at Reims Cathedral. Only after 1220 did it become a common feature in French architecture. The Christ Church elevation was thus designed at a time when linkage was not a pre-occupation of French architects.
65. G. Webb, *Architecture in Britain; The Middle Ages* (Harmondsworth 1965), 99.
66. For the early 13th-century work at Worcester, there is now the recent discussion by Barrie Singleton, 'The Remodelling of the East End of Worcester Cathedral in the Earlier Part of the Thirteenth Century', *Worcester Cathedral*, BAACT (1978), 104–15.
67. The present appearance of these façades, and indeed a great deal of the east end of Worcester, dates from the 19th-century restoration. However in general terms the design is authentically medieval, R. B. Lockett, 'The Victorian Restoration of Worcester Cathedral', *Worcester Cathedral*, BAACT (1978), 160–85.
68. Singleton, 'Remodelling of the East End of Worcester Cathedral', 112.
69. Brakspear (1931), passim.
70. Masonry marks on the exterior walls of the clerestory, particularly in the north transept, strongly suggest the original existence of three lancets.
71. The building campaigns at Lichfield in the years around 1200 have apparently never been analysed in detail. The most useful works are VCH, *Staffordshire*, III (1970), 140–99; H. E. Savage, 'The Architectural Story of Lichfield Cathedral', *Transactions of the North Staffordshire Field Club*, XLVIII (1913–14), 113–23; R. Willis, 'On Foundations of Early Buildings Recently Discovered in Lichfield Cathedral', *Archaeol. J.*, XVIII (1861), 1–23.
72. A comprehensive discussion of the integrated triforium and clerestory in English architecture obviously lies beyond the scope of this article.
73. The measurement of the medieval dimensions of Christ Church is fraught with difficulties. By 1871 the floor level had risen well above the bases and one has to assume that Street's new floor is at the medieval level. Since there is a crypt below the nave, Street could not have dropped the floor much below the 13th-century level and so it is likely that his restoration is approximately correct. A second problem is the lean in the north wall. This makes the dropping of plumb lines difficult and it also means that the nave is wider at the top than at the bottom. The blocking of triforium and clerestory passages in the 19th century is a further impediment to careful measurement. The figures given in the table make no claim to be anything other than approximations.
74. I am grateful to Dr R. Cox of the Department of Engineering, Trinity College, Dublin, for calculating this height for me. With the aid of a theodolite, he was able to measure the height of the soffits of the present ribs, at a point in the centre of the nave. This point is approximately level with the formeret, though adjustments had to be made to allow for the lean in the 13th-century north wall. The measurement of 48 ft 6 in. therefore has a margin of error of at least 6 in.
75. The outer walls of the nave have been completely rebuilt so it is impossible to be certain of its original width. It must have been in the order of 69 ft 6 in. If the height of the building, 48 ft 6 in., is multiplied by $\sqrt{2}$, one reaches a dimension of 68 ft 7 in., sufficiently close to the width to suggest there may have been a deliberate relationship.
76. The proportional system of Worcester Cathedral was analysed by Dr Peter Kidson at the BAA Worcester Conference in 1975.
77. Stalley (1979), 117–18.
78. A. C. Champneys, *Irish Ecclesiastical Architecture* (London 1910), 140–42; Leask, II (1958), 79.
79. Stalley (1979), 109–15.

POSTSCRIPT

Cormac's Chapel and Ewenny Priory: Since writing the text of this article, I have discovered evidence that strongly suggests that Ewenny was finished by 1134, rather than being constructed after 1141 as hitherto suggested. A letter of Gilbert Foliot, abbot of Gloucester, records that the church of St Michael's, Ewenny, was dedicated during the episcopate of Urban, bishop of Glamorgan, 1107–34 (*Letters and Charters of Gilbert Foliot*, ed. A Morey and C. N. L. Brooke (Cambridge 1967), 82). The church at Ewenny could have been, therefore, an important source for the design of Cormac's Chapel.

Wells, the West Country, and Central European Late Gothic

By PAUL CROSSLEY

The spotlight of Central European *Kunstgeschichte* first fell on Wells cathedral in the late 1950s and early 1960s with the publication of three important studies: Nikolaus Pevsner's review of Karl Heinz Clasen's book on German Late Gothic vaults, and Henning Bock's two works on the Decorated style and its influence in Prague.[1] Both scholars argued that the 14th-century work at Wells and related West Country buildings had a formative influence on German Late Gothic architecture. Pevsner's claims turned mainly on the problem of 'decorative' vaulting patterns. Precedents for many of the decorative vaults in the southern Baltic as well as for the vaults used by Peter Parler in Prague cathedral could, according to Pevsner, be found in Wells and English West Country architecture of the Decorated period. Even the flamboyant *Bogenrippe* of the 15th century had their tentative prototypes in the small curving ribs first used in the West Country in the first half of the 14th century. Bock made more specific claims for the influence of Wells in Central Europe. He saw the choir of Wells as a direct inspiration for Peter Parler's elevation and vault of the choir of Prague cathedral, and he argued that Wells and the West Country architecture of the Decorated style should be placed, side by side with Rhenish and south-west German architecture, as a vital source of Peter Parler's mature style. These were ambitious claims, for Parler's work in Prague and its environs in the second half of the 14th century is still regarded as a *fons et origo* of the German Late Gothic; and by suggesting that many of Parler's ideas derived from England Bock elevated Wells and the West Country to the status of grandparent to the German *Sondergotik*.

In the wake of these pioneering investigations a steady stream of books and articles have appeared — mostly German, Austrian and American — postulating further connections between 14th-century England and Late Gothic Germany. Claims for a connection between Parler's sculpture in Prague and architectural sculpture in England, and for the influence of English decorative details on the work of such acknowledged masters of the German Late Gothic as Madern Gerthener and Hanns von Burghausen have strengthened the case for placing the architectural leadership of Europe in the first half of the 14th century in England, and more particularly in western England. Indeed, in the last fifteen years English Gothic has so intrigued continental historians that today it is rare to find any publication dealing with Central European Late Gothic architecture that does not uncover some new point of comparison with the English Decorated Style. In a recent book on English 14th-century architecture Jean Bony has given a new authority to these claims for English influence. Referring to the Late Gothic of the Baltic coast and of the Parler school he concluded that 'England remained, in matters of vaulting as much as in matters of curvilinearity, the source and constant model for all Late Gothic elaboration'.[2]

A collection of essays on Wells cathedral is hardly an appropriate place to examine the validity of all these suggestions for English influence. But Wells cathedral and related buildings figure prominently in most discussions of the 'English connection', and for that reason this paper will confine itself to a critical investigation of the relations between German Late Gothic and the Decorated work at Wells, also including those West Country buildings stylistically associated with the Wells workshops. In some cases the influence of West Country architecture in Germany seems to have been even stronger and more widespread

than continental scholars have imagined; but it is also true that a close examination will often show that what passed at first sight for a direct English inspiration, reveals itself as nothing more than a parallel and autonomous development. Much of the latest English research on the Decorated Style has not yet crossed the channel, and some European scholars, in their enthusiastic rediscovery of English architecture, have overlooked the presence in Germany itself of more likely, and perhaps less exotic, sources of their Late Gothic. In examining the play of influences between England and Central Europe the observer has to pick his way cautiously through a confusing mixture of fact, hypothesis and half-truth.

The ambiguity surrounding the claims for a connection between the English West Country and Central Europe is brought out clearly in the problem of English influence on the 14th-century architecture of the southern Baltic. English precedents have been invoked to explain the vaults of the Cistercian abbey church at Pelplin, the choir of St James at Toruń, the nave pillars and capitals of St James at Rostock, the westwork of St Mary at Stralsund, the west towers of St Mary at Stargard-Szczeciński, a number of brick basilicas with broad, projecting transepts, and a series of centralised chapels in Pomerania.[3] Wells is agreed to have played an important part in this 'invasion' of English forms in the Baltic. Pevsner, Bony and Frazik saw the palm-like vaults of 13th-century English chapter houses —among them Wells—as one vital precedent for the decorative vaults of the so-called Briefkapelle at St Mary at Lübeck (c.1310) and of the great remters of the 1320s and 1330s in the castle at Malbork (Marienburg),the headquarters of the Teutonic Knights (Pl. XXIA). Frazik even went so far as to date the Malbork vaults a decade later than`is normally accepted in order to place them after what he considered to be their principal source, the retrochoir at Wells.[4]

These and other English attributions have built up a generally accepted picture of the powerful and continuous penetration of English ideas — among them important innovations from Wells — into much of the southern Baltic throughout the 14th century. What value can we attach to these claims?

In some cases English influence in the Baltic is undeniable, even if the manner of its transmission is still a mystery. The choir aisle vaults of the Cistercian church at Pelplin, dated by Clasen and Skubiszewski to c.1280, are so similar to the earlier tierceron vaults in the nave of Lincoln cathedral that the Pelplin patterns cannot be explained without this English precedent.[5] The same is true of the star vaults in the two west towers of St Mary at Lübeck (begun 1304 and 1310) and of the Briefkapelle in the same church, begun c.1310 (Fig. 1). The tall centrally-placed columns of this chapel and the palm-like spread of its vaults are without precedent in the Baltic, and the case for an English inspiration from chapter house design is convincing.[6] But such examples of direct English influence are the exception not the rule, and as decorative vaulting spread in the Baltic it becomes increasingly difficult to assess the extent of the English contribution. The problems are clearly exemplified by the vaulting at Malbork. The vaulted rooms of this castle — notably the chapter house of the upper castle and the summer refectory of the Grand Master's palace — are counted among the earliest and most advanced examples of decorative vaulting in the Baltic, and their influence contributed decisively to the spread of decorative vaulting in West and East Prussia and to the status of the Knights as the main disseminators of this type of vault in Poland and north-eastern Germany.[7] The claims, therefore, for the influence on Malbork of English chapter houses and retrochoirs such as Wells are important, but they are very difficult to prove convincingly. If the first of the vaulted rooms in question, the long rect-angular chapter house at Malbork, can be dated 'c.1320'[8] (Pl. XXIA and Fig. 2), then German precedents can be found without recourse to England. The palm-like effect of the

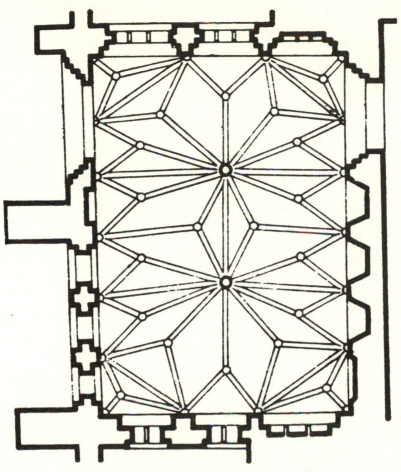

FIG. 1. Plan of the Briefkapelle, St Mary, Lübeck

vaults, springing from central columns, is superficially English, but the elements of the
vault patterns are different. The English vaults, as Clasen pointed out, are true tierceron
vaults, whereas the essential unit of the Prussian patterns is the three-pronged rib figure
called a triradial (*dreistrahl*) which fills each triangular segment of the vault. Very similar
triradial figures, also carried over a rectangular space on a file of central columns, appear a
little earlier in the Briefkapelle in Lübeck, a town which in its position as head of the
German Hansa had close connections with the Knights[9] (Fig. 1). An influence from Lübeck
rather than from England would offer the most convincing explanation for the Malbork
vaults and for the spread of the triradial in the territory of the Teutonic Knights. Alterna-
tively the two Malbork rooms can be seen as combinations of the typical two-aisled secular
hall with the idea of triradial vaults applied over the whole space. The Knights had already
made modest use of triradials — quite independently of English influence — since the 1280s,[10]
and for their use over a whole space there was a precedent close at hand in the vaults
(dated *c.*1300) of the chapter house at Pelplin, lying only twenty-five miles south-west of
Malbork.[11] Whether the Lübeck chapel or these more local solutions inspired the architects

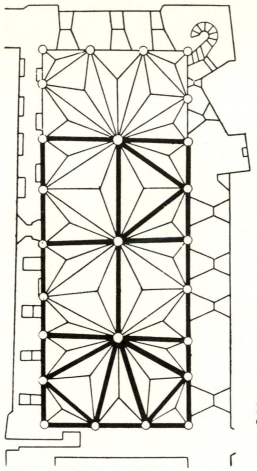

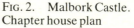
FIG. 2. Malbork Castle.
Chapter house plan

at Malbork, no English chapter house or retrochoir — not even the strikingly similar examples at Wells — is needed to explain this sequence. At best, English influence on the Knights can be recognised only as a vague presence, felt indirectly and indistinctly behind the more immediate influence of local forms.

The failure to take into account local precedent also makes other claims for English influence in the Baltic seem one-sided or far-fetched. The west end of St Mary at Stralsund (begun 1416) owes its inspiration not to the west towers and transept of Ely cathedral but to a *Backsteingotik* tradition of large westworks with single towers.[12] The use of a gable to break up large panels of tracery in the west towers of St Mary at Stargard-Szczeciński (15th century) can be seen, not as a reflection of English tracery design, but as the applica-tion to a tower of the brick panels of gables and tracery used by Hinrich Brunsberg for the exterior decoration of his churches.[13] Similarly, the vaults, the flat east end, the capitals and the great eastern gable of the choir of St James at Toruń, began in 1309 by the Teutonic Knights as their parish church, are all elements which may have English analogies, but which

derive from local precedent in the Chelmno region or from earlier Mendicant and Cistercian patterns in northern and middle Germany.[14] Finally, the high vault of the choir of Pelplin (closed sometime before 1323)[15] is simply the combination of Prussian triradials with the longitudinal ridge rib used in the choir aisles. It need have no genetic relationship with the vault of the lower chapel of St Stephen's chapel Westminster, or the Lady chapel of St Augustine at Bristol.[16] If each claim for English influence is examined on its own merits, without invoking a nexus of other hypothetical English connections, then it becomes clear that English ideas made only a partial and fleeting impression on the progress of north German *Backsteingotik*. Lincoln's influence in Pelplin and the debt which the Briefkapelle in Lübeck owes to Wells and other English chapter houses are significant, for they triggered off a new interest in patterned vaults; but the English prototypes were soon forgotten in the creative excitement that followed. Jean Bony, a strong advocate of English influence in the Baltic, admitted that 'suggestions from abroad become irresistibly caught up, wherever they are adopted, in other circuits of speculation and develop into unexpected variants, which give them a new character'.[17]

Similar problems of direct and indirect influence are raised by the supposed connections between the Decorated work at Wells and the architecture of Peter Parler in Prague. Bock first isolated Wells — and to a lesser degree related West Country buildings — as a principal source of the choir of Prague cathedral (Figs. 3 and 4). He argued that the prominent balustrade in Prague has precedents in Exeter and Lichfield cathedral choirs; the skeletal vaults of the sacristy and south transept portal are prefigured in the flying ribs of the choir screens at Lincoln and Southwell and of the ante-chapel to the Berkeley chapel at St Augustine at Bristol; the net vaults of the choir can be derived from English net vaults with limited penetrations, such as Wells and Gloucester cathedral choirs; while for Peter Parler's curious device of setting the clerestory windows back from the inner plane of the wall and connecting them to the vault shafts by obliquely-placed panels of tracery Bock found a precedent in the interior clerestory passage of the Wells choir, with its splayed super-imposed arches flanking the clerestory windows.[18] These English derivations appeared all the more convincing when Reiner Haussherr put forward the suggestion that the famous cycle of busts in the Prague choir triforium, commemorating the Emperor Charles IV and his family and court, was directly inspired by the use of royal and ecclesiastical busts and heads in English 14th-century interiors, for example those above the wall passage openings of the Lady chapel of St Augustine at Bristol.[19] Bock and Haussherr both suggested that Peter Parler may have been introduced to English ideas through the connections between his father and Cologne cathedral, and this hypothesis was given some weight by Rainer Palm's recent claim that some tracery patterns in the choir stalls of Cologne cathedral (1308–11) and what may be Heinrich Parler's work at Ulm (*c*.1340) derived from the windows of the Lady chapel at Wells.[20] Peter Parler's very early use of flowing tracery in Prague (the first example is the portal to the sacristy, 1356–62) has also been seen as a sign of English influence.[21] All these attributions, and many others, have merged together to establish a seemingly invincible case for the derivation of many of Peter Parler's more dynamic and wilful creations from the English Decorated style, and particularly from the architecture of Wells and the West Country. Most scholars accept this English contribution as a certainty, and some have even gone as far as to suggest that the English elements in Peter Parler's work are so authentic that the young mason must have spent part of his *Wanderjahr* in England.[22]

It would be perverse to dismiss all these English parallels as lucky coincidences. The similarities between the Decorated Style and Peter Parler's works are too insistent to be ignored. Indeed, as we shall see later, there is reason to believe that an interest in English

FIG. 3. Prague Cathedral.
Elevation of choir

ideas was not confined to Peter Parler, and that the Prague lodge continued after his death to be a point of distribution for English ideas in southern Germany. Nevertheless, the English contribution in Peter Parler's work must not be allowed to overshadow the enormous debt he owed to his German training; and in recent years there are signs that German scholarship may have exaggerated his dependence on England. In the first place, the idea of an English *Wanderjahr* cannot stand up to analysis. Everything suggests that Peter Parler was permanently resident in Bohemia from his arrival in Prague in 1356 to his death in 1399. If he did leave Prague, it may have only been to accompany Charles IV on his continental travels.[23] Therefore his English journey must have taken place before 1356, and we would expect English ideas to appear in some of the southern German buildings which the young mason may have worked on before his call to Prague. But in none of these enterprises — the choir of the Holy Cross church at Schwäbisch Gmünd, the nave and choir aisles of Augsburg cathedral, the church of Our Lady at Nürnberg, the church of Our Lady at Esslingen, the transepts of the Cistercian church at Salem, the choir of the Cistercian church at Kaisheim — is there the slightest trace of English influence of the kind we encounter in Prague.[24] And yet, paradoxically, it is only in Prague, when English buildings are no longer directly accessible to Peter Parler, that the English similarities begin.

Second, the English motifs at Prague are expressed in the language of German Rayonnant, not English Decorated. If Parler had visited English buildings in the West Country in the late 1340s — some of them, like Gloucester and Exeter, still under construction — one would expect some analogies with English moulding profiles in Parler's work. But his mouldings are typically 'continental' (Diagram page A). The use of a large roll flanked by beads and hollows, the preference for casements and bowtells, and the liking for angular wedge-shaped projections — what Kletzl called *Zwei- und Dreikanter*[25] — are all elements which distinguish Parler's profiles from those of his predecessor in Prague, Mathias of Arras.[26] Although some of these profiles appear in early Perpendicular buildings in the West Country (the south transept of Gloucester cathedral, the choir clerestory of Lichfield cathedral), the common source for both sets of mouldings is proably north-eastern France and the Lower Rhine. Certainly Cologne cathedral and its derivatives in the Rhineland and further east has a decisive influence on Peter Parler's architectural details in the choir of Prague cathedral. For some time scholars have seen in the broad diamond-shaped bases and boldly projecting shafts of the choir pillars a reversion to the 'classic' High Gothic profiles of the pillars of Cologne cathedral;[27] and in the lower stories of the south-west tower of Cologne and in the adjacent south-west aisle bays of the nave, as well as in a series of early 14th-century buildings relating to Cologne—the 'triangle' at Erfurt, the Werner chapel at Bacharach, and the nave of St Catherine at Oppenheim—there are mouldings which anticipate closely Peter Parler's in Prague (Diagram Page A).[28]

This dependence on Rhenish Rayonnant makes the arguments for Parler's English journey look much less convincing; it also suggests that some of the 'English' features in Prague are not English at all, but are derived from Parler's early training in Germany and his continental Rayonnant background. For example, the famous diagonal breaks in the elevation wall at Prague are pre-figured, not only at Wells, but in the ambulatory cornice of the choir at Schwäbisch Gmünd, by Peter Parler or his father Heinrich.[29] Similar breaks, at the same height, are also to be found on the *exterior* of the Prague clerestory, and for these exterior panels there are precedents in the diagonal projections which mark each clerestory bay of the nave at Reims cathedral (Pl. XXIв), or of the choir at Cologne where a similar movement is set up across the exterior of the clerestory windows.[30] But these exterior projections may provide a vital clue to the origins of the oblique panels inside the elevation wall, for it was hardly beyond an architect of Peter Parler's ingenuity to apply this common

G

DIAGRAM PAGE A

A. Prague Cathedral, Wenceslas chapel, jambs of west portal

B. Prague Cathedral, Wenceslas chapel, Jambs of north portal

C. Bacharach, Wernerkapelle, choir wall responds, interior (detail)

D. Nuremberg, St Mary, nave aisle shafts (detail)

E. Augsburg Cathedral, choir, responds of piers

F. Cologne Cathedral, north east pillar of south west tower (detail)

G. Prague Cathedral, Wenceslas chapel, wall shafts (detail)

H. Prague Cathedral, wall respond in choir aisle (Peter Parler) (detail)

I. Cologne Cathedral, responds and window jambs, south aisle of nave (detail)

J. Kolin, St Bartholomew, choir pillars (detail)

K. Cologne Cathedral, rib of lower storey of south west tower

L. Prague Cathedral, sacristy, rib

M. Magdeburg Cathedral, Tonsur, rib

N. Oppenheim, St Catherine, nave pillar (detail)

O. Prague Cathedral, sacristy, rib

DIAGRAM PAGE B

BPC 1979
DRAWINGS NOT
TO SCALE

BRISTOL: ST MARY
REDCLIFFE : NAVE
AISLES

STEYR : PLAN
FOR CHOIR AISLES

STEYR : CHOIR
AISLES

BRAUNAU : PARISH CHURCH :
NAVE AISLES

VIENNA : ST MARIA AM GESTADE
NAVE GALLERY

EXETER CATHED-
RAL : ROOD SCREEN

VIENNA : DRAWING IN AKADEMIE
DER KÜNSTE NR 16921 v

FRANKFURT : PARISH
CHURCH : NORTH PORCH, WEST
TOWER .

WELLS CATHEDRAL
CHOIR AISLES

NEW COLLEGE OXFORD
STAIRCASE TO HALL

CANTERBURY CATHEDRAL
NAVE AISLES

LANDSHUT: HOLY
SPIRIT : CENTRAL
AISLE

OTTERY ST MARY:
VAULT OF LADY
CHAPEL

LANDSHUT; CHAPEL
OF ST CATHERINE

SALZBURG : FRANCISCAN CHURCH
CHOIR

device of cathedral Gothic to the interior as well as the exterior of the clerestory, trans-
ferring something of the sharp angularity of the buttressing system to the Ste-Chapelle-like
'glass house' of the sanctuary.

The same stylistic ambiguity underlies the sources of the vaults and window tracery of
Parler's buildings in Prague and its environs. The design of these essentially linear elements
rank among Peter Parler's most original and ingenious conceptions, and yet it is here, in the
devising of new linear patterns, that scholars have seen him most indebted to English
precedent. In the portal to the sacristy (c.1360), in the chapel of St Laurence (c.1362) and
in the clerestory of the choir in Prague (c.1380), as well as in the clerestory windows of the
choir of St Bartholomew at Kolin (1360–85), Peter Parler created some of the earliest
examples of fully-developed, large-scale flowing tracery on the continent.[31] The prolifera-
tion of flowing tracery in England in the first half of the 14th century may provide an
obvious precedent, but not such an obvious source. Apart from a few motifs that are com-
mon to all flowing tracery (interlocking mouchettes, divergent mouchettes, and mouchette
wheels), Parler's designs have little in common with English patterns, and certainly suggest
nothing of the close familiarity with English designs shown by early Flamboyant tracery in
France. Indeed, it may be easier to see Parler's tracery as an ingenious elaboration — carried
on perhaps against the background of a vague knowledge of English tracery — of those
suggestions of curving forms to be found in German Rayonnant tracery in the first half of
the 14th century. These suggestions, either discreet (Cologne Riss F, c.1310, choir stalls
1308–11)[32] or bold (north transept window Salem Cistercian church, c.1350), often occur in
buildings by the Parler family or in the circle of Parler influence.[33] The interweaving pat-
terns in the nave windows of Schwäbisch Gmünd must have been known to Peter Parler,
and they in turn suggest a knowledge of early curvilinear tracery in Cistercian architecture
in Austria and south-west Germany in the first half of the 14th century.[34] Once again we
may be dealing here with the phenomenon of a minor and familiar motif taking on new
powers of suggestion; something that was previously little more than a mannerism suddenly
acquiring, in the hands of an imaginative architect, a new visual impact.

The same power of creative adaptation is evident in Peter Parler's vault designs (Fig. 4).
The succession of decorative vaults in Prague cathedral, starting with the sacristy vaults of
1356–62 and ending with those of the high choir (finished before 1385) are now seen as
Peter Parler's most decisive contribution to the creation of the German Late Gothic.[35]
The problem of the sources of these vaults has therefore attracted much attention. Scholars
have suggested debts to early decorative vaults as far apart as south-west Germany, East
and West Prussia and Bohemia,[36] but Bock and Pevsner have argued forcefully that the
decisive influences came from the Decorated Style, particularly the vaults of Wells and the
West Country.[37] What are the merits of these 'English' claims?

Peter Parler's rib patterns are complicated enough to be read in a number of different
ways, but the ingredients of the patterns fall clearly into three categories. First, the triradial,
used in the eastern bay of the sacristy and the south porch of Prague cathedral; second, the
skeletal vault, used in conjunction with pendant bosses in the two sacristy bays, and as a
fan of ribs in the south porch (Pl. XXIIA); third, the simple cross-rib vault which as a
unit is multiplied and combined in different ways to produce net-like patterns, initially in
the western bay of the sacristy, then in the vault of the chapel of St Wenceslas (consecrated
1367), and finally in the choir high vault. Obviously, the triradial does not come from
England, where it was used comparatively rarely. A much more likely source of this motif —
as scholars have long recognised — is the series of Cistercian buildings in south-west Ger-
many which from c.1330 adopt the triradial as the leitmotif of their vaulting. It is hardly
conceivable that Peter Parler, as a young mason working under his father in Schwäbisch

Gmünd, did not visit the summer refectory at Bebenhausen (complete by 1335), or the chapter houses at Maulbronn (second quarter of the 14th century) and Eberbach (*c.*1350)—all with 'umbrella' vaults composed of numerous branching triradials.[38]

The use of skeletal ribs is, at first sight, much more English, for in England and Wales a number of examples appear in small-scale works of architecture at Lincoln, Southwell, Bristol, and St David's.[39] But Germany has its own early examples of 'flying' ribs at Strasbourg, Freiburg and Magdeburg. Roland Recht has reconstructed the vault of St Catherine's chapel in Strasbourg cathedral, begun 1331 and complete by 1347, as two square bays covered by eight-pointed star vaults made up of orthodox triradials, and with pendant bosses and, probably, flying ribs.[40] The upper storey of the west tower at Freiburg-im-Breisgau, of *c.*1304, has skeletal ribs;[41] and in the so-called 'Tonsur', a polygonally-apsed chapel opening off the north walk of the cloister at Magdeburg cathedral, and dated by Ernst Schubert to the 1330s, there are skeletal ribs erected under a flat ceiling (Pl. XXIIB).[42] All these vaults are earlier than Peter Parler's, and occur in places with direct and indirect Parler connections. The links between the Parlers and Freiburg are well documented, for the architect of the minster choir, appearing first in 1359, was a 'Johannes of Gmünd', and

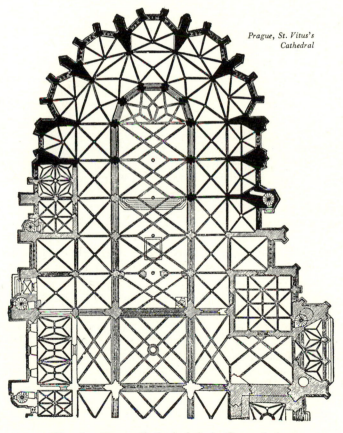

Prague, St. Vitus's Cathedral

Fig. 4. Prague Cathedral choir. Ground plan

at least two of the many medieval drawings of the Freiburg steeple, done as copies of the completed building in the third quarter of the 14th century, can be attributed to members of the Parler family.[43] The ties with Strasbourg go back to Peter Parler's father Heinrich Parler, who was probably the second master mason of the nave of the Holy Cross church at Schwäbisch Gmünd (c. 1320–48), and who learnt much from Alsatian and south-west German architecture.[44] But Recht suggests that Peter Parler's contacts with Strasbourg may have been more direct, namely through the Emperor Charles IV who was a friend of the Strasbourg bishop, Berthold von Bucheck, the founder of St Catherine's chapel. The Emperor would have seen the completed chapel on his visit to Strasbourg in 1347, and not only did its original vaulting anticipate Parler's flying ribs and pendant bosses in the Prague sacristy, but the details of the chapel are so close to those of the Wenceslas chapel in Prague that the Emperor may have sent Peter Parler to study the chapel in the later 1350s.[45]

These long-standing connections with Strasbourg may also explain the Magdeburg Tonsur in this group of precedents. The Tonsur was going up at the same time as the main portal and first story of the west façade of the cathedral, the design of which clearly shows a knowledge of the lower parts of the Strasbourg west front. The family's links with Strasbourg may therefore have provided the young Peter Parler with an introduction to the current work at the Saxon cathedral, and it is worth noting, in this context, a number of details in the 14th-century work at Magdeburg which anticipate some of Parler's motifs in Prague. The mouldings of the ribs of the Tonsur are close to Peter Parler's (Diagram Page A); the construction of the apse of the Tonsur from an even number of polygonal sides anticipates the geometry of the Parler apses at St Bartholomew at Kolin and St Barbara at Kutná Hora; the use of a balustrade around the exterior of the choir clerestory, an archaic motif derived perhaps from Reims, anticipates Parler's revival of this horizontal accent in Prague; the west window of the main facade, dated by Schubert to c.1360, has divergent mouchettes which anticipate similar patterns in the Prague clerestory and the nave aisles of St Barbara at Kutná Hora; and finally, the openwork tracery balustrade running behind the gable of the west portal exactly prefigures the tracery of Parler's balustrade above the Prague clerestory. If any further evidence was needed to prove Peter Parler's debt to the 14th-century work at Magdeburg, it is provided by the now-destroyed Fountain Pavilion at the Cistercian church of Zlatá Koruna in southern Bohemia. The pavilion was strikingly similar to the Magdeburg Tonsur: polygonally-shaped, it projected from a walk of the cloister and had an almost identical vault with skeletal ribs supporting a flat ceiling. It is significant that Libal dates this pavilion to c.1360, and attributes it to Michael Parler, an older brother of Peter Parler, who is mentioned as a mason at Zlatá Koruna in 1359.[46] Whether Peter Parler was introduced to Magdeburg via Strasbourg or through his elder brother does not alter the conclusion that the young mason could have arrived at the idea of skeletal vaults without recourse to England.

It was not, however, the triradial nor the flying rib but the simple cross-rib vault that became the vehicle for Peter Parler's most imaginative experiments in patterned vaulting. In the west bay of the sacristy in Prague he groups four of these cross-rib bays together so that four ribs, springing from the middle points of the bay, form the outline of a square that lies at 45° to the square plan of the whole bay. These two components—the rotated square and the small cross-rib unit—become the leitmotifs of the extraordinary vault over the Wenceslas chapel, where the pattern is more complicated and the cross-ribs overlap to form parallel tracks swinging across the whole room. A decade later, in the 1370s, Peter Parler adopted these motifs as the basis for the design of the choir high vault. This vault, also made up of parallel ribs, consists, in each bay, of two overlapping cross-rib patterns with their points of intersection marked by bosses.

All these variants of the cross-rib vault have precedents in England. Pevsner pointed to the western chapels of the nave of Lincoln cathedral and he drew attention to the wooden net vault of York Minster (begun probably in 1345 and complete by 1360) as an important precedent for the high vault at Prague.[47] But in England the idea of the vault as a mesh of small cross-ribs overlapping to form a series of squares rotated at 45° had a greater success in the West Country. The motif appeared first in the side aisles of the choir of St Augustine at Bristol (from 1298), then in the Exeter cathedral rood screen (1317–26), and in the strange criss-cross motifs over the south transept of Gloucester cathedral, and finally, in a series of highly complicated patterned vaults in the nave and choir of Tewkesbury abbey and the choirs of Gloucester and Wells cathedrals and Ottery St Mary.[48] These West Country examples can all be described as net vaults, and when Peter Parler arrived in Prague in 1356 no area of Europe could match the west of England in the variety and complexity of this type of vault. Parler's high vault in the Prague choir is the first of a long series of net vaults in German Late Gothic, and it was natural for Bock to assume that it presupposed a knowledge of the English West Country.[49] In particular the net vaults used by William Joy at Wells and Ottery St Mary in the 1330s anticipate Prague in having no conventional diagonal ribs, and in filling each bay with two small cross-rib patterns (overlapped by other cross-rib configurations). In the Lady chapel at Ottery St Mary the diagonal ribs break away from the transverse ribs in a way especially reminiscent of Parler's high vault (Diagram Page B).[50]

The simple geometric principles underlying the design of these English vaults also prefigure the Parler net vault. It is obvious that the Parler vault and the West Country precedents are variations on that old geometrical formula of rotating and subdividing the square —the 'Vierung über Ort' or what Frankl called the *ad quadratum* rule — used by medieval architects from Villard de Honnecourt to Mathes Roriczer for such different tasks as the laying out of cloisters, the design of towers, and the tapering of pinnacles.[51] In the high vaults at Prague the formula is handled especially cleverly, for Kotrba has shown that the crucial point where the diagonal ribs join the interrupted transverse arches is determined by an invisible grid of diagonal squares and a network of simple criss-cross patterns.[52] The fact that Parler applied the principle of the rotating square with such consistency to the design of vault patterns may explain his reputation (however unfounded) among 15th-century German masons as the architect who brought this old geometrical formula to light. Both Hans Schmuttermayer and Mathes Roriczer, in their treatises on the manipulation of rotating squares in the design of pinnacles, acknowledge that they owe the technique to the 'Junckhern' or 'iungkherrn' of Prague, that is, the Parler family.[53] But since the West Country architects had used this formula in the design of net vaults much earlier than Peter Parler, it is tempting to see the English examples as Parler's inspiration and the source for much of his posthumous reputation.

These visual and geometrical similarities between the net vaults of Prague and England suggest some knowledge of English ideas in the Prague lodge. But there is equally strong evidence that other sources lay closer at hand from which Peter Parler could draw his main inspiration for the net idea. First, the high choir vault in Prague can be seen as the result of a purely internal process of design, starting with a simple pattern of cross-ribs and applying the rotating formula in more complicated and ingenious variations. For the vault which starts this sequence, that of the western bay of the sacristy, there are sources enough in German buildings connected with the Parlers. At Cologne cathedral the sacristy, complete by 1277 (Fig. 5), and the lower storey of the great south-west tower (begun before 1325) are both square spaces covered with four small cross-rib vaults. The only difference is that the Cologne vaults are in the form of radiating cones of ribs whereas the Prague bays have no

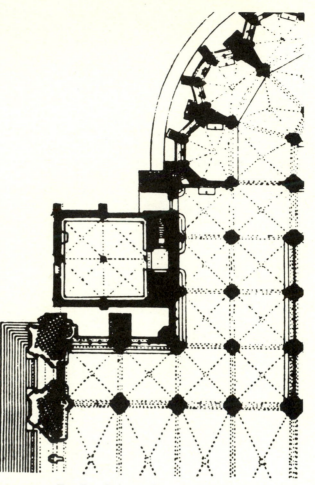

Fig. 5. Cologne Cathedral, sacristy

central support. But the young Peter Parler may be referring precisely to this omission by his ingenious flying ribs which in both sacristy bays radiate from a pendant boss and hang like skeletal cones, as if waiting for a central support to be inserted under them.[54] The subdivision of a large square space into smaller squares was also the problem confronting the architect of the nave of the church of Our Lady in Nürnberg, begun *c*.1353, and perhaps an early work of Peter Parler;[55] and in the choir of the Cistercian church at Salem, a building certainly known to Parler masons in south-west Germany, the idea of tilting the square to produce a new kind of vault pattern occurred as early as 1299, in the eastern bay of the sanctuary, where a polygonally-shaped vault figure is derived out of the flat east end by diagonally twisting the square formed by the sanctuary east bays.[56]

It is therefore quite possible that an architect of Parler's ingenuity could have arrived at the form of the net vault in the high choir by manipulating the older German practice of vaulting in small cross-rib compartments. But if Parler needed a precedent to justify the

use of such a novel form of vault over the sacred space of a cathedral choir then he could have found it, not only in England, but in Anjou, and in Angevin-influenced buildings. In the church of Toussaints at Angers (c.1240), or of St Jouin de Marnes (mid-13th century) the Angevins created the earliest examples in Europe of the net vault, composed, like the Parler vaults and some of the English West Country vaults, of two small cross-rib vaults in each bay, their diagonal ribs continuing into the adjoining bays to form a tight mesh. Also, like the later English and German examples, the vaults have limited penetrations and were often in the form of pointed barrels.[57] The first English net vaults may have been directly inspired by these Angevin solutions, but Parler's knowledge of Anjou was almost certainly indirect, and it seems to have come, paradoxically, via the Cistercians. The Cistercian abbey church of Zbraslav (Königssaal, Aula Regia), just south of Prague, was founded by King Wenceslas II in 1297. The choir of the church was substantially complete by 1333, but destroyed in the Thirty Years War. If we can trust a 19th-century transcription of a plan and elevation of the church,[58] the choir was in the shape of a hall, and the vaults over the eastern bay of the sanctuary consisted of two small cross-rib patterns placed side by side (Fig. 6). In elevation the effect must have been very similar to that multiplication of cross-rib patterns found in the vaulting of some 13th-century Angevin east ends (e.g. St Jean at Saumur) (Fig. 7). The comparison with Anjou is not as far-fetched as it may seem, for in the second half of the 13th century Bohemia and Moravia were quick to adopt Angevin vaulting

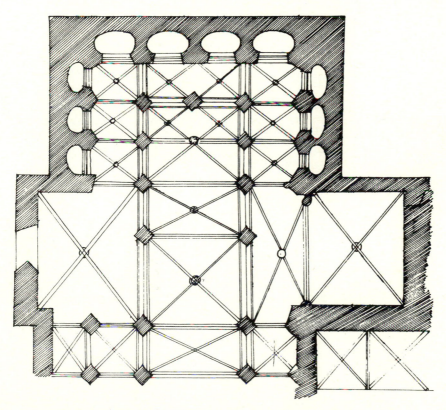

FIG. 6. Zbraslav, Cistercian church. Reconstructed plan of choir

patterns, either directly or via Westphalia;[59] and some indirect support for my reconstruction of Zbraslav is given by the vault over the eastern bay of the sanctuary of Kraków cathedral in southern Poland, begun in 1320 under the influence of Zbraslav (Pl. XXIIc).[60] Although the Kraków vaults use triradials and not cross-ribs, both buildings show the same massive half cone of ribs springing from the middle of a flat eastern wall. If Peter Parler needed a respectable precedent for the use of small cross-rib patterns in a high vault then he could have found it in Zbraslav. Before the foundation of Prague cathedral in 1344 Zbraslav was the most up-to-date and prestigious Gothic church in Bohemia. It was the first of the Bohemian Gothic *Königskirchen*, intended by Wenceslas II as the mausoleum of the Premyslid dynasty, and containing the tombs of Wenceslas himself, his daughter, and Queen Elizabeth, wife of King John of Luxembourg. Situated only ten miles south of Prague, Peter Parler must have visited the church, at the latest, soon after his arrival in Prague in 1356.

As far as we know Peter Parler himself never used, for a main vault, this 'pure' Angevin pattern of two small adjoining cross-ribs in one bay. Such a net vault appears over the canopied tomb depicted in the Stuttgart fragment nr.2, which Kletzl saw as a design by Peter Parler for the tomb of St Adalbert in Prague,[61] but this drawing may not be connected with Prague or Peter Parler at all.[62] Nevertheless, the appearance of this simpler type of net vault from c.1375 onwards in such distant parts of Central Europe as Legnica (Liegnitz) in Lower Silesia (nave of SS Peter and Paul church), Kraków in southern Poland (choir of Dominican church), and Munich (choir vault of former Franciscan church) suggests that the initial impetus for the popularity of this simpler type of net came from Prague.[63] The reappearance of the pattern in the mid-15th century in Graz, under Frederick III (nave of Graz cathedral, complete by 1464; side aisles of Franciscan church) can be seen as a revival of what was by then a traditional form. Such a return to 'orthodoxy' is typical of the architecture of Frederick III, and the Graz vaults need not presuppose the influence of the Wells choir vault.[64]

The German Rayonnant and Cistercian origins of the Parler net vault confirm the conclusion suggested by other aspects of Peter Parler's style: that an appeal to English inspiration is superfluous when so many of Parler's innovations have precedents in his own German background. In particular Cologne and Strasbourg cathedrals and their affiliations seem to have played a decisive part in Peter Parler's early training; and his introduction to the latest work at Cologne was certainly facilitated by his father Heinrich, who worked there as a foreman until c.1320. This Cologne connection raises another issue concerning the English origins of Peter Parler's style. In the first half of the 14th century the lodge at Cologne was still a foyer for the latest Rayonnant innovations, and in view of the close trading contacts between the city and England, Bock and Haussherr suggested that Peter Parler may have first come into contact with English ideas through his family connections with the cathedral.[65] Rainer Palm gave this hypothesis some substance by arguing that certain tracery forms in the choir stalls of Cologne cathedral, definitely dated 1308–11— such as prominent inward-pointing spheric triangular shapes, and the oculus filled with alternating circular patterns and 'panel tracery', or bullet-shaped patterns—derived from the tracery of the Lady chapel at Wells (which he dated c.1300–15) and the clerestory windows of York Minster (which he dated c.1300–10).[66] But again, no English source is necessary to explain these very German-looking patterns. Both occur in less developed form in the Strasbourg Riss B (1275/77); and there is good reason to believe that these English examples date *after* the Cologne stalls. Even on the most generous estimate, Palm's date for the Wells Lady chapel is too early; it may have been begun, if Peter Draper's interpretation of the documents is correct, as late as c.1320–23.[67] The York clerestory

windows are dated by Nicola Coldstream to sometime before 1310, and she points out that the 'panel tracery' of the windows is a rare motif in England.[68] But it is present in the Strasbourg Riss B of 1275/77, and it was widespread in the Rhineland from the turn of the 13th century, so that if there was any influence between York and Cologne the tracery motifs suggest that ideas went the other way, from the Rhine to England. Far from proving the strength of English influence in the Lower Rhine and the importance of Cologne as a transmitter of English ideas to Peter Parler, Wells and York suggest the reverse: that Cologne had become, c.1300, a centre for the diffusion of Rhenish tracery patterns, not only east of the Rhine, but across the channel.

This attempt to place Peter Parler's style in a more 'local' perspective may help to correct what might be called the 'English bias' of some German scholarship; and it may also finally dispose of the theory of Peter Parler's journey to England. But none of these German explanations can completely exclude the likelihood of English influence in Prague. The elusive intimations of English — particularly West Country — influence remain, and they suggest that Peter Parler's innovations, although explicable through German precedent,

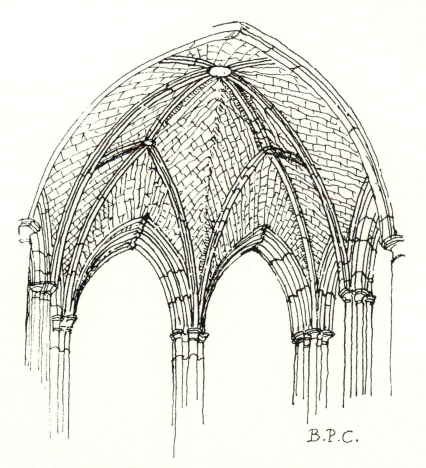

FIG. 7. Zbraslav, Cistercian church. Reconstruction of sanctuary vault

took place against the background of some knowledge, however vague, of English Decorated. Two-dimensional vault patterns, drawn in a sketchbook like Villard de Honnecourt's, are among the most transportable of medieval architectural ideas, and it is at least likely that a fund of English material was collected in Prague during Peter Parler's lifetime and was available to a younger generation of architects who worked there. Admittedly, no drawings of English buildings can be found in the Parler drawings from Prague now preserved at Ulm, Stuttgart and Vienna, but a number of English-looking vaults appear in Prague-influenced buildings outside Bohemia in the first decades of the 15th century, and since some of these buildings are not directly connected with each other and show no evidence of a link with England, they all suggest the presence, in Prague, of a lost corpus of English designs.

English-looking patterns are particularly evident in Vienna, where the lodge of St Stephen's came to be dominated, from c.1400/01 onwards, by Prague-trained architects, all of them working on the south tower; first a master Wenczla (c.1403–04) identified by Kletzl as Wenzel the son of Peter Parler;[69] followed by Peter von Prachatitz (1404–29) and Hans von Prahatitz (1429–35).[70] The English similarities in the work of this Parler lodge are most clearly displayed in the vaults of the nave of St Maria am Gestade in Vienna, begun in 1394 (Fig. 8). The first architect of the nave was a Master Michael,[71] court mason of Leopold III and Albrecht III. The nave was completed in 1414, the year of Michael's death,

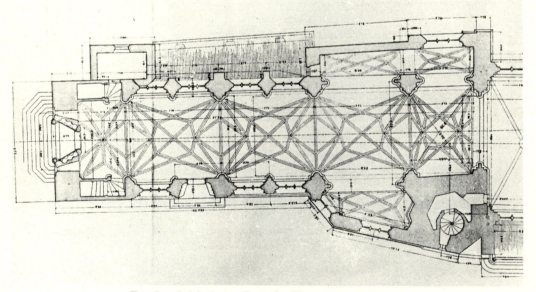

FIG. 8. St Maria am Gestade, Vienna, nave plan

but how much of it was built under his direction and according to his plans is not certain,[72] for the west front, the porches and the vaults of the church do not conform to what we know of Michael's style, but are closely related to the Parler style of the Vienna south tower. The vaults are remarkably English in plan and in general effect. The high vault is the first surviving example of a true lierne vault in Central Europe. Lozenge-like patterns, superficially similar to liernes, appear in Peter Parler's net vault in Prague cathedral, and in his vault under the Old Town Bridge Tower in Prague. Lozenge-type patterns are also to be

found in the choir vault of the Karlshof church in Prague (1350–77?), in the western bay of St Maria am Gestade nave, and in the second story of the south-west tower of the abbey church at Klosterneuburg (finished by 1405).[73] But the nave vault of St Maria am Gestade has true lierne ribs meandering across the summit of each bay. The shape of the vault as a pointed barrel, the lack of bosses, and the brittle skeletal quality of the whole configuration is reminiscent of the south transept vault at Gloucester cathedral; while the use of conventional diagonal ribs surrounded at the apex by polygonal-shaped lierne figures has an almost exact precedent in the lierne vault of the north choir aisle at Ely cathedral, of c.1330. The vaults of the two narrow side chapels of the nave of St Maria, using four little cross-ribs and opening out the cells of the vault into the adjoining space again suggests an English precedent, in this case the vaults over the side aisles of St Augustine at Bristol. But the closest English analogies are to be found in the vault under the west gallery, which forms a huge coving across the western bay of the nave. In elevation the ribs form a net, while in plan the design resolves itself into an overlapping of smaller and larger cross-ribs (Diagram Page B). Marlene Zykan has compared this vault to the plan of a net vault in the Vienna Akademie der Künste (Inv.-Nr 16921v),[74] dating to the second half of the 15th century but possibly a copy of a 14th-century design (Diagram Page B). Both the drawing and the executed vault are remarkably similar to the type of net vault with one- and two-bay diagonal ribs pioneered by West Country masons, first—as Bock pointed out—in the Exeter rood screen (Diagram Page B), and then in the nave of Tewkesbury and the choirs of Tewkesbury and Gloucester.[75]

Goetz Fehr attributed these vault patterns to Master Michael,[76] but they are hardly consistent with his known work. Admittedly, his tall pinnacled cross at Wiener-Neustadt, the so-called 'Spinnerin am Kreuz' of 1381–84 has provoked comparisons with the English Eleanor crosses, and suggests at least a passing acquaintance with Parler sculpture in Prague;[77] but its real pedigree lies in the pre-Parler work at St Stephen's, particularly in the design for triangular pinnacles in an unrealised plan for the south tower.[78] If the vault designs are therefore not by Master Michael, then they must be part of the strong injection of Parler/Prague forms into the nave during its construction. No vault in Prague, or any drawings from the Prague lodge anticipate the lierne vault of the nave,[79] but given the close associations between the Parlers and the church, it is likely that the vault patterns derived from some central fund of ideas in Prague, thus suggesting, indirectly, the presence of English patterns in the Prague cathedral workshop. Certainly Wenzel Parler and his successors, before they arrived in Vienna, employed English-looking motifs in the lower stages of the south tower in Prague (begun 1396).[80]

The hypothesis that the Prague lodge was active in the distribution of English ideas, or of English-looking patterns, to various southern German centres in the first decades of the 15th century may explain the appearance, at that time, and in widely separate parts of Germany, of two English innovations, both from the West Country: the curving rib and the vault with applied tracery patterns.

The idea of applying blind tracery to a vault surface by decorating its small rib patterns with cusps was first tried out in England in the choir of St Augustine at Bristol (sometime after 1298). It then spread to the high vaults in the choirs of Wells and Ottery St Mary, and reappeared at Bristol in the nave south aisle of St Mary Redcliffe (Diagram Page B). If this little device had any influence in Central Europe its impact was delayed. Only in the second quarter of the 15th century did it first appear, in Upper Saxony and the Middle Rhine. The north porch of the west tower of Frankfurt parish church, begun c.1415 by Madern Gerthener has perhaps the earliest tracery vault on the continent, its curving ribs filled with large cusps.[81] In Middle Germany a group of tracery vaults appear in the 1440s,

some of them ascribed to the leading architect of the period in Upper Saxony, Moyses von Altenburg.[82] The earliest may have been the vault over the Fürstenkapelle at Meissen cathedral (1443–46) (Fig. 9), and very similar vaults appear in the choir of the castle chapel at Altenburg (1444) and in the nave of St Catherine at Borna.[83]

These tracery vaults in Saxony are so different from those in Frankfurt that any influence from the Middle Rhine to Upper Saxony is unlikely. A more reasonable explanation for their appearance, in distant parts of Germany, would therefore be a common source, and this may well have been the Parler lodge in Prague. If Madern Gerthener did not actually work in Prague he belonged to a generation of German architects who learnt much from Peter Parler's innovations, and the tower at Frankfurt, together with the so-called Riss A, shows a clear debt to the Parlers. The half-hexagonal plan of the north porch, the blind flowing tracery patterns on its side walls, and the use of interlocking ogee arches and semi-circular windows all point, not so much to the 'court style' of Burgundy, but to the inspiration of Peter Parler in Prague.[84]

A similar derivation from Prague may explain the Middle German vaults. They all consist of large semicircular star-shaped motifs at the apex of the vault, decorated with

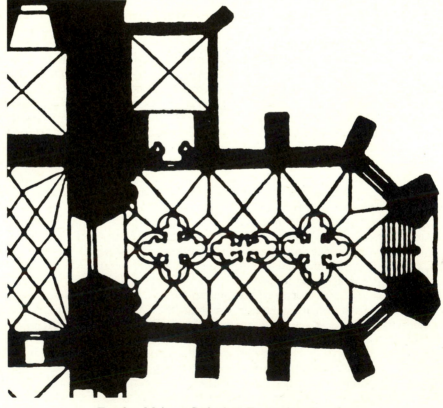

Fig. 9. Meissen Cathedral, Fürstenkapelle, plan

cusps, heraldry or fleurs-de-lis. The stylistic origins of these motifs are not clear. They do not look like English tracery vaults, nor — as we have seen — do they resemble Madern Gerthener's at Frankfurt. Therefore a direct influence from either quarter seems unlikely. Fischer and Clasen suggested a source in 13th-century Westphalian vaults with circular ridge ribs (e.g. Billerbeck), but these rustic Angevin-inspired precedents of two centuries earlier could hardly have been a decisive influence.[85] A more likely explanation lies in Parler influence from Prague. There is no evidence that Peter Parler ever used tracery vaults, but the decorative ingredients of the Middle German vaults have Parler similarities, particularly those of the Meissen chapel. Here the use of a simple net pattern, the preference for cusped semicircular tracery arches and the use of fleurs-de-lis terminations in the lobes is thoroughly Parlerian. Moreover, other references to Prague are clear in the whole design of the Meissen and Altenburg chapels. Both chapels were founded by Margrave Frederick IV and inspired in their general shape and elaborate exterior details by Peter Parler's chapel of All Saints in Prague castle, begun c.1370. The influence of this Prague chapel in Middle Germany in the first two decades of the 15th century was profound. It was the inspiration for a whole group of richly embellished chapel choirs, known as 'Middle German choir façades', to which Altenburg and Meissen belong.[86] To what extent the vaults of Altenburg and Meissen reflect those in the Prague chapel is a mystery, for the Prague vaults were rebuilt in the 16th century. Czech scholars agree that the chapel had some kind of net vault,[87] and since Meissen and Altenburg chapels also have a net pattern, it is tempting to suggest that the Prague chapel vaults, like those of the Saxon examples, combined this net pattern with some kind of tracery decoration. Admittedly, such a suggestion is little more than speculation. The vault at Meissen was not completed until twenty years after the beginning of the chapel, and that at Altenburg replaces the original vault, completed by 1413.[88] By the time Moyses von Altenburg constructed these vaults the Parler inspiration which so clearly informs the design of the chapels may have waned; indeed the vaults may differ considerably from the original plans. In addition, vital evidence is missing. We have no record of the choir vaults of the destroyed Holy Cross church in Dresden, which, of all these Middle German 'choir façades', was the closest copy of the Prague chapel.[89] It would also be revealing to know whether Conrad von Einbeck, a pupil of Peter Parler and the architect who introduced the idea of the 'choir façade' to Middle Germany, intended tracery vaulting in his choir of St Moritz in Halle (1388–c.1420).[90] But for the present there is no evidence against the hypothesis that Peter Parler introduced, perhaps under English influence, some discreet tracery patterns in his vault for the All Saints chapel, and that this idea, together with other motifs from the chapel, took root in Middle Germany a generation later.

It is worth noting that the Prague chapel was distinguished by at least one other English-looking motif. The dado was composed of a continuous row of concave niches which ran all round the chapel and must have set up an undulating motion below the windows at least reminiscent of the wall arcades of the chapter house at York or of the dado niches of the Ely Lady chapel.[91] Moreover, the first appearance of such a vault in such a setting is quite consistent with the function of tracery vaults, for in Germany these vaults are hardly ever used in large buildings over main spaces, but were confined to porches, church treasuries, burial or castle chapels.[92] By assuming the existence of tracery vaults in the Prague chapel we can best explain the use of this rare motif, independently, in widely distant parts of the German Empire. Of course, even if the motif was first used by Peter Parler in Prague, there is no evidence that the idea came from England; but given the English precedents, and the other English intimations in Prague, it is possible that the tracery vault, like the lierne vault, entered into the mainstream of German architecture in the Bohemian capital, and

then triggered off a series of experiments in Prague-influenced buildings after Peter Parler's death.

The invention of tracery vaults in the West Country had its counterpart in the use of the curving rib. In fact, both motifs appear alongside each other in the same buildings. Curving ribs appear at St Augustine at Bristol (in the vaults of the Lady chapel reredos and of the piscina in the ante-chapel to the Berkeley chapel), in the high vault of the choir of Ottery St Mary (c.1335) and in the south aisle vaults of St Mary Redcliffe in Bristol (c.1340?) (Diagram Page B). Pevsner pointed to these curving vaults as modest precursors of the huge curving ribs used by Stephan Krumenauer and Benedikt Ried at the end of the 15th century; but to him the English examples are so modest that they can hardly be considered as sources.[93] However, Goetz Fehr has since shown that these fully developed German curving vaults grew out of a long tradition of German curving ribs going back to the early 15th century. Like the English examples, these early curving ribs in Germany are tentative experiments: the curving elements, far from dominating the whole pattern, appear as discreet accents in an otherwise conventional pattern.[94] Does this mean that the Germans knew the West Country examples?

The answer points to conclusions remarkably similar to those suggested by the tracery vault. Once again, the motif of the curving rib appears almost simultaneously in south and west Germany in the second decade of the 15th century, and in buildings impregnated with Parler motifs. In the tracery vault of the north porch of the Frankfurt west tower sometime after 1415 (Diagram Page B) and in the west choir of St Catherine at Oppenheim (begun c.1414) Madern Gerthener uses large curving ribs.[95] In the chapel of St Catherine ('soon after 1411') and in the sacristy ('around or before 1432') of the Holy Ghost church at Landshut Hanns von Burghausen inserts curving ribs into the vault (Diagram Page B).[96] According to Fehr the curving ribs of these two architects are the earliest examples on the continent of the use of the motif with a clear 'decorative' intention. At this early stage the curving patterns do not look English; it is only towards the middle of the 15th century, in the vaults used by Hanns Puchspaum in the side aisles of the choir at Steyr (before 1443) and by Stephan Krumenauer in the parish church at Braunau (begun 1439) that we see the curving lozenge patterns similar to the West Country vaults (Diagram Page B).[97] The absence of a close similarity with England in the first examples of the German curved rib suggests that we are dealing, not with a direct English connection, but — at best — with the influence of an intermediary. Fischer saw a strong Franco-Flemish component in the art of both Madern Gerthener and Hanns von Burghausen, and implied that English elements came to both architects through the 'court style' of Burgundy and the Low Countries.[98] The difficulty with this theory is that no curving ribs can be found in eastern France or Flanders that pre-date their use in Germany, and, as Ringshausen has pointed out, the surviving Franco-Flemish architecture of the later 14th century is too conservative to have stimulated the imaginative achievements of German architecture around the year 1400.[99] Nor can we posit any direct exchange of ideas between Madern Gerthener and Hanns von Burghausen: their vaulting designs are too individual to suggest mutual dependence. But throughout their work both architects show a debt to Peter Parler, and the idea of Parler influence seems the most likely explanation for the simultaneous appearance of this motif in different workshops. Madern Gerthener's Parler debt has already been acknowledged, but in a special and hitherto unnoticed way his curving vault in the north porch of the Frankfurt tower may reflect a Parler influence. In the south porch of Prague cathedral, completed in 1368, two semicircular arches run back from the trumeau to the portal doors (Pl. XXIIA). In the space between these two arches Peter Parler inserted skeletal curving ribs.[100] If this can be described as a vault, then it is the first curving vault on the continent. Madern

Gerthener's use of curving ribs also in a half-hexagonal porch, and also to connect points of support standing on a triangular plan, strongly suggests that he derived the idea from Prague.

The pedigree of Hanns von Burghausen's curving ribs is more complicated because his work contains a curious number of vaguely English similarities.[101] For example, in his use of large nodding ogee arches in the nave portals of St Martin at Landshut (1429–32), and his preference for arches composed of a central ogee and two flanking semi-circular lobes (west portal door arches, St Martin, Landshut) Fischer discerns an English source.[102] It is worth adding that some of Hanns von Burghausen's vaults look very English. William Joy was among the first architects in England to use, in the aisles of the choir of Wells, vaults with no diagonal ribs. Star vaults without diagonal ribs are one of the 'trade marks' of Hanns's vaulting; and the vault of St Catherine's chapel in the Holy Ghost church at Landshut, and those over the middle aisle of the Franciscan church at Salzburg (the latter built, perhaps to Hanns's designs, by Stephan Krumenauer) are very similar to the choir aisle vaults at Wells (Diagram Page B).[103] The idea of vaults without diagonals was taken up in the later 14th century (perhaps under William Joy's influence) by English West Country architects, such as John Sponlee (vault of the Aerary porch Windsor castle 1353–54) and William Wynford. Wynford's vault over the staircase to the hall at New College Oxford, c.1385, anticipates very closely Hanns von Burghausen's vault in the central aisle of the Holy Ghost church at Landshut (Diagram Page B).[104]

But all these English intimations are inseparably bound up with a strong Parler influence in Hanns von Burghausen's work. Although English-looking, the vaults with no diagonal ribs have, for example, precedents in Prague and Prague-influenced buildings, while other rib patterns used by Hanns are little more than straightforward copies of Peter Parler's inventions.[105] Like Madern Gerthener, Hanns von Burghausen's innovations grew out of an admiration for the 'junkers of Prague' and it is precisely this Parler debt which throws indirect light on the problem of the English curving rib and its influence. The fact that this English device and these other English undertones in both architects' work, particularly Hanns von Burghausen's,[106] appear in the context of a strong Parler influence, suggests that the English curving ribs, like the English tracery vaults, were known to Peter Parler through drawings or descriptions, and formed part of a fragmentary collection of English ideas that could be exploited by Parler's pupils.

The conclusions drawn from this analysis of the curving rib and the tracery vault add a paradoxical note to the arguments put forward earlier in this paper. The work of Peter Parler's successors seems indebted to English ideas, and yet these were distributed only via Prague where (we have argued) English patterns, especially from Wells and the West Country, were not as important a source for Peter Parler as some authorities have supposed. But there need be no contradiction here. Peter Parler was an eclectic architect and the source of much of his influence lay in his power to bring together and transform ideas from very different sources. His use of the tracery vault and the curving rib may have been directly provoked by English influence, but most of his vault patterns draw together the threads of a rich German tradition, transforming and enhancing it with great originality. English Decorated did not play a leading role in this complicated synthesis, but it may have endorsed its results. Having fashioned a new type of Rayonnant architecture out of German Cathedral Gothic and Cistercian building, Peter Parler could have found a kind of confirmation of his new style in sketches or descriptions of English Decorated, itself a 'transformation' of French Rayonnant. If there were drawings of English buildings in Prague, Peter Parler need never have 'used' them, since not all medieval architectural drawings were working drawings, and many were kept in the lodge as exemplars or as works of art in themselves.

H

But if Peter Parler had little need of English inspiration his successors who worked with him and then distributed his ideas across southern Central Europe may have come into contact for the first time with English ideas in Prague. If so, they seem to have been particularly impressed by the novelty of some English West Country vaults. A tendency to develop ideas ignored, or half-suppressed by Peter Parler characterises that group of self-conscious and individual architects which dominated southern Germany in the first half of the 15th century.[107] In their works the vault patterns of Wells, Bristol and Ottery St Mary underwent a brilliant metamorphosis.

ACKNOWLEDGEMENTS

I am grateful to the British Academy for the award of a bursary which enabled me to complete the research for this article.

REFERENCES

SHORTENED TITLES USED

Bock (1961)—'Der Beginn spätgotischer Architektur in Prag (Peter Parler), und die Beziehungen zu England', *Wallraf-Richartz Jahrbuch*, XXIII (1961), 191–210.

— (1962)— *Der Decorated Style, Untersuchungen zur Englischen Kathedral-architektur der Ersten Hälft des 14 Jahrhunderts*, Heidelberger Kunstgeschichtliche Abhandlungen, new ser. VI (Heidelberg 1962).

Bony (1979)—J. Bony, *The English Decorated Style. Gothic architecture Transformed 1250–1350* (London 1979).

Clasen (1958)—K. H. Clasen, *Deutsche Gewölbe der Spätgotik* (Berlin 1958).

Die Parler—Exhibition catalogue of *Die Parler und der Schöne Stil 1350–1400: Europäische Kunst unter den Luxemburgern*, 3 vols (Köln 1978).

Fehr (1961)—Goetz Fehr, *Benedikt Ried. Ein deutschen Baumeister zwischen Gotik und Renaissance in Böhmen* (Munich 1961).

Frazik (1967)—J. T. Frazik, 'Zagadnienie sklepień o przęsłach trójpodporowych w architekturze średnio-wiecznej', *Folia Historia Artium*, IV (1967).

Kletzl (1939)—Otto Kletzl, *Plan-Fragmente aus der deutschen Dombauhütte von Prag in Stuttgart und Ulm*, Veröffentlichungen des Archivs der Stadt Stuttgart, III (Stuttgart 1939).

Palm (1976)—Rainer Palm, 'Das Masswerk am Chorgestühl des Kölner Domes', *Kölner Domblatt*, XLI (1976).

Pevsner (1959)—N. Pevsner, review of Clasen (1958) in *Art Bulletin*, XLIX (1959), 333–36.

Skubiszewski (1957)—P. Skubiszewski, *Architektura Opactwa Cysterskiej w Pelplinie*, Studia Pomorskie, I (Wroclaw 1957).

1. Pevsner (1959); Bock (1961); Bock (1962).
2. Bony (1979), 67.
3. For a discussion of some of these claims see below; for the use of broad transepts see Skubiszewski (1957), 52 ff; for the centralised chapels in Pomerania see Andrzej Grzybowski, 'Centralne Kaplice gotyckie Pomorza Srodkowego', in *Sztuka Pomorza Zachodniego*, ed. Z. Swiechowski (Warszawa 1973), 134 ff.
4. Frazik (1967), 83.
5. Clasen (1958), 32 ff; Skubiszewski (1957), 33–36.
6. Pevsner (1959), 335; Frazik (1967), 81; Bony (1979), 64.
7. Clasen (1958) passim.
8. The dating of the Malbork chapter house is controversial and probably no solution will be found until new evidence comes to light. C. Steinbrecht dated it '*c*.1320' see *Die Wiederherstellung der Marienburger Schloss* (Berlin 1891), 16; B. Schmid put it '1310–12', see *Die Marienburg* (Würzburg 1955), 17–24; Clasen dated it '*c*.1300' (1958), 41; and so did B. Guerquin, *Zamek w Malborku* (Warszawa 1960), 17, 18; Frazik however dated it much later, to 1331–44 (1967), 82; if Clasen is right the chapter house is the first vaulted space of this type in Central Europe and the model for the Briefkapelle in Lübeck; if Frazik is correct the reverse is true; I am inclined to think that the chapter house was built in the 1320s and comes after the Lübeck chapel. A large rebuilding of *c*.1300, as Clasen suggests took place, is

unlikely considering the political instability of the Order in the first decade of the 14th century; see Karol Górski, *Zakon Krzyżacki a Powstanie Państwa Pruskiego* (Warzsawa-Kraków-Gdańsk 1977), 54–55.

9. The dating of the Briefkapelle is also controversial. D. Ellger and J. Kolbe, *St Marien zu Lübeck und seine Wandmalerein* (Neumünster 1951) date the conception of the chapel to *c*.1310; Clasen (1958), 43–48 to the 1330s. Some light may have been thrown on the problem by W. A. Steinke, 'Die Briefkapelle zu Lübeck:ihre Herkunft und ihre Beziehung zum Kapitelsaal der Marienburg', *Jahrbuch des St Mariens-Bauvereins* (Lübeck), VIII (1974), but this article has not been accessible to me.

10. The castle chapel at Lochstedt, and the original chapel at Malbork, both *c*.1280, use small triradials in the corners of their eastern bays. See Schmid (1955), 19; and C. Steinbrecht, *Schloss Lochstedt und seine Malereien* (Berlin 1910), 14 and fig. 20.

11. Skubiszewski (1957), 90 dates the chapter house vaults to the last quarter of the 13th century; Clasen (1958), 38–40 to *c*.1300.

12. The suggestion of Ely influence was made by W. Burmeister, A. Renger-Patzsch, *Norddeutsche Back-steindome* (Berlin 1930), 27; but note the *Backsteingotik* use of single-tower westworks at St Mary at Bergen auf Rügen, *c*.1190, St Petri in Lübeck, and others; see W. Teuchert, *Die Baugeschichte der Petrikirche zu Lübeck*, *Veröffentlichungen zur Geschichte der Hansastadt Lübeck*, XV (Lübeck 1956), 47.

13. O. Schmitt, *Mittelpommern* (*deutsche Land, deutsche Kunst*) (Berlin 1927), 20 and fig. 37.

14. Steinke has argued that St James was indebted to England, and particularly to Lincoln, in a number of ways, of which the most important seem to me to be: (1) the capitals and vaults of the choir (2) the flat east end, and (3) the great eastern choir gable. See W. A. Steinke, 'The influence of the English Decorated Style on the Continent: Saint James in Toruń and Lincoln Cathedral', *Art Bulletin*, LVI (1974), 505–16. But none of these features need come from England: (1) although the Toruń capitals look English the examples in both countries derive from a common Cistercian root. The undecorated capital with an abacus of tall rings occurs in the west porch of Maulbronn, as a shaft ring in St Michael's chapel at Ebrach, and in the choir and ambulatory chapels at Henryków in Lower Silesia. Undecorated capitals (without the prominent abacus) appear *c*.1290 in the hall choir of St Blasius at Mühlhausen, whose patron was Kristan von Samland, Grand Master of the Teutonic Order. Unmoulded caps reached *Backsteingotik*, probably under Mendicant or Cistercian influence, in the last quarter of the 13th century, appearing in Toruń *c*.1270 in the east bay of the choir of St John's church. (2) The flat east end was popular in the Chełmno region from *c*.1250 (Chełmża cathedral 1251–63; Franciscan church Chełmno *c*.1290; Franciscan church Toruń '*c*.1270' (?)), see Teresa Mroczko, 'Ruch Budowlany na Ziemi Chełmińskiej w XIII wieku', in *Sztuka i Ideologia XIII wieku*, ed. P. Skubiszewski (Wrocław-Warszawa-Kraków-Gdańsk 1974), 296–98; note also the popularity of the flat east end in Mendicant architecture in southern and central Poland around 1250: Franciscan churches at Sandomierz, Zawichost, and Kalisz, and Dominican churches at Poznan, Kraków, and Wroclaw. The vaults of St James at Toruń, begun sometime after 1309, have precedents at Pelplin. The eastern gable of St James has tracery which is similar to the choir gable tracery at Lincoln, but this is probably coincidence: see, e.g. identical tracery in the piscina of the Dominican church at Kolmar, cf. H. Konow, *Die Baukunst der Bettelorden am Oberrhein*, *Forschungen zur Geschichte der Kunst am Oberrhein* (Berlin 1954), 15 and pl. 42. (3) The large gable surmounting the choir had already appeared, modestly, in East Pomerania and the Chełmno area in the second half of the 13th century, e.g. Chełmża cathedral, after 1286(?), see L. Przymusiński, 'Rozwój szczytów w architekturze gotyckiej 1250–1450 na ziemi chełmińskiej i Pomorzu Gdańskim', *Zeszyty Naukowe UAM*, *Historia Sztuki*, IV (1966), 1–58; and also in *Biuletyn Historii Sztuki*, XXVI (1964), 211–15.

15. Skubiszewski (1957), 35–36.

16. Pevsner (1959), 335.

17. Bony (1979), 64.

18. Bock (1961), 193–209.

19. Reiner Haussherr, 'Zu Auftrag, Programm und Büstenzyklus des Prager Domchores', *Zeitschrift für Kunstgeschichte*, XXXIV (1971), 21–46.

20. Palm (1976), 64–65; I would like to thank Mr L. S. Colchester for drawing my attention to this article.

21. Bony (1979), 66.

22. Haussherr, 'Zu Auftrag . . .', 43; Bony (1979), 66.

23. Jaromir Homolka has suggested that Peter Parler may have travelled to Italy in 1368–69 with Charles IV, see 'Die Skulptur' in *Die Parler*, II, 663; V. Kotrba has proved that Peter Parler arrived in Prague not in 1353 but in 1356, see 'Kdy přišel Petr Parléř do Prahy. Příspěvek k historii počátků parléřovské gotiky ve střední Evropě', *Umění*, XIX (1971), 109 ff.

24. None of these enterprises can definitely be attributed to Peter Parler. The only strikingly English similarity I have found in any of them is the large blind gable jutting into the north transept window of Salem, reminiscent of the south transept window at Tintern abbey church.

25. Kletzl (1939), 80 ff.
26. For Peter Parler's profiles in Prague see V. Mencl, 'Tvary klenebních žeber v České gotické architektuře', *Zprávy Památkové Péče*, xi (1952) 268–81; V. Mencl, 'Vyvoj středověkého portálu v Českých žemich', *Zprávy Památkové Péče*, xx (1960), 112. I would like to thank Dr Richard Morris and Dr John Maddison for kindly allowing me to study their collections of English and continental moulding profiles.
27. K. M. Swoboda, 'Klassische Züge in der Kunst des Prager Deutschen Dombaumeisters Peter Parler', in: *Studien zu Peter Parler* (*Beiträge zur Geschichte der Kunst im Sudeten- und Karpatenraum*, ii, Brunn-Leipzig 1939), 9 ff.
28. For the Cologne south-west tower see E. Zimmermann-Deissler, 'Das Erdgeschoss des Südturmes vom Kölner Dom', *Kölner Domblatt*, xiv/xv (1958), 61–96; the author suggests that the young Peter Parler actually worked on the south tower.
29. The attribution of the choir is still a matter of controversy. A short survey of the arguments is given by R. Wortmann, 'Die Heiligkreuzkirche zu Gmünd und die Parlerarchitektur in Schwaben', in *Die Parler*, i, 315 ff.
30. For the Reims nave see H. Reinhardt, *La cathédrale de Reims*, Paris 1963, pl. 20. The whole question of exterior and interior passages in Central Europe before Peter Parler has been dealt with (without solving the problem of Peter Parler's sources) by P. Héliot, 'Coursières et passages muraux dans l'églises de l'Europe centrale', *Zeitschrift für Kunstgeschichte*, xxxiii (1970), 173 ff.
31. There are earlier examples of flowing tracery in Germany on a small scale, see, for example, the Lettner-Altar of *c*.1360 in Doberan Cistercian church, cf. G. Gloede, *Das Doberaner Münster* (Berlin 1970), pl. 178.
32. See Palm (1976), figs. 23, 24.
33. For examples see O. Kletzl, 'Zwei Plan-Bearbeitungen des Freiburger Münsterturmes', *Oberrheinische Kunst*, vii (1936), 26; for the development of the ogee in Peter Parler's work see J. Bureš, 'Ein unver-öffentlichter Choraufriss aus der Ulmer Bauhütte. Zur nachparlerischen Architektur in Süddeutschland und Wien', *Zeitschrift für Kunstwissenschaft*, xxix (1975), 3–27.
34. The examples are: Heiligenkreuz (Lower Austria), dado of fountain pavilion (*c*.1300); east wing of the cloister of Constance Münster (before 1317 or *c*.1330) by the Salem lodge; blind rose in the north walk of the cloister at Maulbronn (*c*.1330); tracery of Bebenhausen refectory (1335); see Kletzl, op.cit. (1936), 26; and Wortmann, *Die Parler*, 315.
35. Goetz Fehr (1961), 87 ff.
36. For the south-west German origins see Kletzl (1939), 83–84; for the Prussian derivation see Clasen (1958), passim; for the Bohemian precedents see E. Bachmann, 'Vorstufen Parlerischer Wölbformen im Sudetenraum', *Zeitschrift für Sudetendeutsche Geschichte*, v (1941–42), 93–109.
37. Bock (1961), 202 ff; Pevsner (1959), 335.
38. See Clasen (1958), 52–56.
39. The vaults of the Easter Sepulchre at Lincoln, and the choir screens at Southwell and St David's cathedral, and the vault of the Berkeley ante-chapel in St Augustine at Bristol; see Bock (1961), 207.
40. Roland Recht, 'La chapelle Saint-Venceslas et la sacristie de la cathédrale de Prague et leur origine strasbourgeoise', in: *Actes du XXIIe Congrès International d'Histoire de l'Art* (Budapest 1973), 521 ff; Roland Recht, *L'Alsace Gothique de 1300 à 1365* (Colmar 1974), 54, 227.
41. Bock mentions that a Dr Reutsch pointed this out to him, but I have been unable to find other references to these ribs, see Bock (1961), 208, n. 34.
42. E. Schubert, *Der Dom zu Magdeburg* (Berlin 1974), 38.
43. One is the so-called second Vienna plan (Akademie der Künste 16.874) and the other is a fragment in Stuttgart (Stadtarchiv Planfragmente nr 3r), see Kletzl, 'Zwei Plan-Bearbeitungen' (above, n. 33), 15 ff., and Kletzl (1939), 61 ff.
44. Wortmann, *Die Parler*, 315 ff.
45. Recht, 'La chapelle Saint-Venceslas . . .' (above, n. 40), passim.
46. D. Libal, in *Die Parler*, ii, 628; for Michael Parler see O. Kletzl, 'Parler' in *Thieme-Becker, Allgemeines Lexikon der Bildenden Künstler* (Leipzig 1932), xxvi, 242–48.
47. Pevsner (1959), 335.
48. Bock (1962), 56 ff.
49. Bock (1961), 203 ff.
50. See Brian Knox, *Bohemia and Moravia. An Architectural Companion* (London 1962), 24, fig. 4.
51. Paul Frankl, 'The Secret of the Medieval Masons', *Art Bulletin*, xxvii (1945), 46–60; for Mathes Roriczer see now Lon R. Shelby, *Gothic Design Techniques, The Fifteenth-Century Design Booklets of Mathes Roriczer and Hanns Schmuttermayer* (Southern Illinois University Press, 1977).
52. V. Kotrba, 'Kompoziční schéma kleneb Petra Parléře v chrámu sv. Víta v Praze', *Umění* vii (1959), 260–64.

53. See Shelby, *Gothic Design Techniques*, 82, 127; and Kotrba, op.cit., 255.
54. An idea first suggested by Fehr (1961), 89; for the Cologne sacristy see A. Wolff, 'Chronologie der ersten Bauzeit der Kölner Domes 1248–1277' *Kölner Domblatt*, xxviii/xxix (1968), 7 ff; for the Cologne south tower see above n. 28.
55. It is attributed to Peter Parler by G. Bräutigam, 'Gmünd-Prag-Nürnberg. Die Nürnberger Frauenkirche und der Prager Parlerstil vor 1360', *Jahrbuch der Berliner Museen*, iii (1961), 38–75; G. Bräutigam, 'Die Nürnberger Frauenkirche; Idee und Herkunft ihrer Architektur' in: *Festschrift Peter Metz* (Berlin 1965), 170–88, esp. 185 ff; Kotrba, 'Kdy přišel Petr Parléř do Prahy . . .' (above, n. 23), 128–29.
56. L. Schürenberg, 'Die ursprungliche Chorform der Cistercienserkirche in Salem', *Zeitschrift für Kunstgeschichte*, vii (1938), 342.
57. See A. Mussat, *Le Style Gothique de l'ouest de la France (XIIe-XIIIe siècles)* (Paris 1963), 232–38, and pl. xxviii-A.
58. The drawing, now in the National Gallery in Prague, was made in 1850 and was based on old views and plans of the church (not now surviving) found in the tower of the church at Horni Mokropsy, see V. Novotny, *Klašter Zbraslavský (Poklady národního Umění)* (Praha 1948); and J. Neuwirth, *Geschichte der Bildenden Kunst in Böhmen* (Prag 1893), 103–04, 416, 444; Jaromir Homolka, 'Einige Randbemerkungen zu den Büchern von Dobroslava Menclová, Česky Hrady i/ii, Praha 1972, und Albert Kutal, Česke Gotické Umění, Praha 1972', *Mediaevalia Bohemica*, vi (1974), 204–08. I am grateful to Dr Homolka for this article.
59. The main example is the nave of the Benedictine abbey church of Třebič, c.1250, see E. Bachmann, *Sudetenländische Kunsträume im 13 Jahrhundert, Beiträge zur Geschichte der Kunst in Sudeten- und Karpatenland*, iv (Brunn-Leipzig 1941), 37.
60. J. T. Frazik, 'Sklepienia tak zwane Piastowskie w Katedrze Wawelskiej' *Studia do Dziejów Wawelu*, iii (Kraków 1968), 127–47; and B. P. Crossley, *The Architecture of Kasimir the Great. A Study in the Architecture of Lesser Poland 1320–1370*, unpublished Ph.D. thesis, University of Cambridge, 1973.
61. Kletzl (1939), 50 ff.
62. Hans Koepf, 'Die Stuttgarter Parlerpläne', in: *Festschrift Julius Baum* (Stuttgart 1952), 60–61.
63. For Legnica see Mieczyslaw Zlat, 'Sztuki śląskiej drogi od gotyku' in: *Późny Gotyk, studia nad sztuka przełomu średniowiecza i czasów nowych* (Warszawa 1965), 211–14; for the Kraków vault see B. P. Crossley, *Architecture of Kasimir the Great*.
64. See R. Wagner-Rieger, 'Architektur' in: *Gotik in Osterreich*, catalogue of the exhibition at Krems a.d. Donau 1967, 350 and n. 136.
65. Bock (1961), 192; Haussherr, 'Zu Auftag . . .' (above, n. 19), 41.
66. Palm (1976), 64–67, 68–70.
67. See Peter Draper, 'The Sequence and Dating of the Decorated Work at Wells'; above, p. 20 f.
68. Nicola Coldstream cites the nave at Exeter cathedral (c.1320), Claverley in Shropshire, and the blind tracery on the tomb canopies of Farncombe chantry at St Thomas at Winchelsea, see Nicola Coldstream, *The Development of Flowing Tracery in Yorkshire*, unpublished Ph.D. thesis, University of London, 1973. She kindly pointed out to me that the first bays of the York clerestory were being glazed in 1310.
69. O. Kletzl, 'Zur Identität der Dombaumeister Wenzel Parler d.ä. von Prag und Wenzel von Wien', *Wiener Jahrbuch für Kunstgeschichte*, ix (1934), 43–62.
70. For all three masons see R. Perger, 'Die Baumeister des Wiener Stephansdom im Spätmittelalter', *Wiener Jahrbuch für Kunstgeschichte*, xxiii (1970), 87 ff; for a full stylistic analysis of the south tower see Marlene Zykan, 'Zur Baugeschichte des Hochturmes von St Stephan', *Wiener Jahrbuch für Kunstgeschichte*, xxiii (1970), 28 ff.
71. For historical problems surrounding this mason see Perger op.cit., 78 ff.
72. Much of my information on the nave of St Maria am Gestade is based on the work of Dr Marlene Zykan who kindly allowed me to read her doctoral dissertation, *Der Hochturm von St Stephan in Wien*, University of Vienna 1967, and who drew my attention to her article on the nave of St Maria: 'Zur Identifierung eines Gotischen Gewölberisses in der Wiener Sammlungen', *Mitteilungen der Gesellschaft für Vergleichende Kunstforschung in Wien*, xxv Jahrg. (1973), 13 ff.
73. For the Old Town Bridge tower and the Karlshof church see E. Bachmann. 'Architektur bis zu den Hussitenkriegen' in: *Gotik in Böhmen* (München 1969), 96–97, 105; for Klosterneuburg see R. Wagner-Rieger, 'Zur Baugeschichte der Stiftskirche von Klosterneuburg', *Jahrbuch des Stiftes Klosterneuburg*, N.F. iii (1963), 164–69.
74. Zykan, 'Zur Baugeschichte . . .' (above, n. 70), 14.
75. Bock (1962), 56 ff.
76. Fehr (1961), 95–96.
77. The Eleanor cross comparison was made by F. W. Fischer, *Unser Bild von der deutschen spätgotischen Architektur des XV Jahrhunderts (mit Ausnahme der nord- und ostdeutschen Backsteingotik)*, *Berichte der*

Heidelberger Akademie der Wissenschaften (1964, IV) (Heidelberg 1964), 32; for the Parler sculptural connections see Zykan, 'Der Hochturm von St. Stephan . . .' (above, n. 72), 70–71.

78. Vienna, Akademie der Künste, 16819v, see Zykan, 'Zur Baugeschichte . . .', 53 ff.

79. The Stuttgart fragment nr 3v of a ground plan of a church, published by Kletzl (1939), 77 ff., has a vault very similar to St Maria's high vault, but Kletzl's date of *c.*1370 for the plan is too early and his arguments for its origins in Prague are not convincing; see Koepf 'Die Stuttgarter Parler-Pläne' (above, n. 62), 61–64, who dates it to the mid-15th century.

80. The continuous shafts rising behind gables are reminiscent of the Ely Lady chapel; the use of concave arches — for the first time in Central Europe? — is pre-figured at St Augustine in Bristol (wall passage openings); the big south window of the tower, shown clearly in the Vienna drawing (Akademie der Künste nr 16817) has 'coinciding' arches which Bräutigam compared to the arches in the west porch at St Mary at Nürnberg, but which also have analogies with English 13th-century patterns (see Bräutigam, 'Die Nürnberger Frauenkirche' (above, n. 55), 185 ff.); the upper of the two blind windows to the left of this main window is, on the Vienna drawing, remarkably similar to early Perpendicular window tracery, e.g. William Wynford's in the cloisters at New College Oxford or the west bays of the nave at Winchester cathedral.

81. See F. W. Fischer, *Die spätgotische Kirchenbaukunst am Mittelrhein 1410–1520* (Heidelberg 1962), 19–20; and G. Ringshausen, 'Mittelrheingebiet', in *Die Parler*, I, 232–33.

82. C. Gurlitt, *Beschreibende Darstellung der alteren Bau- und Kunstdenkmäler in Sachsen*, Heft XL (Dresden 1919), 183; Fischer, 'Unser Bild . . .' (above, n. 77), 40.

83. For Meissen see E. Lehmann, E. Schubert, *Der Dom zu Meissen* (Berlin 1971), 48 and pl. 41; for Altenburg and Borna see Dehio/Dieter, *Handbuch der Deutschen Kunstdenkmäler, Die Bezirke Dresden, Karl-Marx Stadt, Leipzig* (Berlin 1965), 6, 40, 264.

84. G. Ringshausen, *Die Parler*, I, 232–33; G. Ringshausen, 'Die spätgotische Architektur in Deutschland unter besonderer Berucksichtigung ihrer Beziehungen zu Burgund im Anfang des 15 Jahrhunderts', *Zeitschrift für Kunstwissenschaft*, XXVI (1972), 63 ff.

85. Clasen (1958), pls. 35–37; Fischer, 'Unser Bild . . .' (above, n. 77), 40.

86. Werner Gross, 'Mitteldeutsche Chorfassaden um 1400', in: *Kunst des Mittelalters in Sachsen, Festschrift Wolf Schubert* (Weimar 1968), 117 ff; also Hans Joachim Krause, 'Zum Einfluss der Prager Parler Architektur auf Sachsen und die Oberlausitz', in *Die Parler*, II, 553–56.

87. A net vault like the Prague cathedral choir vault is proposed by J. Sokol, 'Parléřův kostel Všech Svatých na Pražském Hradě', *Umĕni*, XVII (1969), 574–82; like the Old Town Bridge Tower vault, by Dobroslava Menclová, *České Hrady*, II (Praha 1972), 125 ff.

88. Krause, *Die Parler*, II, 553–56; Dehio/Dieter, *Handbuch der Deutschen Kunstdenkmäler* (above, n. 83), 6, 264.

89. Krause, *Die Parler*, II, 553.

90. For St Moritz in Halle see Gross, op.cit. (above, n. 86), 120 ff; and W. Schadendorf, 'Wien, Prag und Halle. Ein Beitrag zum Einfluss der Dombauhütten von Wien und Prag auf die Baukunst Mitteldeutschlands, dargestellt am Chor und Langhaus von St Moritz in Halle/Saale', *Hamburger Mittel- und Ostdeutsche Forschungen*, III (1961), 148–99.

91. See Sokol, op.cit. (above, n. 87), fig. 8.

92. Fischer, *Die Spätgotische Kirchenbaukunst* (above, n. 81), 19.

93. Pevsner (1959), 336.

94. Fehr (1961), 97 ff. and pls. 70–83.

95. Fischer op.cit., 17 ff.

96. Fehr (1961), 97–100.

97. Ibid., 96–97, 101; for Steyr in particular see B. Grimschitz, *Hanns Puchspaum* (Wien 1947), 48; for Braunau see P. Ortmayer, 'Stephan Krumenauer, ein deutscher Baumeister des 15 Jahrhunderts', *Christliche Kunstblätter* (1938), LXXIX, 77 ff.

98. Fischer *Die Spätgotische Kirchenbaukunst*, 19–50 passim; Fischer, 'Unser Bild . . .' (above, n. 77), 24–25, 34–37, and n. 58; support for his theory also came from W. Paatz, *Verflechtungen in der Spätgotik zwischen 1360 und 1530* (Heidelberg 1967), 77–79.

99. Ringshausen, 'Die spätgotische Architektur . . .' (above, n. 84), 69 ff.

100. K. M. Swoboda, *Peter Parler. Der Baukünstler und Bildhauer* (Wien 1940), pl. 19.

101. So does Madern Gerthener's. Apart from the tracery and the curving vaults there is what Fischer calls the 'baldachine' portal, in which the portal is framed by pinnacles and shafts supporting a large ogee arch. Fischer thinks that this English motif comes via Burgundian portals, see *Die spätgotische Kirchenbankunst*, 19, 24, 40.

102. For the nodding ogees he cites the choir stalls of Hereford cathedral, for the 'broken ogee' he refers to the Godfrey Foljambe monument in Bakewell. See 'Unser Bild . . .' (above, n. 77), n. 58.

103. On the building of the choir at Salzburg see Jan van der Meulen, 'Die baukünstlerische Problematik der Salzburger Franziskanerkirche', *Österreichische Zeitschrift für Kunst und Denkmalpflege*, XIII (1959), 52–59.

104. See J. H. Harvey, *The Perpendicular Style* (London 1978), 152 and figs. 11, 12.

105. The net vault in the middle aisle of the nave of St Martin at Landshut comes from the high choir vault in Prague cathedral; the net vault in the sacristy of the Holy Ghost church Landshut is from the St Wenceslas chapel in Prague; the lierne vault in the west porch of the Holy Ghost church Landshut is similar to the nave vaults of St Maria am Gestade in Vienna; star vaults without diagonal ribs are prefigured in the nave of the Holy Cross church in Wrocław (1350–71), in the chapel adjoining the south tower in Prague cathedral, and in the sacristy of St Vitus at Ceský Krumlov (from 1407), and the ambulatory vaults of St Barbara Kutná Hora (from 1388).

106. The Parler debt in Hanns von Burghausen's work has been stressed by all the authorities. See F. Dambeck, 'Hans Stethaimer und die Landshuter Bauschule', *Verhandlungen des historischen Vereins für Niederbayern*, LXXXII (Landshut 1957); T. Herzog, 'Meister Hanns von Burghausen genannt Stethaimer, sein Leben und Werken', *Verhandlungen* ..., LXXXIV (Landshut 1958); recently Hanns's debt to the Parlers in south-west Germany and Bohemia has been underlined by John W. Cook, 'A New Chronology of Hanns von Burghausen's Late Gothic Architecture', *Gesta*, XV (1976), 97 ff.

107. Ringshausen 'Die Spätgotische Architektur ...' (above, n. 84), 77.

Glastonbury Abbey before 1184:
Interim Report on the Excavations, 1908–64

By C. A. R. RADFORD

PREFACE

'In the summer (of 1184), . . . on St. Urban's day (25 May), the whole monastery, with the exception of a chamber with its chapel built by Abbot Robert (1171–78), in which the monks afterwards assembled, and of the bell-tower built by Bishop Henry (Abbot 1126–71), was consumed by fire'. So wrote Adam of Domerham, the historian of Glastonbury, about one hundred years after the event.[1] Not only the buildings and the treasure perished in the catastrophe, but many of the records of the great abbey, with its traditions reaching back into the early days of Christianity in Britain were also destroyed.

Earlier in the 12th century a controversy had arisen between Glastonbury and Westminster as to which could establish the earlier date of foundation.[2] The dispute gave birth to a tract entitled 'On the antiquity of the church of Glastonbury' (*de antiquitate Glastoniensis ecclesiae*).[3] The author, William of Malmesbury, was a scholarly historian, but his work has survived only in a farced edition compiled after the fire of 1184. The interpolations mainly concern the earlier part of the tract and, even here, much of the original text can be restored by use of the third edition of the *Gesta Regum* of the same author;[4] into this he copied long passages taken from the earlier work. The latter part of the surviving text is free from serious interpolation and is based on the charters and monuments of the monastery, to which the writer had access. To quote Dean Armitage Robinson, a critical historian of the early traditions of Glastonbury: 'we shall be even surprised at the patient investigation to which the great historian submitted them (the Glastonbury charters); there is perhaps hardly a parallel in medieval history to the task which he undertook and carried through'.[5] In addition, William of Malmesbury wrote two other historical works which have survived and are relevant to the early history of the Abbey — the *Gesta Pontificum Anglorum*[6] and the *Vita Dunstani*.[7] In the present context it is unnecessary to discuss the later developments of the Glastonbury legend, as this report is concerned only with the period before the fire of 1184.

The picturesque elements in the Glastonbury legends acted as a magnet for the romanticism of the 19th century. A series of searches — generally ill-conducted and worse recorded — led to discoveries within the area of the abbey. But excavation conducted on a scientific basis only began in 1908 when the site was acquired by public subscription and placed under Trustees appointed by the diocesan authorities of Bath and Wells. Before and immediately after the First World War the work was in charge of F. Bligh Bond, a talented architect and ecclesiologist. Ten reports, presented to the Somersetshire Archaeological and Natural History Society, were published, at first annually and later at longer intervals.[8] They differ in a number of respects from his later writings, which were claimed to rest on spiritualistic communications with medieval monks and others who had known the abbey. From 1925 to 1939 excavation was continued under the direction of a Committee appointed jointly by the Society of Antiquaries of London and the Somersetshire Archaeological and Natural History Society. A number of short reports were published, the most considerable being an account of the pre-Conquest church.[9] The work carried out for the Committee by the present writer began in 1951 and continued until 1964, with intermissions in several

of the intervening years. As no full report on any of these campaigns has been published this interim account covers all the relevant discoveries.

THE ORIGINS

The Glastonbury tradition which carried the foundation of the Abbey back to the earliest days of Christianity is better considered in connection with the evidence for the British monastery (p. 112). But the discovery of Romano-British pottery in the course of the excavations deserves more than a passing mention. The pottery has not yet been studied in detail, but the circumstances of its discovery are now clear. As Mr Wedlake informs me, it was first recorded in some quantity in the clay used to level up the nave and in the filling in the centre of the latrine at the south end of the east range. These deposits belong to the reconstruction after the fire of 1184 and date from the early 13th century. Romano-British sherds were also found in the west walk of the cloister, sealed under the bedding for the 12th-century pavement. A few lay near the floor level of the early oratory (p. 115) and it seemed in 1951 that they might be *in situ*, though the strata were disturbed and they could have arrived there in the 12th century. Since then no similar fragments have been found in early or pre-Conquest levels. It must be concluded that the presence of this pottery on the site of the abbey is secondary and that it arrived with the clay. It is unlikely that the great quantity of clay required in the later 12th and early 13th century was brought from any distance; an obvious source is the Almoner's Pond, lying about 100 m (100 yds) south of the cloister.

The pottery — terra sigillata and coarse ware — is predominantly, if not exclusively, of the 1st and 2nd centuries. Its occurrence in this area of the 'island' of Glastonbury is part of the wider question of the occupation and use of the Somerset Levels. On the present evidence it has no bearing on the origins of the monastery.

THE BRITISH MONASTERY

The earliest surviving account of the origins of Glastonbury is found in a passage inserted in the later editions of the *Gesta Regum* of William of Malmesbury.[10] The insertion is clearly based on researches at the Abbey, undertaken after he had completed the first edition. The passage appears after mention has been made of Cenwalh, King of Wessex (643–74) and the opening paragraph runs in part, in the translation of Armitage Robinson, 'There came therefore by the sending of Eleutherius (Pope, 175–89), preachers to Britain, the effect of whose work will last for ever, though their names have perished through the long neglect of time. The work of these men therefore was the Old Church of St Mary in Glastonbury, as antiquity has not failed faithfully to hand down through the ages of the past. There is also that written evidence of good credit found in certain places to this effect: the church of Glastonbury did none other men's hands make, but actual disciples of Christ built it. Nor is this irreconcilable with truth: for if the Apostle Philip preached to the Gauls, as Freculfus says in the fourth chapter of his second book, it may be believed that he cast the seeds of his doctrine across the sea as well. But lest I should seem to cheat the expectations of my readers by fanciful opinions, I will leave disputable matters and gird myself to the narration of solid facts'.

It is clear that William of Malmesbury placed little reliance on this opening passage and it is needless to point out the chronological discrepancy involved in the foregoing quotation. The author continues: 'The church of which we speak was called by the English the Old

Church. It was first formed of wattles. Plain as it was, its fame was widespread and pilgrims came from every quarter'. He then names the famous British saints connected with Glastonbury, starting with Gildas the historian. St Patrick and St Indracht, both British saints, were enshrined in pyramids set one on each side of the altar of the Old Church, a location confirmed by the *Vita Sancti Indrachti*, a source contemporary with, but independent of, William of Malmesbury.[11] These and other British connections mentioned were largely based on the survival of cults and the possession of relics. They are sufficient evidence of the existence of an important British monastery at Glastonbury in the period before the Saxon Conquest of east Somerset, which took place in the third quarter of the 7th century.

William of Malmesbury records the names of three British abbots, who figured in a painting in the great church, i.e. the church of St Peter and St Paul built by Ini (p. 116).[12] The first of the three is also named in a charter seen by the same writer. This granted to the Old Church, the five 'hides' or households (cassatos) of the land of Ineswitrin, on which the church stood. The donor was a King of Dumnonia, whose name was no longer legible, on account of the age of the document. The alleged date — A.D. 601 — cannot have appeared in this form in the charter and must represent a calculation made either by William himself or by an earlier investigator, perhaps the compiler of the lost *Liber Terrarum*, a cartulary of the abbey, which probably dated from the later 10th century.[13] In any case the charter belonged to the period before 670. There is no reason to doubt its existence. It falls into line with the Welsh land grants (graphia) calendared in the late-11th-century *Vita Sancti Cadoci*,[14] and those edited in the 12th-century *Book of Llandav*, many of which go back to the 7th or 8th century or even earlier.[15]

Though the Old Church is said to have been formed first of wattles and then covered with planking,[16] William of Malmesbury always describes the building which was still standing in his day (p. 125) as the wooden church (*ecclesia lignea*). The stone church of St Peter and St Paul, built by Ini, King of the West Saxons (688–726), was, he says, an appendix to the Old Church.[17] The position of the latter is even more clearly defined by a later writer, Adam of Domerham, the 13th-century historian of the Abbey. Describing the rebuilding after the fire of 1184, he states that Ralph Fitz Stephen, who was in charge of the work, 'brought to completion the church of St Mary (the present Lady chapel) in the place where the Old Church had originally stood.'[18]

The Lady chapel measures internally 16.15 m (53 ft) by 7 m (23 ft). No wattled building could have reached these dimensions. But there is evidence that, as early as the 7th century, 'sixty feet' (18.25 m) was an acceptable norm for a major Irish church or cathedral, all of which were then built of wood. The church of St Bridget at Kildare (Fig. 1), which was rebuilt in the early 7th century, must have fallen into this category and it has been possible to prepare a restored drawing based on the contemporary description.[19] A wooden church of the same size as the Lady chapel may therefore be accepted as an appropriate centre for a great British monastery such as Glastonbury; it has been adopted in the restored plans which illustrate this article. The clear implication of William of Malmesbury's narrative is that a building of this type had long been standing at the time when Ini added his church of stone. That its size was considerable is borne out by the existence of two shrines (pyramids) flanking the altar (Fig. 1); it must be assumed that all three stood forward from the east wall, as in the restored drawing of Kildare.

The earliest structural phase identified on the abbey site contains two elements uncovered during the excavations. A substantial bank with an eastern ditch — the *vallum monasterii* — runs north and south along the transept and across the chapter house of the post-Conquest church. Inside, to the west of the bank, lay the Old Church with, to the south, an extensive cemetery including wooden oratories and stone hypogea; this has not been

Kildare Church ~ conjectural plan and section.

10	20	30	40	50	feet	
	5		10		15	metres

FIG. 1

explored in detail. Outside the ditch nothing of pre-Conquest date has been found. It is true that Bond claimed to have located what were possibly 'traces of very early habitations' outside the Edgar chapel at the east end of the latest medieval church.[20] These lay at a considerable depth — '10 feet or so (3 m) under the lawn'. The whole area was subsequently lowered, removing at least 50 cm (1 ft 8 in.) of the natural clay, but nothing more was found. The exact level of the remains cannot now be recovered, but they certainly lay some distance below the normal surface of the subsoil. It is possible that Bond had chanced on the water channel subsequently located, as Mr Wedlake informs me, in a trial trench outside the south quire aisle of the 13th century. This channel remained open in the 12th century, when it probably provided the water to flush the monastic latrine. Bond produced no evidence of date and it is uncertain whether the remains had any connection with the abbey.

The Vallum Monasterii

The best section across the bank and ditch was that cut along the axis of the 12th-century chapter house (Pl. XXIIIA); it extended for 36 m (118 ft) only a part of which is shown in the drawing here published (Section CHI, Fig. 7). This includes the east wall of the chapter house and the two steps rising from the vestibule, on the line of the outer wall of the contemporary east range. About 30 cm (1 ft) below the grass, which represents approximately the level of the 13th-century pavement, a layer of mortar some 5 cm (2 in.) thick formed the bedding for the robbed pavement of the 12th century. West of the line of the outer wall of the contemporary east range, the level of the mortar dropped by 45 cm (1 ft 6 in.), indicating

the position of two steps rising from the vestibule into the chapter house. With minor breaks, which are not significant in the present context, this mortar bedding sealed all earlier levels. Immediately below the mortar was the base of a clay bank, which had been levelled to take the bedding. The bank, 6 m (20 ft) wide at the base, had been piled directly on to the undisturbed turf, which sloped gradually up to the east. On the west or inner side the base of the bank stood to a height of rather over 50 cm (1 ft 8 in.). The lower part was of iron-flecked clay, with whiter clay above, reversing the natural sequence. The reverse slope of the bank was steep, rising at an angle of some sixty degrees; it had interleavings of darker material, representing the turf with which it had been revetted. The front had slid forward, but the angle was probably continuous with that of the inner slope of the ditch, which also rose at an angle of 60°. Immediately in front of the bank was the V-shaped ditch, about 4.25 m (14 ft) wide at the surface and 2.10 m (7ft) deep. The outer slope had been deformed at an early date by a slip of material. The filling of soft silt, a gradual accumulation, was capped by a layer of clay with some soil and turf, probably thrown in from the upper part of the bank when this was levelled. The mortar bedding had sunk into this filling to a depth of some 10 cm (4 in.). Inside the bank a layer of soil and clay with occasional stones and darker patches of rubbish extended westward into the later cloister. It appeared to have been continuous and homogeneous, but was cut by wide foundation trenches of the 12th and 13th centuries and by other disturbances. The layer was a gradual accumulation, consisting in part of material that had slid down during a long period when the area behind the bank was not occupied. It was later cut into by glass furnaces of the 9th or 10th century.[21] It is difficult to allow less than two hundred years for the accumulation of this layer, placing the date of the bank and ditch at *c*. 700 at the latest.

A similar, but more disturbed, section was cut in front of the transeptal chapel immediately north of the quire aisle of the 13th-century church. The bank was demonstrably older than the early-12th-century foundation trench of the Romanesque church and older than an even earlier foundation trench, which is ascribed to the church begun by Abbot Turstin in the late 11th century (p. 125). In 1931 a trench 48.75 m (160 ft) long was dug along the main axis of the late medieval church, starting in the nave and continuing up to the site of the high altar. The average depth of the soil overlying the clay was 1.50 m (5 ft). 'At one place, a few feet east of the north east pier, the depth was 13 ft (4 m) before the undisturbed clay was reached'.[22] The position shows that the same ditch as that located in the other two sections had been found and Mr Wedlake informs me that it was 3.66 m (12 ft) wide at the top. The bank and ditch therefore ran in an approximately straight line for over 50 m (165 ft). In 1978 a similar ditch was located on the same line about 64 m (210 ft) further north in the course of a rescue excavation in the new car park. A trench cut across the 13th-century east range in the course of the excavations failed to produce any evidence of the ditch some 25 m (82 ft) south of the section in the chapter house; there was undisturbed clay near the surface, into which the foundation trenches of the 12th and 13th centuries had been cut.

The bank lies directly on the undisturbed surface. No artefact was found either on this surface or in the make-up of the bank. The filling of the ditch was also barren. Bank and ditch mark the eastern limit of the British monastic enclosure. The scale, though not the details of the construction, resemble the bank and ditch forming the *vallum monasterii* at Tintagel, Cornwall, which is securely dated to the 5th or 6th century by the occurrence of imported Mediterranean pottery, both in the make-up and trodden into the surface.[23] The failure to discover the continuation of the ditch in the trial section across the east range indicates that the plan of the monastic enclosure must have been angular, a feature also noted, for instance, at Clonmacnois.[24]

The Cemetery

The cemetery was an important element in a Celtic monastery. It often grew up round the tomb and relics of a 'founder' and its sanctity was enhanced by the translation of relics from elsewhere.[25] At Glastonbury the ancient cemetery lay south of the Lady chapel and Galilee of the later church. Eastward it extended into the area of the cloister, but the dispersal of the graves in this direction suggests that it did not go far beyond the west walk.

A trench dug obliquely across the cemetery, near its centre, showed oriented, slab-lined graves, packed closely together, so that a single slab sometimes formed the sides of two adjacent burials (Pl. XXIIIb). Within the cemetery were a number of small buildings and two hypogea.

The buildings were represented by postholes, some isolated, others in groups forming straight lines, which followed the orientation of the graves (Pl. XXIIIc). The best plan recovered lay within the cloister. Postholes outlined a building 4 m (13 ft) wide and between 5.50 m (18 ft) and 7.50 m (25 ft) long, of which the west end had been destroyed by a later foundation trench. The small postholes lay some 1.20 m (4 ft) apart and can only have supported a light building, probably of wattle and daub; it serves to confirm the tradition that the earliest church of St Mary was a building of wattles (p. 112). A roughly trodden surface indicated the floor level.

The early Christian hypogeum was a small chamber sunk, wholly or in part, into the ground. It served as the resting place of a martyr or other saint or of a 'founder'. Two hypogea were discovered in the. ancient cemetery at Glastonbury. They were empty, the relics having been translated at a later date. The first lay east of the church of St Peter and St Paul and was incorporated in the early extension of this building (p. 117).[26] The second lay south of the Lady chapel, with the graves identified in 1191 as those of King Arthur and Queen Guinevere immediately alongside.[27]

British Glastonbury must be considered in a wider context than the abbey site; it must cover the whole of the Island of Avalon. The areas of the early monastic site explored between 1951 and 1964, lay entirely within the cemetery or in the area between the cemetery and the vallum to the east, which yielded no remains of the earliest period. The main living quarters probably lay on the rising ground to the north, where no work has yet been carried out. The Island of Avalon or of Glastonbury is an isolated rise, measuring at its greatest about 1.5 km (1 mile) in each direction and projecting boldly into the surrounding marshes. The earliest settlement on Glastonbury Tor, the highest point, has produced fragments of imported pottery of the 5th or 6th century.[28] The cemetery at Beckery included a grave, placed in Period Ib, which gave a C.14 date in the 8th century.[29] Both these sites must be regarded as part of the earliest monastic 'city'. The island is separated from the main ridge to the east by a narrow neck, which rises barely 6 m (20 ft) above the modern margin of the land liable to flooding. Beyond and cut by the modern road to Shepton Mallet are the great bank and ditch known as Ponter's Ball, which runs from one edge of the marsh to the other. Its layout, though facing away from the island, is not defensive; it could be too easily outflanked. A single section, cut by Mr P. Poyntz Wright on the south side of the modern road, produced pottery of the 12th century at the base of the clay bank. But the road now turns outside the bank and has certainly been realigned at some period. It is possible that the section was cut on the line of the original entrance and that the realignment took place during the later Middle Ages, perhaps after 1184. Or it may be that the bank represents a 12th-century boundary on a traditional line. The Island of Avalon, delimited by Ponter's Ball, would then appear as a great monastic city, comparable to 7th-century Kildare, which included commercial suburbs clustered around the sacred centre.[30]

THE EARLY SAXON MONASTERY

The Saxon conquest of east Somerset took place in the third quarter of the 7th century. The earliest known Saxon grant to Glastonbury was made by Cenwalh, King of Wessex (643–74) towards the end of his reign.[31] The extant text embodies 'fragments ... of an original charter of the 7th century, which has undergone more than one modification'.[32] A later king of Wessex, the great Ini (688–726), built the stone church of St Peter and St Paul to the east of the old church of wood.[33] The new church dated from the end of his reign. Abbot Hemgisl, who died about 705, was buried in the wooden church, where the community continued to commemorate him as is recorded in a charter of 745, a corrupt text, but one in which this detail is unlikely to be interpolated.[34]

The excavation of the pre-Conquest church began in 1926 and covered four seasons. In addition to areas outside the great church of the 13th century and flanking the Galilee, the whole of later nave and aisles was cleared for a distance of about 23 m (75 ft) from the west end. Within this area wide strips had been dug down into the natural clay to provide foundations for the walls and sleeper walls of the 12th and 13th centuries. At the end of the fourth season a plan was prepared; it forms part of the report for 1929.[35] This plan, which was made at a time when the masonry had deteriorated, differs in certain respects from that published in 1928;[36] the earlier plan is likely to be the more reliable and has generally been followed (cf. p. 121).

The excavations also included an area covering the nave of the 13th-century church and extending 4.90 m (16 ft) east of the added tower (p. 121). This disclosed no evidence of further walls. But centrally placed at the end of the extension, was a stone-lined receptacle set into the natural clay. The area was here enlarged to 6 m (20 ft) east of the tower to uncover the whole of the structure. This measured 2.50 m (8 ft) from north to south and 1.25 m (4 ft) from east to west. The bottom was about 1.80 m (6 ft) below the level of the 13th-century pavement. Internally it was divided into two parts by a stone slab. Water had seeped into the space, which was otherwise empty. The receptacle was sealed by three slabs of lias. No record of this receptacle appears on the published plans of the excavations and the writer is indebted to Mr W. J. Wedlake for the details here recorded.

In 1959 a trench was dug along the inner edge of the sleeper wall of the 13th-century south arcade, exposing the surface of the natural clay (p. 129). From this trench two short extensions were cut northward into the nave. The western extension, 6.75 m (22 ft) east of Dunstan's tower, brought to light a foundation trench 1.20 m (4 ft) wide running east and west and sealed beneath the bedding for the pavement of the 12th-century church. The eastern extension 14 m (46 ft) east of the tower, produced no evidence of a similar foundation trench, but the area was disturbed by a late medieval stone-lined grave, which left only a thin strip of apparently undisturbed clay on the west side of the extension.

The church of St Peter and St Paul not only occupied much of the west end of the post-Conquest nave, but extended beyond this to the full length of the Galilee. The remains had been destroyed in the 12th century almost to, and in places to below, ground level and were fragmented by wide foundation trenches of the 12th and 13th centuries, including those which had carried the sleeper walls of the arcades. Of the three building periods recognised the latest was of the age of Dunstan (p. 121). The second period marks an enlargement of Ini's church; it does not figure in the historical record.

Ini's church (Fig. 2) had a rectangular nave measuring internally 11 m (36 ft) by 6.40 m (21 ft) with porticus 3.60 m (12 ft) wide and of unknown length flanking the east end of the nave and overlapping the presbytery. Of the presbytery only stubs of the side walls remained. No apse was found, though one may be inferred both from the sudden truncation of the

side walls and by analogy. There were traces of a pavement of pink *opus signinum* in the nave and at the west end of the presbytery. Fragments of painted plaster, one with part of a draped figure, probably came from this building.

The plan and the pavement of *opus signinum* link this building with the Kentish churches of the 7th century.[37] The closest parallel is Reculver, founded in 669. The Kentish influence is doubtless due to St Aldhelm. Aldhelm took over an earlier Irish foundation at Malmesbury and, as abbot, he witnessed the Glastonbury charter of Cenwalh, to which reference has been made (p. 116). He was an illustrious alumnus of the Schools established at Canterbury by Archbishop Theodore (669–90) and Abbot Hadrian, and later founded monasteries at Frome and Bradford-on-Avon, before becoming the first bishop 'west of the wood' with his cathedral at Sherborne (705–09). As a leading figure in the establishment of the Saxon church in the newly-won lands west of Selwood and as an ecclesiastic seeking to secure the conformity of the British church in a still independent Dumnonia, he would have had a clear interest in the great British shrine which had recently fallen into Saxon hands.

10 m (33 ft.)

FIG. 2. Glastonbury *c.* 720

The second building phase in the church of St Peter and St Paul (Fig. 3) is marked by the use of a characteristic purple mortar. The older church was extended eastward and flanking porticus and an atrium were added at the west end.

The new east end, which stretched about 6 m (20 ft) beyond the division between the nave and the presbytery of Ini's church, is difficult to interpret, as the eastern part was largely destroyed by the heavy foundations of the tower added by Dunstan (p. 121). The western ends of the side walls were traced for 4.50 m (15 ft), up to the tower and the foundation of the east wall was clear on the far side. Immediately west of the tower a wide but slighter foundation of the same date had an irregular face, suggesting the base of a flight of steps leading up to a raised annexe, which had been largely destroyed. Within this annexe, under the later tower was the rectangular hypogeum (p. 115), which had a flight of steps leading down from the west end.[38] The hypogeum was older than phase two; the published plan hatches it as phase one (i.e. contemporary with Ini's church). But in the text it is tentatively suggested that it may be the 'church' built by the twelve hermits shortly before the visit of St Patrick. A note made by the writer when the site was open records that the masonry consisted of thicker stones than the walling of Ini's church and gave the impression that it was older. The legend of the hermits is a later interpolation in the work of William of Malmesbury and must be ruled out.[39] The most likely restoration of the east end of phase 2 would show a raised chapel with a shrine above a crypt entered by a narrow stair in the centre of the rising flight.

10 m. (33 ft.)

FIG. 3. Glastonbury c. 760

Large asymmetrical porticus were added flanking the west end of the nave in this phase; their relation to the earlier smaller porticus was not determined. From the wide west front thus formed, side walls ran west at an angle, exactly aligned with the Old Church. They could not be traced for the whole distance, but clearly formed part of an enclosure or atrium, of which the west side must have been linked with the east wall of the Old Church. The 'Chapel of St Mary (St David's)' shown on the published plan must be eliminated.[40] As Armitage Robinson pointed out, the authority for placing it in this position is late and un-reliable.[41] All William of Malmesbury says is that St David 'quickly built another church and consecrated that', after being told by Our Lord that He Himself had dedicated the Old Church.[42] William of Malmesbury does not mention the position of this church, which can only have been a slight structure. The atrium was a forecourt of the normal type with covered walks on all four sides. It formed a part of the great church of St Peter and St Paul and explains William of Malmesbury's statement that this was coterminous with the Old Church of wood.[43] An approximate date for the addition of this atrium, and for phase 2 as a whole, is indicated by the record that Abbot Tica, who died about 760, 'obtained for himself a notable tomb in the right corner of the greater church, over against the entry to the Old Church'.[44] The position indicated is near the south-west angle of the atrium.

Nothing is known about the monastic buildings of this period. The space between the cemetery and the bank to the east, in the area of the later cloister, was perhaps used for industrial purposes. But the glass furnaces (p. 114) the waste from which Dr Harden has dated to the 9th or 10th century, may be as late as the age of Dunstan.

THE LATER PRE-CONQUEST MONASTERY

The monastic revival in 10th-century England was closely associated with Dunstan, who became abbot of Glastonbury about 944. He was subsequently bishop of Worcester (957), bishop of London (959) and archbishop of Canterbury (960–88). 'During his fifteen years at Glastonbury he brought into being the first organized community of monks, which had existed in England for at least two generations'.[45] His earliest biographer, writing at the end of the 10th century, records a youthful vision of the future abbot, when he visited Glastonbury with his father. He saw an aged man clad in white passing through the pleasant courts of the holy temple and the monastic buildings and other offices, which were

to be erected during his pastorate.[46] Later the same writer records how, as abbot, Dunstan, 'following the health-giving Rule of St. Benedict . . . enclosed the monastic bounds of the cloisters, together with the buildings and other offices that had been revealed to him.'[47] There is no doubt that the writer was describing the position as it was at the end of the century; not unnaturally he ascribed the work to Dunstan. The main buildings of the later pre-Conquest monastery at Glastonbury date from the 10th century, but it would be unwise to conclude that they were all completed during the period when Dunstan was abbot. Some may belong to the following generation, when he was archbishop.

The standard monastic plan of the Middle Ages has four main ranges of buildings, one of which is the church; they enclose a rectangular courtyard or cloister, along the sides of which covered walks provide a working area and internal communications. A layout of this type can be recognised in the St Gallen plan of c.820, which represents the ideal after which the Continental reformers were striving, rather than the actual buildings existing at the date.[48] In England the earliest known examples of this type of layout are at Glastonbury and at Canterbury. The monastery of St Peter and St Paul (St Augustine's Abbey) lies outside the east gate of Canterbury. On the north side of the pre-Conquest church excavation has brought to light a cloister with east and west ranges; the north side is disturbed by later buildings. The early layout, which is not older than the 10th century was connected by the excavator with the community reformed under the influence of Archbishop Dunstan.[49]

At Glastonbury the 10th-century work includes the enlargement of the church, the enclosure of the ancient cemetery and the erection to the south of the church of three ranges of buildings set along the sides of a rectangular courtyard, of which the cemetery formed the north boundary.

The Church

After mentioning Ini's church, which in his view included the work here ascribed to phase 2 (p. 112), William of Malmesbury continues: 'This church Dunstan lengthened considerably, adding a tower; and, to make its width square with its length, he added aisles or porticus as they call them. The result of his labours was that, as far as the design of the ancient structure allowed, a basilica was produced of great extent in both directions; wherein, if ought be lacking of seemliness and beauty, there is at any rate no want of necessary room'.[50] A rather fuller description of the building emerges from the accounts of Abbot Turstin's quarrel with his monks in 1083. The best version is that included in Text E of the Anglo-Saxon Chronicle, which must be quoted at some length, using the translation of Professor Dorothy Whitelock with the addition in brackets of the Anglo-Saxon terms for the building and its parts.[51] The graphic detail of the narrative suggests that the compiler had heard the story from an eye witness, perhaps one of the monks involved. The account of the same events by William of Malmesbury is less detailed, but bears out the contemporary record and adds one significant detail.[52] 'One day the Abbot [Turstin] went in to the chapter [capitulan] and spoke against them [the monks] and wanted to ill-treat them and sent for some laymen [household knights], and they came into the chapter and fell upon the monks fully armed. And then the monks were very much afraid of them and did not know what they had better do. But they scattered; some ran into the church [cyrcan] and locked the doors on themselves—and they went after them into the monastery [mynstre] and meant to drag them out when they dared not go out. But a grievous thing happened that day — the Frenchmen broke into the choir [chor] and threw missiles towards the altar [weofode] where the monks were, and some of the retainers went up to the upper storey [uppflore] and shot arrows down towards the sanctuary [haligdome] so that many arrows stuck in the cross

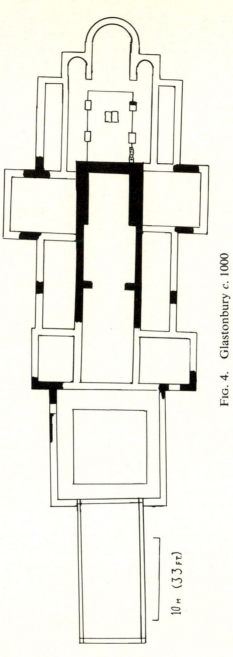

Fig. 4. Glastonbury c. 1000

10 M (33 FT.)

that stood above the altar; and the wretched monks were laying round about the altar and some crept under it . . . they shot fiercely, and others broke down the doors [dura] there and went in and killed some of the monks and wounded many there in the church so that blood came from the altar on to the steps and from the steps on to the floor'. The word mynstre, translated 'monastery' can also mean 'church' and should be so read in this passage. The only significant detail added by William of Malmesbury is his description of the 'upper storey' as the 'upper rooms' or 'passages [solaria] between the columns'.

The published summary of the excavations of 1926–29 describes the tower added by Dunstan over the east end of the earlier church, together with two flanking porticus of the same date which were identified as the aisles or porticus of William of Malmesbury's account.[53] An ingenious calculation of the total length of the enlarged church and the width of Dunstan's added tower and porticus was used to justify the same author's remark about the dimensions.

Dunstan's tower (Fig. 4) had heavy foundations 1.50 m (5 ft) wide enclosing the north, east and south sides of a space 5 m (16 ft) across. No standing masonry survived as the whole superstructure had been removed in the 12th century. It is probable that there were arches on all four sides of the tower. Its erection involved the partial destruction of the older tomb chamber, which was filled in and paved over. At the west end, on the site of the entrance, a large stone sarcophagus was found. Within it were carefully arranged human bones representing seventeen individuals, all male, with an average age of over fifty.[54] They probably came from graves disturbed in the course of the building.

Excavation in the aisles of the 13th-century church brought to light the east and west walls of porticus flanking the tower. No trace of the outer walls of the porticus was found either in the aisles or outside the later church; their length must therefore have been about 7 m (23 ft) internally.[55]

These porticus cannot be the aisles described by William of Malmesbury, nor does the tower by itself constitute a 'considerable' lengthening of the church. Moreover the phrase that the added aisles made the breadth of the building equal to its length should grammatically apply to the extension and not to the whole church, as it has generally been interpreted. The clear implication of the text read as a whole is that the completed extension included an eastern arm and that this was aisled.

The existence of this aisled eastern arm is borne out by a detail shown on the published plan of the excavations, but nowhere discussed. Two stones project eastward from the foundation of Dunstan's tower; their surface is pierced with small holes that carried the uprights of a metal screen. The stones, which overlie the foundation ascribed to phase 2, indicate the position of the south arcade, giving a width of about 4.75 m (15 ft 6 in.) to the sanctuary, on the assumption that the eastern arm was symmetrically planned. In 1959 a trial trench 6.70 m (22 ft) east of the tower picked up a robbed foundation trench on the same line; it was sealed by the mortar bedding for the 12th-century pavement (p. 129). Mr Wedlake recalls that the published plan is incorrect in one respect. The east wall of the north porticus lay 1.20 m (4 ft) west of the line formed by the east sides of the tower and the south porticus; the stub of a wall running east was traced for about 1.50 m (5 ft) from this wall. This would give an overall width of 15.50 m (51 ft) for the eastern arm, with aisles of about the same width as the central sanctuary, an unusual feature at this date.

The solution emerges from a comparison with the plan of Cluny II.[56] In that church the sanctuary, 7 m (23 ft) wide, was separated by arcades from aisles 2.40 m (7 ft 9 in.) wide and enclosed with solid walls. These aisles were flanked, in turn by rectangular cryptae 3.20 m (10 ft) wide. The cryptae, which formally lay outside church, were used by the monks for spiritual exercises.[57] At Glastonbury similar intermediate walls would have lain entirely

within the area of the later sleeper walls. The east end of Cluny II had a central apse, flanked by absidioles, which were externally square-ended. Its total length was 17 m (56 ft). This measurement is sufficiently near the overall width of the eastern arm at Glastonbury to explain the statement that the two dimensions were the same (p. 119). It has therefore seemed legitimate to suggest a restoration of the east end of Dunstan's church based on that of Cluny II. In that church the high altar in the sanctuary was separated from the altars in the apse — exceptionally there were three at Cluny — by an ambulatory. A similar ambulatory may be assumed at Glastonbury, as the liturgical needs of the two churches were similar.[58] Within this ambulatory the sanctuary and the monastic quire were enclosed by screens. It was through doors in the screens that the Normans had to break before they were in a position to cut down the monks sheltering by the altar.

At Glastonbury the screen enclosing the sanctuary was, in part at least, in metal. A pre-Conquest parallel in this country may be cited in the church which Archbishop Ealdred (1060–69) erected at Beverley. According to the Chronicle of the Church of York, using the translation of St John Hope: 'Above the quire door he (Ealdred) also caused to be made a pulpitum of incomparable work of bronze, gold and silver and on either side of the pulpitum he set up arches and in the middle above the pulpitum a higher arch carrying on its top a cross, likewise of bronze, gold and silver fashioned in the German style [*opere theutonico*]'.[59]

Cluny II was begun in 948 and the apse was already in use in 963, when Abbot Aymard was buried there. As the church was consecrated in 983,[60] it would be reasonable to assume that the whole of the eastern part was complete by the date of Aymard's burial. This dating makes it impossible for Cluny II to have been the direct model of the new east end of Glastonbury, if, as is probable, the extension of the church was built during Dunstan's pastorate, before he became bishop of Worcester in 957. But the essential features of Cluny II already appear in older buildings. The triple east end was a feature of Cluny I, consecrated in 927. The *cryptae* occur at Cluny A, the original chapel of the monastery, which was founded in 910; there they were corridors flanking the whole length of the rectangular building.[61] The link is to be found in St Benoit-sur-Loire, Fleury, a monastery reformed from Cluny in 930. In this church excavation has brought to light an elaborate east end, which has not yet been fully published. It was at Fleury that Oda, archbishop of Canterbury (942–58) was professed as a monk many years before his death. It was to Fleury that his nephew, Oswald, the later reformer, was sent for instruction in the principles of the religious life. 'It is clear that even in its earliest phases the English monastic revival cannot have proceeded in complete isolation.' The cautious assessment is that of Stenton.[62] Since he wrote, the long and detailed study by the Medieval Academy of America has shown that Cluny II represents the culmination of a long process, the earlier stages of which must have been known, in outline if not in full detail, to the English reformers.

This study of the 10th-century church at Glastonbury must end with a reference to the receptacle recorded by Mr Wedlake (p. 116). It can only be interpreted as a *fossa* for relics placed under an altar. Its position is that which would have been occupied by the high altar of Dunstan's church and it is so shown on the restored plan. But the position also corresponds closely with that assigned to the Rood altar of Herlewin's church (Fig. 6) and that of the Great Church of the 13th century. A fragment of an encaustic tile was found in the clay filling above the *fossa*. This indicates that it was still in use as late as the 13th century. It was probably opened and the relics translated when the quire was placed in the eastern arm of the church in the time of Abbot Walter de Moynton (1341–75). The level of the *fossa* shows that it was already in use in the 12th century, as it is related to the pavement of that date (p. 121). It is tempting to suggest that it is even older and was made for the high altar of Dunstan's church, but proof is yet to be found.

The Cemetery

After describing Dunstan's alterations to the church (p. 119), William of Malmesbury continues: 'he enclosed the cemetery of the monks on the south side of the church with a stone wall many feet high. The same space was raised as a mound with squared stones and became like a pleasant meadow isolated from the noise of the passers by, so that it might be said of the saints resting therein, their bodies are buried in peace'.[63]

The excavation in the ancient cemetery showed that it was bounded by an added wall, the south side of which ran parallel to Dunstan's church. The masonry had been robbed to its base, but the line of the shallow foundation was traced for some 17 m (56 ft) west of the outer wall of the 13th-century cloister. The east side of the cemetery was marked by the contemporary east range of the monastic buildings, which ran south from the added porticus of the church (p. 121). The trenches on the south side of the cemetery also showed that the ground inside the wall had been raised with a bank of clay more than 1 m (3 ft 3 in.) high. The upper part of this bank has been levelled off in recent times, but the inner edge could be seen tailed down towards the Lady chapel. The clay bank appeared to be contemporary with the wall enclosing the cemetery. It was probably finished as a broad terrace at least 2 m (6 ft 6 in.) high bordering the cemetery. The bank was demonstrably earlier than the 12th century, as it was already consolidated when the monks dug into it in 1191 to exhume the bodies identified as those of King Arthur and Queen Guinevere.[64] The Chapel of St Michael in the Cemetery lay outside this enclosing wall, which formed its north side. The other walls of the chapel had foundations of Tor Burrs, resembling those of the 13th-century buildings at Glastonbury.

The enclosure of the cemetery must be seen in relation to the 'Chapel of St Dunstan' excavated by Bond.[65] This small building, measuring internally about 5.80 m (19 ft 3 in.) by 4.60 m (15 ft 2 in.), lies some 8 m (26 ft) west of the late-12th-century Lady chapel. The side walls project beyond the two ends in the manner of a temple *in antis*. This is a form found in many early Irish churches, particularly in the 10th century.[66] Very little of the masonry survived, but the use of Tor Burrs in the foundations suggest that the structure uncovered in 1913 dated from the 13th century and was a rebuild after the fire of 1184. 'All over the middle part of the site a hard layer of pebble concrete was encountered in digging, having the appearance of a former road-bed.' The west 'wall' had two stones with grooves at sill level, which could have held slabs, suggesting that it was an open arch. Near the west end of the building a wall ran north with drains at old ground level. The structure lay at a considerable depth. It is now completely covered in, but the plan is marked in the turf.

The passage quoted verbatim explains the purpose of this building as a gateway to the cemetery, of which the western wall was traced for at least 4.50 m (15 ft) to the north. The ground here falls gradually to the west and the drains recorded under the bank and its retaining wall would be necessary to prevent the accumulation of standing water and its discharge along the entrance, which must also have provided the main public access to the Old Church.

Bond relied on post-Reformation sources for his identification of the chapel as St Dunstan's. He also tentatively suggested that the costly shrine for the relics of the arch-bishop provided by Abbot Michael of Ambresbury (1236–55) was placed in this chapel. It is possible that there was a chapel on the upper floor above the gate, but this would be an unlikely place for a costly shrine, which was probably set in a chapel within the great church. There is a passage in the earliest *Vita* of St Dunstan — a nearly contemporary source — which records that 'he built, on the west side of the Old Church, a church [*ecclesiam*] with four equal angles to serve as a little beacon and consecrated it in honour of John the

I*

Baptist'.[67] That such a chapel could become known by the name of the founder is not impossible and a charter of Abbot John de Breinton, dated 8 April 1340, provides a measure of confirmation. Certain properties then granted to the office of Cook of the abbey were burdened with the obligation to pay annually to the monk serving as Custodian of the Lady chapel, sums which were to be expended on lights in that chapel, in the chapel of St Dunstan, in the parish church of St John and in the chapel of St Benignus.[68] The order, in which they are named implies a building near the Lady chapel and the Outer Gate.

The Monastic Buildings

The earliest biography of Dunstan gives no indication of the planning of the monastic buildings erected at Glastonbury, though it may legitimately be deduced that they were extensive (p. 118). The passage quoted from the Chronicle (p. 119) makes it clear that the chapter house lay outside the church.

Early walls, unrelated to the post-Conquest monastic plan, were first recorded by Bond in the south-west corner of the later cloister.[69] Further walls of the same type were found in 1938 between the Refectory and the Monks' Kitchen and were then recognised as pre-Conquest. Excavation of the west walk of the cloister in 1951 and later provided a more extensive plan and better dating.

The walls discovered within the west walk of the later cloister were sealed by the mortar bedding for the robbed pavement of the 12th-century walk (Pl. XXIIID); the contemporary pavement lay about 25 cm (10 in.) above the ground level of the early wattled oratory (p. 115). The outer walls of the range were aligned with the added porticus of Dunstan's church. No clear evidence of a contemporary cloister walk was found.

The range was traced for a total length of about 60 m (200 ft). Two cross walls were found north of the later refectory. The normal width of the range was about 6.70 m (22 ft) overall, but the central room north of the refectory projected a further 1.50 m (5 ft) to the east. There were no cross walls to the south of the refectory, giving a room at least 4.50 m (15 ft) long. The walls were of local lias, with roughly squared stones set in a hard yellow mortar. Only a single course normally survived and the line masonry was often reduced to isolated stones in a shallow foundation trench. In one angle within the enclosure of the later cloister three courses remained. It is uncertain whether the walls were carried up in masonry; the base may have served as a plinth for a superstructure of timber or of timber framing filled with wattle and daub. In either case the walls were sufficiently strong to have carried an upper storey (Pl. XXIVA, B, C).

In 1962 part of a range running east and west was picked up on the south side of the Abbot's House. In 1978 Mr W. J. Wedlake found part of a cross wall of the west range embedded in the 14th-century foundation of the west wall of the Abbot's House. The latter find indicates that the outer wall of the west range was approximately on the line of the west wall of the cemetery. In both cases the masonry was similar to that of the east range and floors of the south range also showed a mortar bedding resembling that under the badly robbed pavements of the east range. The south range could only be dated stratigraphically as earlier than the Abbot's House of the 14th century. But the cross wall at the west end of this House lay at the base of a more complex sequence. The 14th-century foundation trench had cut into a thick layer of burnt debris, which rested on a layer of soil with some builders' rubbish. The burnt debris may be attributed to the fire of 1184 and the early wall appeared to have been destroyed at a period before this date. This result is tentative, as the excavation conducted by Mr Wedlake was directed to completing the plan of the Abbot's House and there was no opportunity to pursue the wider implications of the earlier walling.

In spite of the fragmentary nature of the evidence about the south and west ranges, which have only been located at the base of exploratory trenches, there is no doubt that all the masonry can be ascribed to a single building period and that this is of the age of St Dunstan. The cloister of this date was a courtyard measuring 55 m (180 ft) by 36 m (120 ft), with ranges of buildings between 6 m (20 ft) and 8 m (26 ft) wide enclosing it on the east, south and west sides. The wall of the cemetery, which rose to a height of at least 2 m (6 ft 6 in.) formed the north side of the enclosure. It may be assumed that there were covered walks providing a connection between the different buildings and the church.

THE ROMANESQUE CHURCHES

The Norman Conquest was a traumatic experience for the Saxon churches. Glastonbury was no exception. The last native abbot, Ailnoth, was deposed at Lanfranc's fourth Council, held in London in his eighth year as Primate (1077–78).[70] In his place Turstin, a monk of Caen, was made abbot by favour of King William. Turstin, who desired to change the ancient customs of Glastonbury, was soon in conflict with his monks. Matters came to a head in 1083, when Turstin entered the chapter house (*capitulum*) and there was a bitter dispute (p. 119). Following this disaster, Turstin was sent back to Normandy. But after the accession of William II (1087), he bought back his position and lived at Glastonbury until his death in 1100.[71] His successor Herlewin (1101–20), restored the finances and organisation of the abbey. 'Considering that the church begun by his predecessor, did not correspond to the greatness of the possessions [of Glastonbury], he razed it completely and began a new building, on which he spent £480.'[72] Herlewin was succeeded by Seffrid, who after six years (1120–26), became bishop of Chichester. The next abbot was Henry of Blois (1126–71), brother of King Stephen, who from 1129 held the abbey in plurality with the bishopric of Winchester. He was a great builder. At Glastonbury 'he adorned the place with very fine buildings, a kingly palace called the castle, a bell-tower, chapter house, cloister, lavatory, refectory, dormitory, infirmary with its chapel, a fine outer gate of squared stones, a large malthouse and stables, completing these from the foundations upwards'.[73] Although Adam of Domerham, the 13th-century historian of the Abbey, does not mention the church in this catalogue of Abbot Henry's works, this was not completed in the twenty years of Herlewin's rule. He was buried, according to William of Malmesbury,[74] in the north porticus of Dunstan's church, alongside his predecessor, Turstin—a sufficient indication that this was still standing and that the new Romanesque nave can hardly have progressed beyond the three bays required for the monastic quire. It must therefore be accepted that the pre-Conquest church was known to William of Malmesbury, when he was working at Glastonbury and that his information is that of an eye-witness. It also follows that the church planned by Turstin cannot have progressed far, before it was razed.

Abbot Turstin

No systematic attempt was made to look for traces of Turstin's church in the course of the excavations carried out between 1951 and 1964. But the trenches cut to explore Herlewin's plan brought to light three stretches of older walling that ante-date the main Romanesque church and have no connection with the pre-Conquest layout. In the long trench (Section TI, Fig. 8) running west along the axis of the inner chapel in the north part of the 13th-century transept, the robbed foundation trench of part of a small apsidal chapel was noted near the centre of the transept; it was filled with loose rubble and mortar. The section line runs along

the centre of the north wall of this chapel and the fill is sealed by a layer of debris, on which the mortar bedding for the 13th-century pavement is laid. Immediately to the east a further robbed foundation trench with a few stones remaining in position belongs to a sleeper wall forming part of Herlewin's church. Its relation to the apsidal chapel is not clear on the section here published, but that on the opposite face and the plan on the clay floor of the trench showed that the earlier apse had been truncated by the sleeper wall of Herlewin's church. Only the north wall of the chapel was located with the spring of the apse and part of a sleeper wall crossing the western arch; its length internally, excluding the apse, was about 1.70 m (5 ft 6 in.). Further west a robbed foundation trench running north and south was noted. Its fill resembled that of the trench marking the chapel and it had been cut by a wall trench of the 13th century. The removal of the upper layers in this area prevented a closer dating. In the restored plan (Fig. 5) it has been accepted as the west wall of the transept, giving this a width of 8.80 m (29 ft). On the inner edge of the foundation trench for the later south arcade of the nave, the south-west angle of an older building was found. The fill of its robbed foundation trench resembled that of the chapel in the transept and it was sealed by the mortar bedding for the 12th-century pavement. The west wall was 1.20 m (4 ft) wide; the south wall trench was preserved for a width of 0.75 m (2 ft 6 in.) with the outer edge cut away for the later sleeper wall. There was no trace of a continuation westward. It remains only to note Fyfe's tentative identification of the pavement of Turstin's church at the west end of the nave.[75] This has been ignored by later scholars, and rightly so, in the opinion of the present writer; it will be dealt with later in another context (p. 129).

The scanty data outlined above, when seen in the light of the historical record, provide an indication of the character of Turstin's church. It may be assumed that this was symmetrically laid out in relation to the axis of the pre-Conquest church of Dunstan's day. This would give an overall length of about 34 m (112 ft) for the transept, with an apsidal eastern chapel,

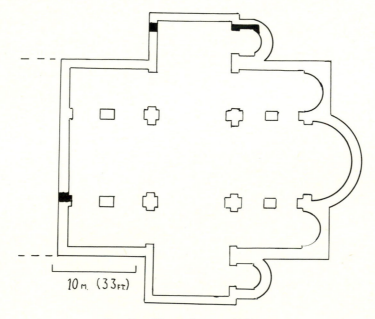

FIG. 5. Glastonbury c. 1100

on each side of the crossing and an aisled eastern arm. The nave would be about 9 m (30 ft) wide internally, some 2 m (6 ft 6 in.) less than that of the 13th-century church. This compares with a number of monastic churches of second rank begun in the late 11th century.[76] Blyth, the example illustrated by Clapham, has an exceptionally short transept, but the figure calculated for Glastonbury is close to the ascertained dimensions at Whitby and Eye. The length of the nave at Glastonbury was about 9.50 m (31 ft). This is only sufficient for two bays west of the transept, the space which would have been required for the monastic quire. It must be concluded that the first stage of Turstin's planned church only extended so far, leaving the completion of the nave for a second campaign and so allowing the pre-Conquest church to remain in use. The churches with which Glastonbury has been compared all had a short aisled eastern arm and an aisled nave of at least five bays. They contrast in scale with the contemporary greater churches, such as St Albans,[77] and the contrast explains the decision of Abbot Herlewin.

Abbot Herlewin (Fig. 6)

One of the main objectives of the excavations carried out between 1951 and 1964 was the recovery of the plan of the church and buildings begun by Abbot Herlewin and brought to completion by Abbot Henry of Blois. It was already known that the west end of the church lay immediately east of the great west door of the 13th century and that the nave arcades and the aisle walls were on approximately the same lines as those of the later church.[78] The east end of the chapter house had also been found before 1939, slightly west of that of the 13th century. It was therefore a legitimate deduction that the 12th-century transept was the same length as that of the 13th century and covered approximately the same area.

A start was made in the south quire aisle. It brought to light the foundation trench of the earlier east end in the third bay east of the 13th-century crossing. The plan indicated an absidiole set within a rectangular ending. A pre-war trench 1.20 m (4 ft) wide had been dug along the main axis of the quire and had failed to bring to light any masonry, apart from a late medieval tomb identified as that to which the remains of King Arthur were translated in 1278.[79] Another trench, also 1.20 m (4 ft) wide, was therefore dug parallel to the first with its nearer edge 0.75 m (2 ft 6 in.) from the centre line of the quire. The narrow wall between the two trenches stood and provided a section on the north face (Section Q2, Fig. 9). Ten feet from the west end an empty tomb of uncertain date and refilled with discoloured clay, cuts into the surface of the natural soil (see p. 130). To the east is the robbed foundation of the 12th-century altar sealed by the clay make-up under the 13th-century pavement, of which no trace remains. Further east a wide foundation trench with a characteristic early 19th-century refill of rubble and debris marks the position of the east end of the 13th-century quire. Further south this trench could be seen cutting through the robbed foundation of the 12th-century apse, which here shows as a separate trench with a few stones remaining near the base of the excavation. At the east end of the section a further trench with a 19th-century refill marks the position of the mid-14th-century high altar and reredos. These stood forward from the east end of the enlarged quire with a narrow sacristy behind the altar, an arrangement that appears at a rather earlier date in Exeter cathedral. The significance of the different foundation trenches was shown both by the diversity of the filling and in the light of the plans. The margin was narrow; the south end of the altar of the 12th century projected only 15 cm (6 in.) into the trench where the foundation could be measured on the surface of the clay. A second trench cut parallel to the first along the edge of the sleeper wall of the later arcade disclosed the position of the respond of the arch spanning the chord of the 12th-century apse and of the pier to the west.

FIG. 6. Glastonbury c. 1140

10 m. (33 ft.)

In the following year trenches were cut in the north end of the transept with sections drawn along the median lines of the two later chapels. They disclosed two apses set en echelon, corresponding to the later chapels. The inner trench was continued west across the transept and revealed the sleeper wall of the west arcade and the west wall of the transept of the 13th century.[80] It also disclosed foundation trenches of an earlier date running immediately to the west of each of the two 13th-century arcades. It then became clear that, although the north and south walls of the Romanesque transept were on similar lines to those of the 13th century, the east arcade and the west wall lay further west. This was confirmed by the discovery both of the west wall of the transept running along the east walk of the later cloister and of the side walls of the eastern range of the 12th century in the same relative position.

The resulting plan showed an eastern arm of four bays in front of the apse and three bays in front of the flanking square-ended absidioles. The inner chapels on each side of the eastern arm had two bays in front of the apse, while those at the outer ends of the transept had a single bay with an apse. An attempt to establish the bay divisions of the nave by clearing the surface of the clay alongside the sleeper wall of the south arcade showed that all trace had been destroyed by the robbery of the foundations.

The form of the piers could not be determined. The foundation trenches showing in the eastern arm were rectangular, a form not precluding the existence of compound piers with colonettes. But the architectural fragments of capitals that can be attributed to Herlewin's church are all straight and compound piers of rectangular outline, like those of St Albans, seem to be indicated.

It is also necessary in this context to consider Fyfe's excavations at the west end of the nave in some detail. His summary must be quoted in extenso: 'Above five inches (13 cm) below an obvious floor level of blue lias paving stones 6 ft 3½ in. (1.92 m) below the floor level of the thirteenth century were the considerable unbroken remains of red plaster floor (of Ini's church) . . . A little to the east of the blue lias pavement previously mentioned as overlying the plaster floor were found fragments in position of another paved floor at a still higher level. These fragments were not only very much blackened by fire but had many pieces of molten lead embedded in their joints. Moreover there was no evidence of any floor above this level except that of the great church 5 ft 3 in. (1.60 m) higher up. It is a matter of historic fact that the great church replaced the second Norman church of Abbot Herlewin which was destroyed by fire in 1184. It therefore follows that the burnt paving belonged to Herlewin's church. It is quite reasonable to suppose that the paving below it belonged to the church of his predecessor, Abbot Turstin . . . One additional fact of interest is the discovery of large thick red tiles in position, on a level with the paving which has been ascribed to Abbot Turstin. These tiles have traces of incised decoration in white, and evidently formed a central tiled strip about 6 ft (1.80 m) wide in the nave of his church.'[81]

The tiles are preserved in the Gatehouse Museum at the Abbey. They are rough and, in the writer's view, not closely datable, but it is doubtful whether they could be earlier than 1150. I saw the site open on more than one occasion. The phrase 'the paving below it' is ambiguous. At no point were the pavements superimposed; they were at different levels. The lower paving was traced to about 4.50 m (15 ft) east of the main door of the great church of the 13th century and the upper, burnt pavement was found some 2.50–3 m (8–10 ft) further east. It is perhaps significant that the Committee consisting of Peers, Clapham and Horne, which took over after Fyfe's withdrawal and published his plan, speaks of the 'Norman church', with no mention of two buildings of this date, although Fyfe's summary was already in print. If Fyfe were correct Turstin's church would have had a nave about 60 m (180 ft) long and the pre-Conquest church of St Peter and St Paul

would have been demolished before 1100. Moreover Turstin's church would have been completed up to the west end and provided with an elaborate pavement to which no contemporary parallel can be quoted. A more reasonable interpretation is that both pavements belonged to the same church, that of Abbot Herlewin. The west end of this church probably had flanking towers, linked by a gallery crossing the west bay of the nave. A step in line with the east face of this gallery would account for the difference of some 25 cm (10 in.) in the levels of the pavements and the part to the west would have been in some measure protected from the results of the fire. This type of arrangement is still well preserved in the nearly contemporary church at Melbourne in Derbyshire.[82] The tiles at Glastonbury would then be of a date not earlier than 1130–40 and could well have been an adornment added a few years before the fire of 1184. It would not have been possible to control this suggestion archaeologically as the two foundation trenches were so close that any projection indicating the wider foundations for 12th-century towers would have been cut away.

Herlewin's church, begun in the early years of the 12th century and completed c.1140, was a cruciform building with a plan resembling that of St Albans, which was started by Abbot Paul of Caen (1077–93) and consecrated in 1115.[83] The only unusual feature is the scale of the apsidal east end. In a church of this type the chord of the main apse is normally set in line with the east ends of the quire aisles. At Glastonbury a bay about 4.50 m (15 ft) long is interposed between this line and the chord. In other respects the plan is normal, with two apsidal chapels en echelon on each side of the crossing and an aisled nave probably of ten bays with twin towers at the west end. The church appears to have been badly set out with a break in the axis at the east end of the nave.

It has already been explained that the liturgical planning of Dunstan's church would require an ambulatory between the sanctuary with the high altar and the apsidal chapel (p. 122). The same must hold true of the Norman monastic churches of post-Conquest England and, probably, of all the major churches of that date. Mr Cruden has recently drawn attention to the architectural evidence for such an ambulatory in the secular cathedral at Kirkwall, Orkney, where the east end dates from the second quarter of the 12th century.[84] The argument holds good for Herlewin's church and in that case there must have been some reason for the prominence given to the eastern chapel. It is not impossible that Abbot Herlewin, a Norman, intended to raze not only the stone church of Ini, but also the older wooden church to the west. The eastern chapel would then need to be large, as it would have to house the shrines of St Patrick and St Indracht, which flanked the altar in the Church of St Mary. It is also possible that the tomb of King Edgar, the second founder of Glastonbury, was intended to stand in this chapel, as it stood at the east end of the extended great church of the later Middle Ages, in the annexe popularly known as the Edgar chapel. The king is known to have been buried at Glastonbury and William of Malmesbury, writing about 1130, does not name his tomb among those listed in the pre-Conquest church. He may already have been translated and it would be tempting to identify his new tomb with the feature immediately west of the 12th-century altar shown on the section in the quire (p. 127). The stratigraphy was inconclusive and the feature lies only 0.30 m (1 ft) west of the altar which would therefore be available for use only if the celebrant took the westward-facing position. The last point is not, in the writer's view, a conclusive reason for rejecting the identification.

The difference of the axis in the two parts of the church is of the order of four degrees. The axis of the nave follows that of the pre-Conquest churches of Ini and of Dunstan and also that of the succeeding great church of the 13th century. Exact measurement is difficult when a plan has to be based on the outline of foundation trenches cut in the clay. These tend to be irregular and deductions based on short stretches are liable to error. But the line

The three sections (or parts of sections) here
published have been chosen from a very much larger
series in order to illustrate the nature of the evidence
available. They will not eventually figure in the
present order and it is impractical to publish at this
time the full explanatory notes and diagrams.
A description of each section has therefore been
published at the appropriate points in the text
(pp. 113, 125, 127). The soil at Glastonbury is a stiff
clay; it can be seen (e.g. under the bank in CHI,
Fig. 7), covered with a layer of humus. A similar
material, mixed with a greater or lesser proportion of
soil and debris, forms the gradual accumulations on
the site and the deliberate levelling up made at
various dates. The sections attempt to show the
variation in these layers by the density of shading.
Stone is scarce on the 'island' and almost complete
robbery of walls and foundations was normal from an
early date down to the 19th century. In the Middle Ages
the small stones and debris resulting from this robbery
were thrown back into the trenches with clay or soil,
and packed to provide a solid base for the later
floors. The post-medieval stone-robbers took no such
precaution, and trenches filled after the Suppression
are normally loosely packed, with little or no soil or
clay. Filling with diagonal tip-lines (e.g. Section TI,
Fig. 8) can generally be correlated with excavations
carried out during the present century.

CHI (Fig. 7) runs up to and includes the east wall
of the 12th-century chapter house. The early bank
and ditch filling are capped by the mortar-bedding of
the robbed 12th-century pavement.

TI (Fig. 8) shows at the east end the edge of
the early ditch. In the centre the rammed fill of the
12th-century sleeper has been cut through by a
loose fill of the early 19th-century, representing a
13th-century foundation. To the west the hard core
under the lost 12th-century pavement overlies an
earlier tightly packed, robbed, foundation, ascribed
to the late 11th-century church.

Q2 (Fig. 9) runs up to the late high altar and
reredos. Above the natural surface, which slopes up
from west to east, are layers of make-up under the
lost medieval floors. The robbed foundation trench
of the 12th-century apse with a tightly packed filling
of debris and clay lies between two later robbed
trenches with a loose fill of early 19th-century date.
These represent, on the west, the high gable of the
13th century, and, on the east the high altar and
reredos of the 14th century.

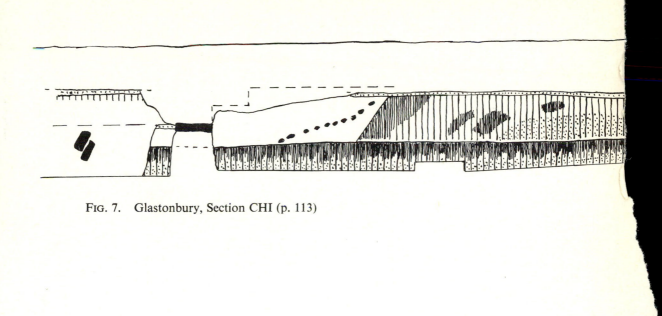

Fig. 7. Glastonbury, Section CHI (p. 113)

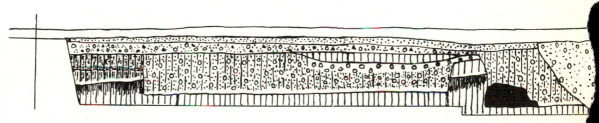

Fig. 8. Glastonbury, Section TI (p. 125)

Fig. 9. Glastonbury, Section Q2 (p. 127)

of the west wall of the transept of Herlewin's church was fixed in two widely separated places, respectively north and south of the aisled nave. The same alignment was found to continue along the west wall of the contemporary east range. It is moreover preserved in the setting out of the 13th-century Refectory, and firmly established by the surviving walls of the late medieval sub-vault. A continuation of the alignment established for the eastern part of Herlewin's church would have made it difficult, if not impossible, to incorporate the old wooden church organically into the new layout. A faulty planning of the east end of the new church, corrected when the nave was begun, remains a possibility. But such an error would be unusual in a Norman church of the first order. In the writer's view the alternative explanation suggested above is to be preferred. The pressures, which led to the change in plan and the retention of the Old Church of St Mary can be more easily imagined than documented. Their discussion would involve the introduction of evidence relating to the period after 1184.

The Romanesque cloister was rather smaller than that of the 13th century, with the north and west sides in the same positions as later and the outer walls on the east and south running along the later walks.[85] The 12th-century chapter house was of the same size as later, but set slightly to the west. The eastern range was probably of the same length as in the 13th century. There was no western range. Much fragmentary sculpture in Dundry stone may be attributed to the Romanesque church. The detail is coarse, but would have been effective at the height of the capitals, for which it was designed (Pl. XXIVD, E). The sculpture in blue lias from the cloister is finer in detail and dates from the later years of Abbot Henry (Pl. XXIVF).

ACKNOWLEDGEMENTS

I am deeply indebted to the Abbey Trustees, who sanctioned the work and granted every necessary facility. Most of those in charge of the earlier excavations were personal friends of my father or of myself; from 1925 onwards I visited the site every year while excavation was in progress and had the opportunity both at those times and on other occasions of discussing with members of the Committee the results and their significance. The only survivor of those who were in control between the wars is Mr W. J. Wedlake, who read this report in draft and from whose comments I have greatly benefited. To all of these, my predecessors in the field, I owe more than can be expressed in words.

The work carried out under my own direction, between 1951 and 1964, would not have been possible without the generous support of many contributors. In this respect a special debt is owed to the late Mrs Blanche van Dusen, who supported the excavations during her life and made provision for this support to continue after her death. She was happily able to visit the site in 1954 and see some of the results. My thanks are also offered to the late Mrs van Harten and her sister, Miss M. Marston, who administered the provision made by Mrs van Dusen and assisted in many other ways in the organisation of the work. With one exception the photographs which illustrate this article were taken by Miss M. Silcock, who also provided a large series illustrating not only the excavations, but the standing buildings of the abbey and the earlier architectural and other finds. The plans are based on surveys made by Mr P. D. Hart, to which earlier discoveries have been added.

At Glastonbury I was assisted in the field by a large band of helpers, who acted as site supervisors and undertook the many other tasks required. Some of them returned year after year and were able to see the full development of the latest of the series of campaigns. It would be impossible to particularise and I shall content myself with recording my own gratitude and that of all others concerned to Miss Mary Ann Dexter, Mr David King, Mrs Florence Nankivell, Mr Peter Poyntz Wright, Dr R. D. Reid, Mr and Mrs Richard Wainwright, Mr F. J. Willey, Miss Linda Witherill and Miss Kate Woodward. Our operations in the field were greatly facilitated by the Custodian of the Abbey, a post held throughout the period by Captain Bowen, R.N.

I have already spoken of Mr W. J. Wedlake. In addition to reading the first draft of this report, he has furnished new and hitherto unpublished data concerning some of the excavations in which he took part. In particular attention should be drawn to the important discovery of the *fossa* under the Rood altar of Herlewin's church (p. 122). It has seemed proper to record these contributions under Mr Wedlake's name, without necessarily committing him to the interpretation here placed on them. Dom Aelred Watkin, O.S.B., the editor of the Great Cartulary of Glastonbury, has throughout placed at my disposal his unrivalled knowledge of the history of the abbey. To Dr D. B. Harden I am indebted for advice on the early glass kilns. To these scholars and to many others, who visited the site and with whom I have discussed the various problems, I offer my most sincere thanks.

REFERENCES

SHORTENED TITLES USED

BOND (1908–26) — F. Bligh Bond, 'Glastonbury Abbey. Report on the Discoveries made during the Excavations of 1908', *P.S.A.N.H.S.*, 54 (1908), 107–30; ... 'Second Report ... 1908–9', ibid., 55 (1909), 104–17; ... 'Third Report ... 1909–10', ibid., 56 (1910), 62–78; ... 'Fourth Report ... 1910–11', ibid., 57 (1911), 74–85; ... 'Fifth Report ...', ibid., 58 (1912), 29–44; ... 'Sixth Report ...', ibid., 59 (1913), 56–73 ... 'Seventh Report ...', ibid., 60 (1914), 41–45; ... 'Eighth Report ...', ibid., 61 (1915), 128–42 ... 'Supplement to the Series of Reports on the Excavations', ibid., 62 (1916), 113–15; ... '(The Loretto Chapel) Ninth Report ...', ibid., 65 (1919), 76–85; 'Glastonbury Abbey Excavations, Tenth Annual Report', ibid., 72 (1926), 13–19.

CONANT (1954) — K. J. Conant, 'Medieval Academy Excavations at Cluny, VIII', *Speculum*, 29 (1954), 1–43.

— (1959) — K. J. Conant, *Carolingian and Romanesque Architecture, 800–1200* (Harmondsworth, 1959).

— (1968) — K. J. Conant, *Cluny. Les Eglises et la Maison du Chef d'Ordre*, Cambridge, Massachusetts, Medieval Academy of America (1968).

DOMERHAM — *Adami de Domerham historia de rebus gestis Glastoniensibus*, ed. T. Hearne, 2 (Oxford: Sheldonian Theatre, 1727).

FYFE (1926–27) — Theodore Fyfe, Glastonbury Abbey Excavations, 1926, *P.S.A.N.H.S.*, 72 (1926), 20–22; ... 1927, ibid., 73 (1927), 86–87.

MALMESBURY, AG — *Gulielmi Malmesbiriensis de antiquitate Glastoniensis Ecclesiae, Adami de Domerham*, ed. T. Hearne, I, 1–122. (Oxford: Sheldonian Theatre, 1727.)

— GP — *Willelmi Malmesbiriensis monachi Gesta Pontificum Anglorum*, ed. N. E. S. A. Hamilton, Rolls Series, LII (1870).

— GR — *Willelmi Malmesbiriensis monachi de Gestis Regum Anglorum*, ed. W. Stubbs, Rolls Series, XC (1887–89).

— VD — *Vita sancti Dunstani auctore Willelmo Malmesbiriensi*, ed. W. Stubbs, Rolls Series, LXIII (1874), 250–324.

PEERS ET AL. — C. R. Peers, 'Glastonbury Abbey Excavations, 1928', *P.S.A.N.H.S.*, 74 (1928), 1–9; '... 1929', ibid., 75 (1929), 26–33;' '... 1930–1', ibid., 77 (1931), 83–85; '... 1932', ibid., 78 (1932), 109–10; '... 1933', ibid., 79 (1933), 30; '... 1934', ibid., 80 (1934), 32–35; '1935', ibid., 81 (1935), 258; '... 1937', ibid., 83 (1937), 153–54; '... 1938', ibid., 84 (1938), 134–36. The report for 1929 is also published (in part) in *Antiquaries Journal*, 10 (1930), 24–29.

RADFORD (1961) — C. A. R. Radford, Melbourne Church, *Archaeol. J.*, 118 (1961), 243–44.

— (1962) — C. A. R. Radford, The Celtic Monastery in Britain, *Archaeologia Cambrensis*, 111 (1962), 1–24.

— (1968) — C. A. R. Radford, 'Glastonbury Abbey', *The Quest for Arthur's Britain*, ed. G. Ashe (London 1968), 119–38.

— (1977) — C. A. R. Radford, The Earliest Irish Churches, *Ulster Journal of Archaeol.*, Series III, 40 (1977), 1–11.

ROBINSON (1921) — J. Armitage Robinson, Somerset Historical Essays. British Academy (1921).

— (1927) — J. Armitage Robinson, 'The Historical Evidence as to the Saxon Church at Glastonbury', *P.S.A.N.H.S.*, 73 (1927), 40–49.

SAWYER — P. H. Sawyer, Anglo-Saxon Charters. An annotated List and Bibliography. London: Royal Historical Society, 1968.

VITA DUNSTANI B — *Vita Sancti Dunstani auctore B*, ed. W. Stubbs, Rolls Series, LXIII (1874), 3–52.

1. Domerham, 2, 333–34.
2. Robinson (1921), 1–5.
3. Malmesbury, AG.

4. Malmesbury, GR, 23–29; Robinson (1921), 1–25.
5. Ibid., 27.
6. Malmesbury, GP.
7. Malmesbury, VD.
8. Bond (1908–26).
9. Fyfe (1926–27); Peers et al. (1928–38).
10. Malmesbury, GR, 23–29; Robinson (1921), 8–28.
11. G. H. Doble, 'St Indracht and St Dominic', *Somerset Record Society*, 57 (1942), 7.
12. Malmesbury, GR, 28–29; Robinson (1921), 22, 27.
13. Ibid., 44–47.
14. A. W. Wade-Evans, *Vitae Sanctorum Britanniae et Genealogiae* (Cardiff: University of Wales 1944), 124–36.
15. W. Davies, *An Early Welsh Microcosm. Studies in Welsh Charters* (London: Royal Historical Society 1978), 7–22.
16. Malmesbury, GR, 22, 27.
17. Ibid., 36.
18. Domerham, 2, 335.
19. Radford (1977), 5–9.
20. Bond (1908), 123–24.
21. D. B. Harden, 'Ancient Glass III: Post-Roman', *Archaeol. J.*, 128 (1971), 87.
22. Peers et al. (1931), 83–85.
23. Radford (1962), 7–8.
24. C. Thomas, *The Early Christian Archaeology of North Britain* (Glasgow: University Publications 1971), 29–30.
25. Ibid., 48–90.
26. Peers et al. (1928), 5–7.
27. Radford (1968), 131–38.
28. P. Rahtz, 'Excavations on Glastonbury Tor, Somerset, 1964–6', *Archaeol. J.*, 127 (1970), 65–67.
29. P. Rahtz and S. Hirst, *Beckery Chapel, Glastonbury, 1967–8*, Glastonbury Antiquarian Society (1974), 83–84.
30. Radford (1977), 9–10.
31. Sawyer, no. 227.
32. Robinson (1921), 49–53.
33. Malmesbury, VD, 271.
34. Sawyer, no. 257; Malmesbury, GR, 40.
35. Peers et al. (1929), pl. II.
36. Peers et al. (1928), pl. I.
37. A. W. Clapham, *English Romanesque Architecture Before the Conquest* (Oxford 1930), 16–33, 47–49.
38. Peers et al. (1928), 5–7.
39. Malmesbury, AG, 19; Peers et al. (1929), 31–33.
40. Ibid., pl. II.
41. Ibid., 32–33.
42. Malmesbury, GR, 28.
43. Malmesbury, VD, 271–72.
44. Malmesbury, AG, 29, 63; Robinson (1921), 37; Robinson (1927), 43.
45. F. M. Stenton, *Anglo-Saxon England* (Oxford 1947), 440–42.
46. *Vita Dunstani B*, 7.
47. Ibid., 25.
48. W. Horn, 'On the author of the plan of St Gall and the relation of the plan to the monastic Reform movement', *Studien zum St Galler Klosterplan* (St Gallen: Fehr'sche Buchhandlung 1962), 125–27.
49. R. U. Potts, 'The plan of St Austin's abbey, Canterbury', *Archaeologia Cantiana*, 46 (1934), 191–94; H. M. and J. Taylor, *Anglo-Saxon Architecture* (Cambridge 1965), 142.
50. Malmesbury, VD, 271–72; Robinson (1927), 43.
51. D. Whitelock, *The Anglo-Saxon Chronicle* (London 1961), XVI and 160.
52. Malmesbury, AG, 114.
53. Peers et al. (1929), 28–29.
54. Peers et al. (1928), 2–3, 8–9.
55. Peers et al. (1929), 28.
56. Conant (1968), 54–59.
57. Ibid., 50.

58. Conant (1959), 82–84.
59. *Historians of the Church of York*, Rolls Series, LXXI (1879–94), 2, 354; W. St J. Hope, 'Quire Screens in English Churches . . .', *Archaeologia*, 69 (1917), 51.
60. Conant (1954), 5–8.
61. Conant (1968), 50.
62. Stenton, *Anglo-Saxon England*, 441–42.
63. Malmesbury, VD, 271–72.
64. Radford (1968), 120–25.
65. Bond (1913), 56–61.
66. H. G. Leask, *Irish Churches and Monastic Buildings*, I, *The First Phases and the Romanesque* (Dundalk 1955), 61–72.
67. *Vita Dunstani B*, 48.
68. A. Watkin, *The Great Chartulary of Glastonbury Abbey*, 3, *Somerset Record Society*, 64 (1956), 726–27.
69. Bond (1911), pl. II.
70. *English Historical Documents*, II (1042–1189), ed., D. C. Douglas and G. W. Greenway (London 1953), 631–35.
71. Malmesbury, GP, 197.
72. Malmesbury, AG, 117.
73. Domerham, 2, 316.
74. Malmesbury, AG, 118; Robinson (1927), 44.
75. Fyfe (1927), 86–87.
76. A. W. Clapham, *English Romanesque Architecture After the Conquest* (Oxford, 1934), 26–28.
77. Ibid., 20–26.
78. Peers et al. (1928) pl. I.
79. Radford (1968), 138; Peers et al. (1931), 83–85.
80. Bond (1915), 129–31.
81. Fyfe (1927), 86–87.
82. Radford (1961), 243–44.
83. Clapham, *English Romanesque . . . After the Conquest*, 22–24.
84. S. Cruden, 'The Cathedral and relics of St Magnus, Kirkwall', *Ancient Monuments and their Presentation*, ed., M. R. Apted, R. Gilyard-Beer and A. D. Saunders (Chichester 1977), 93–94.
85. Bond (1911), pl. II.

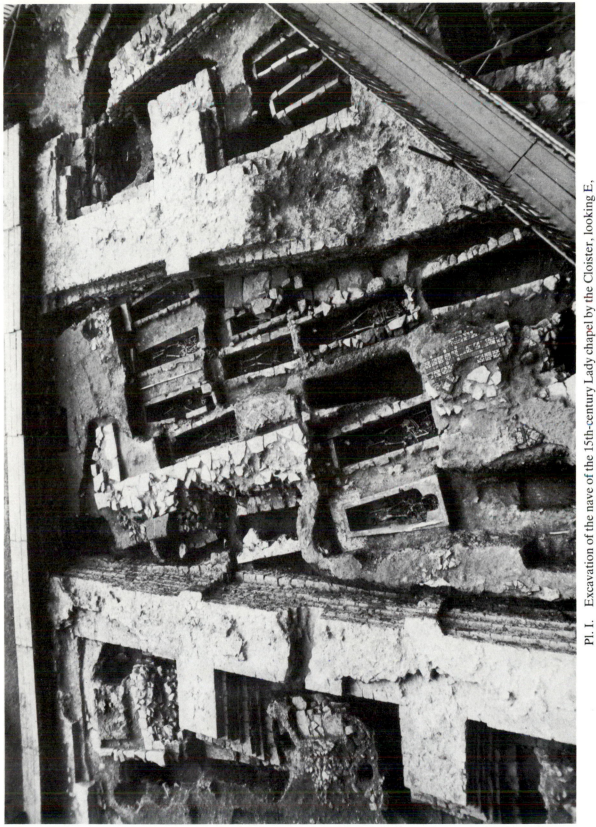

Pl. I. Excavation of the nave of the 15th-century Lady chapel by the Cloister, looking E, showing the earlier walls and graves on a different alignment below

Photo W. J. Rodwell

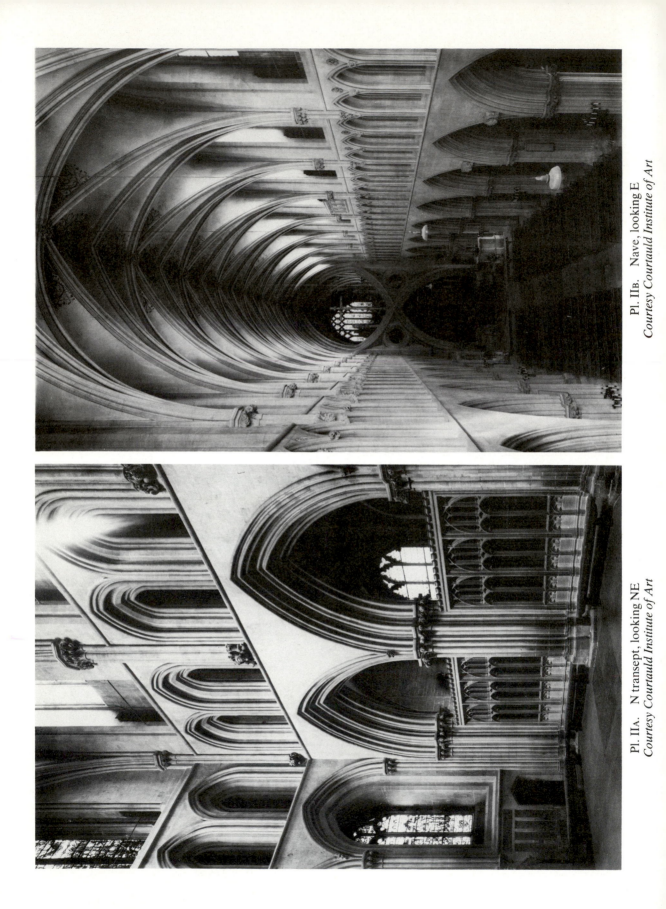

Pl. IIb. Nave, looking E
Courtesy Courtauld Institute of Art

Pl. IIa. N transept, looking NE
Courtesy Courtauld Institute of Art

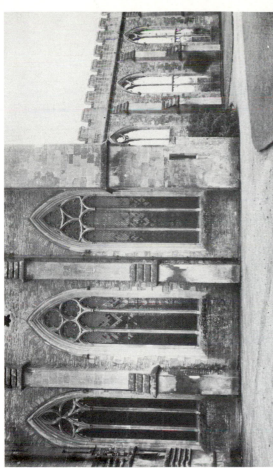

Pl. IIIʙ. Bishop's Palace, Burnell's chapel and hall,
N side
Photo P. Draper

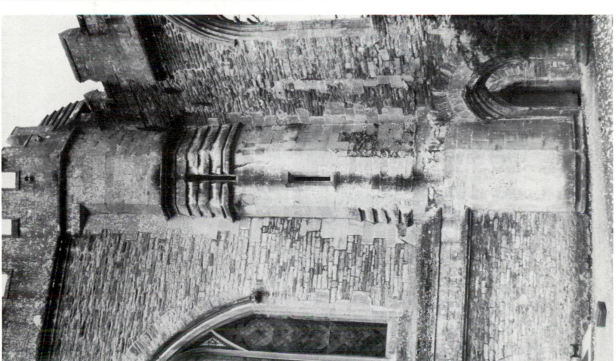

Pl. IIIᴀ. Bishop's Palace, turret common to Burnell's
chapel and hall
Photo P. Draper

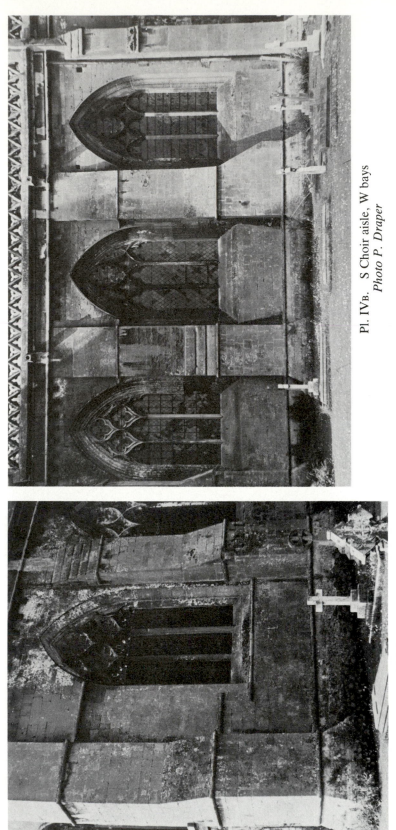

Pl. IVʙ. S Choir aisle, W bays
Photo P. Draper

Pl. IVᴀ. S transept, E wall
Photo P. Draper

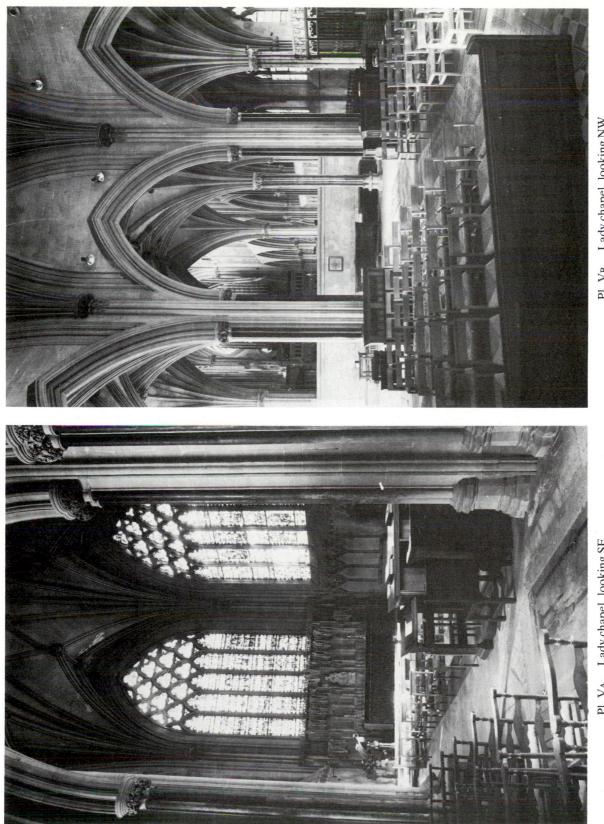

Pl. Vʙ.　Lady chapel, looking NW
Photo P. Draper

Pl. Vᴀ.　Lady chapel, looking SE
Photo P. Draper

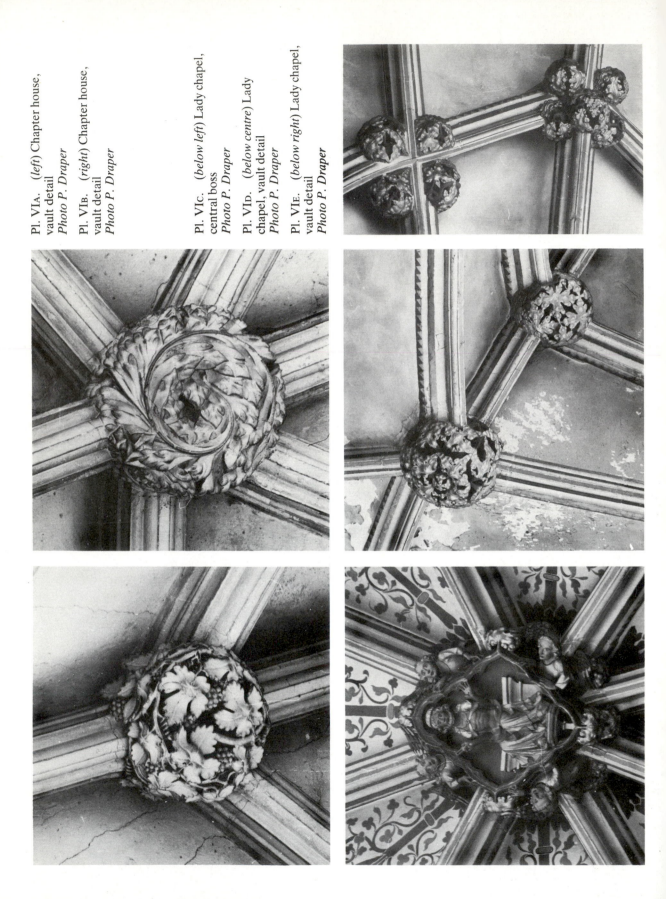

Pl. VIA. (*left*) Chapter house,
vault detail
Photo P. Draper

Pl. VIB. (*right*) Chapter house,
vault detail
Photo P. Draper

Pl. VIc. (*below left*) Lady chapel,
central boss
Photo P. Draper

Pl. VId. (*below centre*) Lady
chapel, vault detail
Photo P. Draper

Pl. VIE. (*below right*) Lady chapel,
vault detail
Photo P. Draper

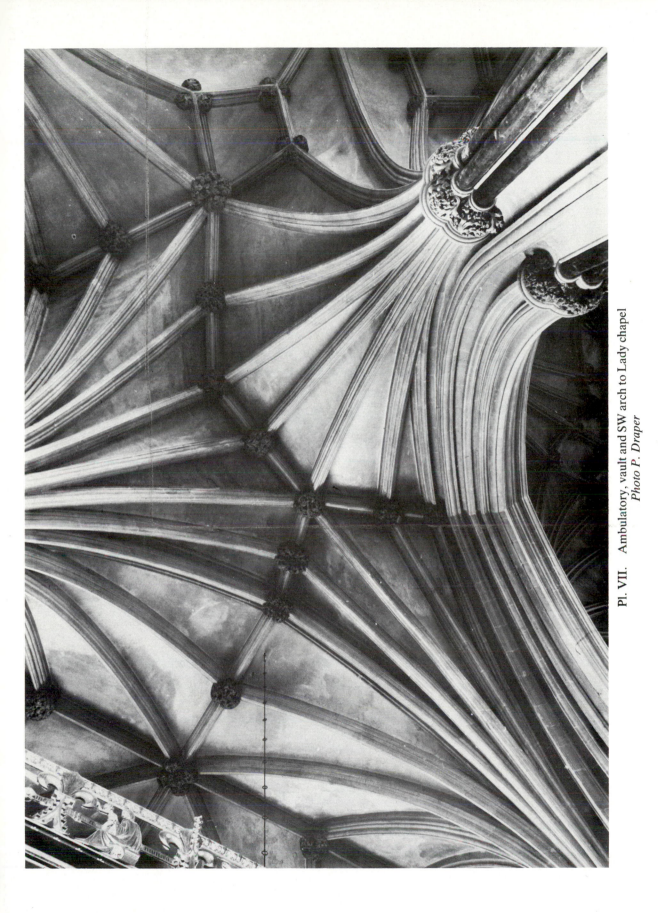

Pl. VII. Ambulatory, vault and SW arch to Lady chapel
Photo P. Draper

Pl. VIIIA. Westminster Abbey, Pyx
chamber door
Photo J. Geddes

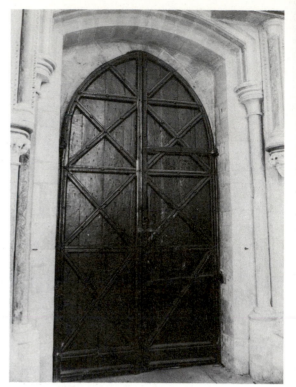

Pl. VIIIB. Lincoln cathedral, N transept,
N door
Photo J. Geddes

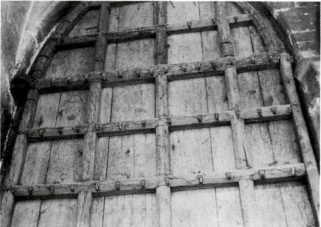

Pl. VIIIC. Nave, N door
Photo J. Geddes

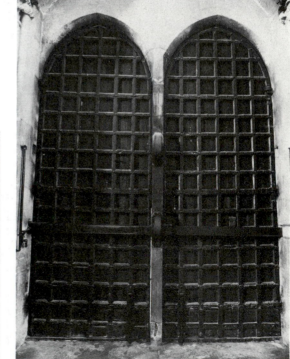

Pl. VIIID. W doors
Photo J. Geddes

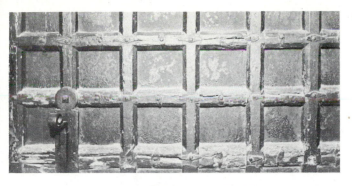

Pl. IXA. W door, detail
Photo J. Geddes

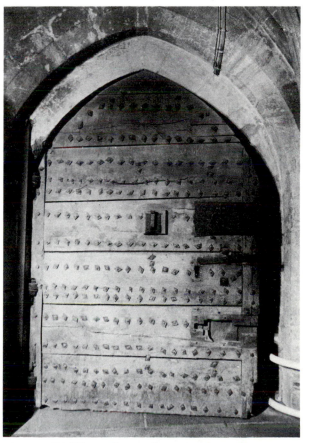

Pl. IXB. Chapter house, undercroft,
inner door detail
Photo J. Geddes

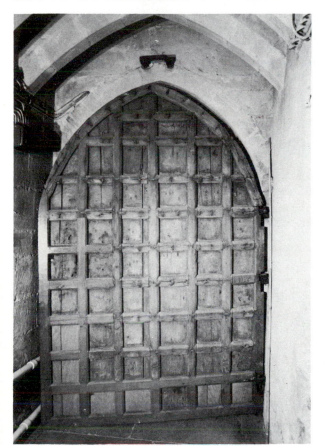

Pl. IXc. Chapter house, undercroft,
inner door
Photo J. Geddes

Pl. IXD. Chapter house, undercroft,
outer door
Photo J. Geddes

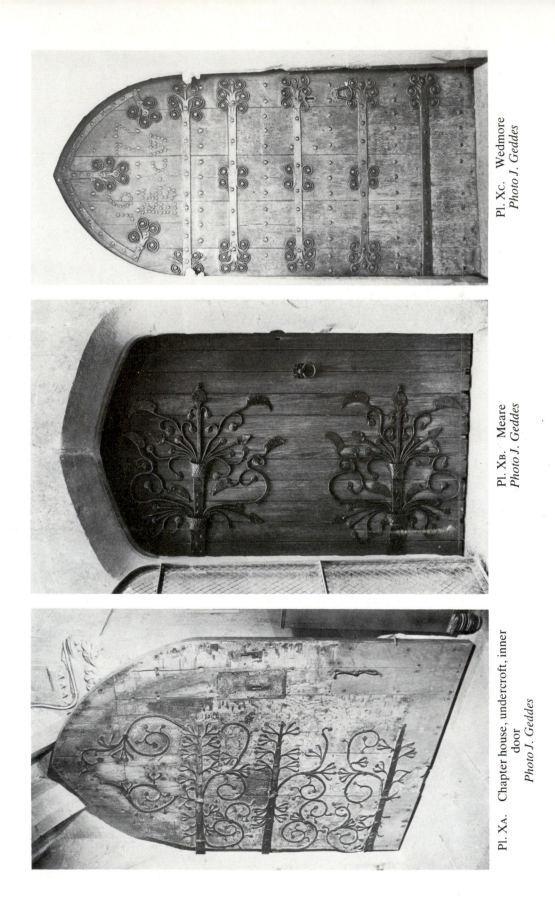

Pl. Xc. Wedmore
Photo J. Geddes

Pl. Xʙ. Meare
Photo J. Geddes

Pl. Xᴀ. Chapter house, undercroft, inner door
Photo J. Geddes

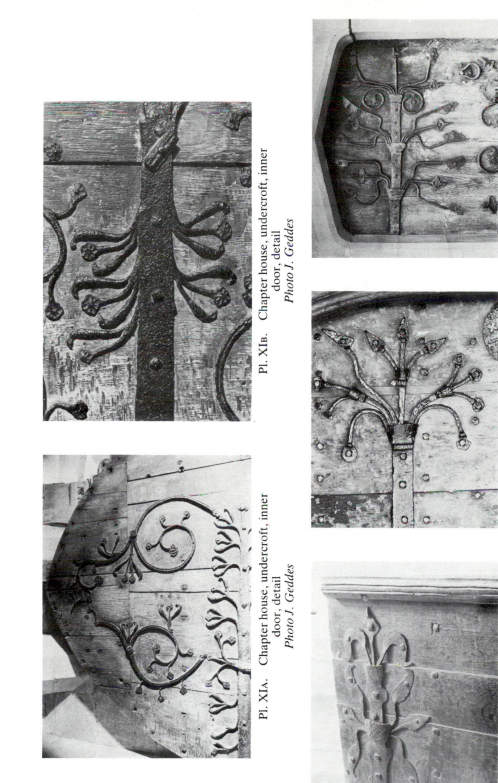

Pl. XIB. Chapter house, undercroft, inner
door, detail
Photo J. Geddes

Pl. XIE. Sharpham Park
Photo J. Geddes

Pl. XIA. Chapter house, undercroft, inner
door, detail
Photo J. Geddes

Pl. XID. Raddington
Photo J. Geddes

Pl. XIc. N Choir aisle, entrance to choir
Photo J. Geddes

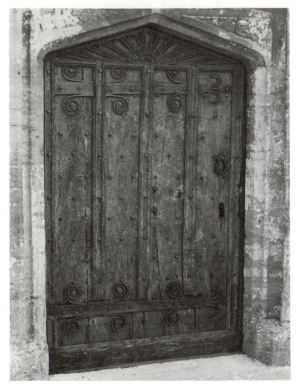

Pl. XIIA. Low Ham, W door
Photo J. Geddes

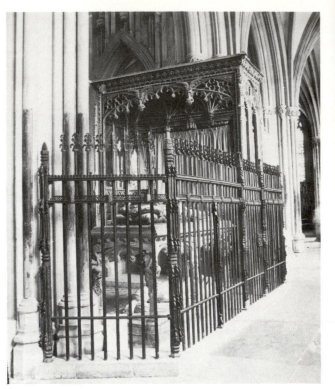

Pl. XIIB. Tomb of Bishop Beckynton
Photo J. Geddes

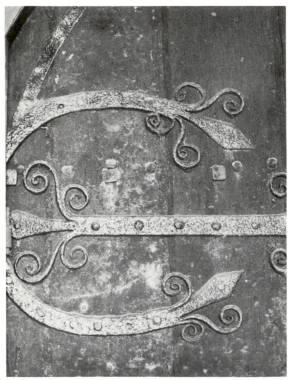

Pl. XIIc. Cuddesdon (Oxon), W door
Photo J. Geddes

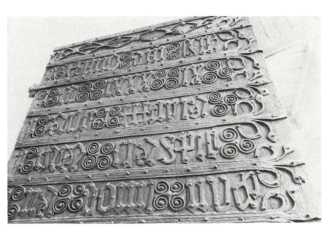

Pl. XIID. Kavslunde
Photo J. Geddes

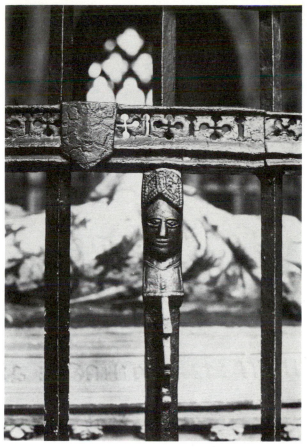

Pl. XIIIA. Tomb of Bishop Beckynton, detail
Photo J. Geddes

Pl. XIIIB. Tomb of Bishop Beckynton, detail
Photo J. Geddes

Pl. XIIIc. **Farleigh** Hungerford (Somerset)
Photo J. Geddes

Pl. XIIID. Farleigh Hungerford (Somerset)
Photo J. Geddes

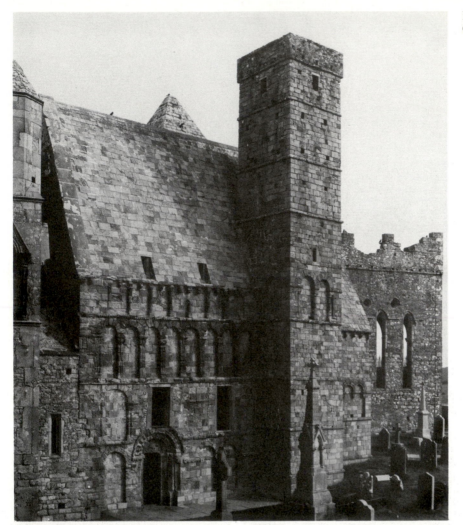

Pl. XIVA. Cashel, Cormac's Chapel, the south façade

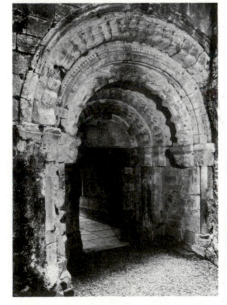

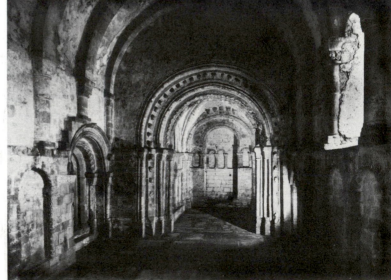

Pl. XIVB. Cashel, Cormac's Chapel, north porch
Commissioners of Public Works in Ireland

Pl. XIVC. Cashel, Cormac's Chapel, interior of the nave

Pl. XVa.　Ewenny Priory, chancel
Courtauld Institute

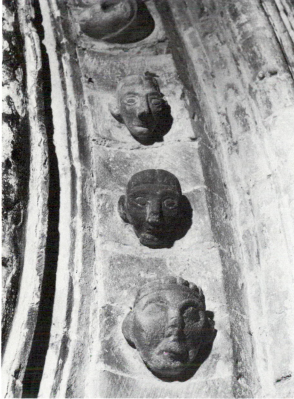

Pl. XVb.　Cashel, Cormac's Chapel, detail of
chancel arch
Commissioners of Public Works in Ireland

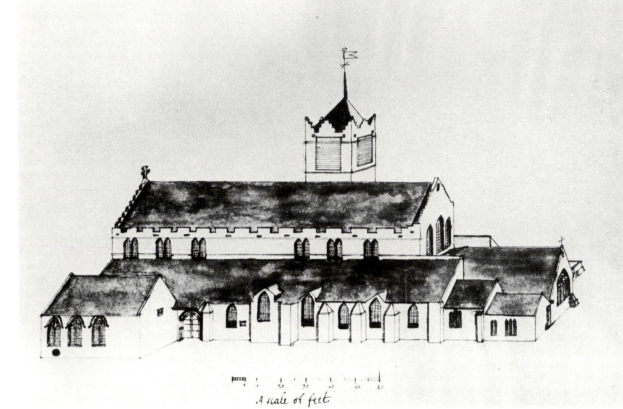

A scale of feet

Pl. XVIA. Waterford cathedral, ext. from SE. 18th-century drawing in National
Library of Ireland

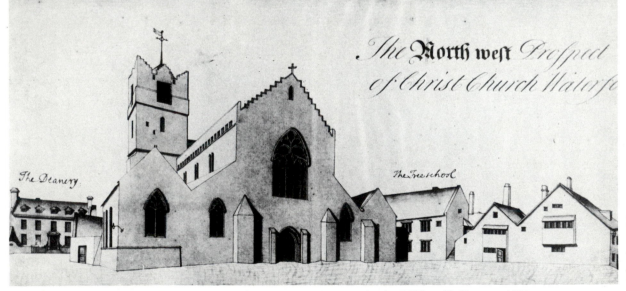

The Deanery

The North west Prospect
of Christ Church Waterfo

The Freeschool

Pl. XVIB. Waterford cathedral, ext. from W. Drawing by William Halfpenny, 1739,
in National Library of Ireland

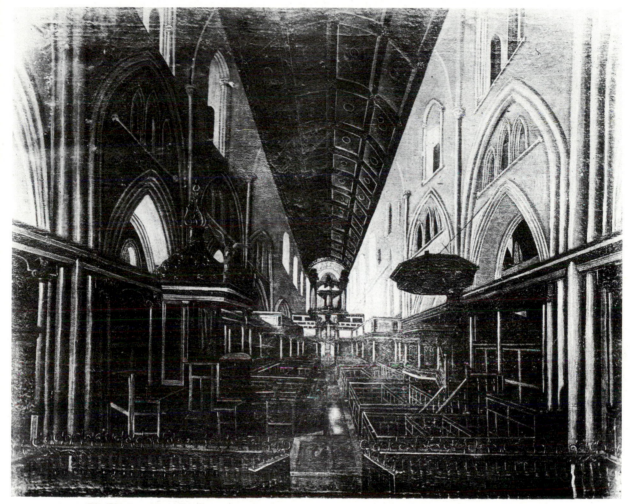

Pl. XVII. Waterford cathedral, 18th-century painting now in Bishop's Palace, Kilkenny

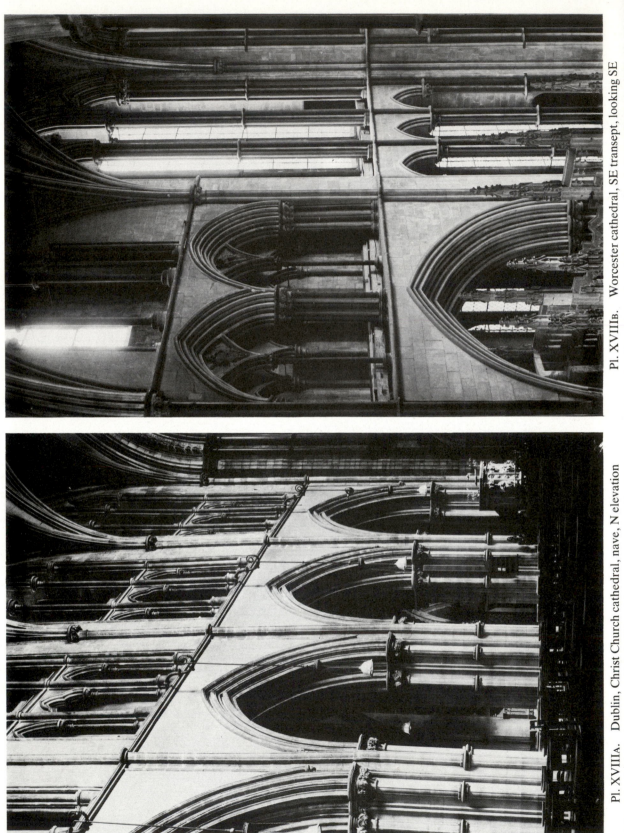

Pl. XVIIIв. Worcester cathedral, SE transept, looking SE

Pl. XVIIIa. Dublin, Christ Church cathedral, nave, N elevation

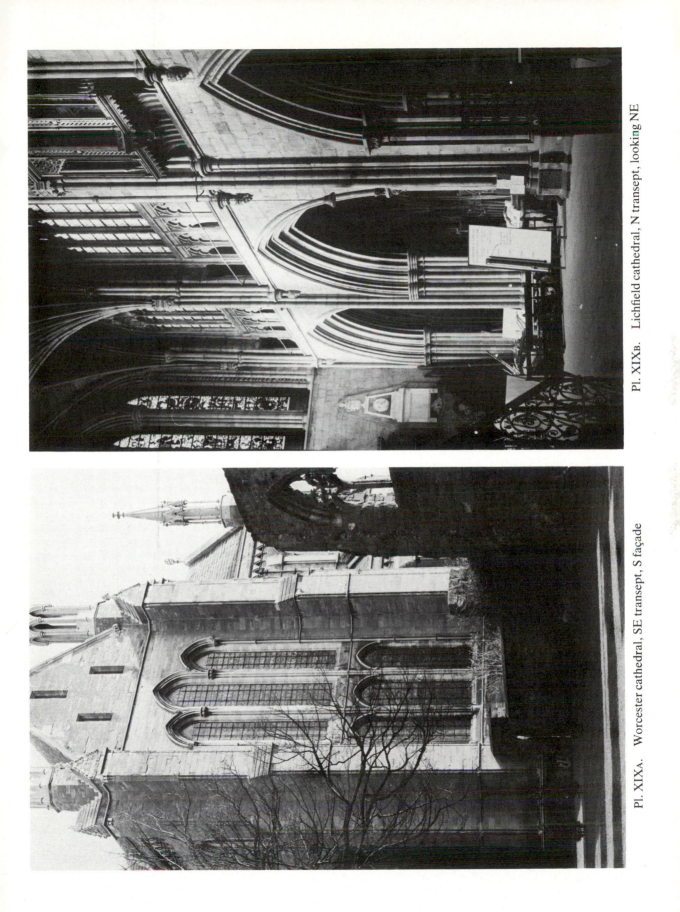

Pl. XIXв. Lichfield cathedral, N transept, looking NE

Pl. XIXа. Worcester cathedral, SE transept, S façade

Pl. XXA. Pershore Abbey, choir, N elevation

Pl. XXв. York Minster, nave

Pl. XXIᴮ. Reims cathedral, nave, ext. S side

Pl. XXIᴀ. Malbork, Chapter House

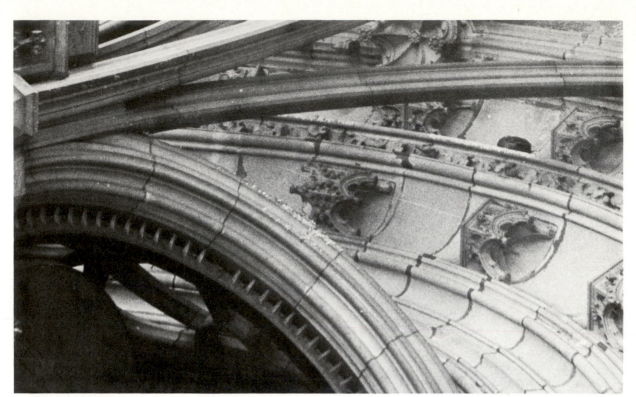

Pl. XXIIA. Prague cathedral, S porch vault

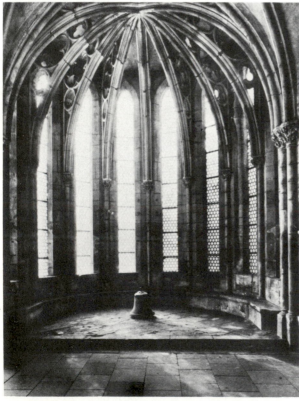

Pl. XXIIB. Magdeburg cathedral, the 'Tonsur'

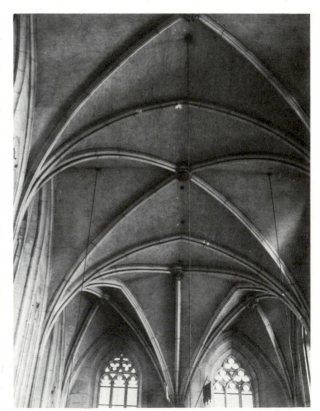

Pl. XXIIc. Kraków cathedral, choir vault

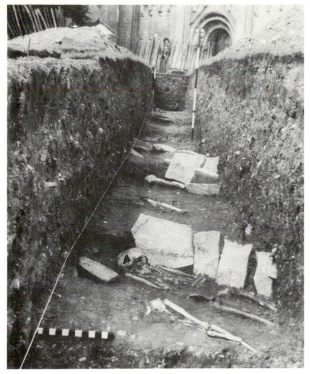

Pl. XXIIIA. Glastonbury Abbey, ditch in chapter
house, looking E

Pl. XXIIIB. Glastonbury Abbey, ancient cemetery,
looking NW to Lady chapel

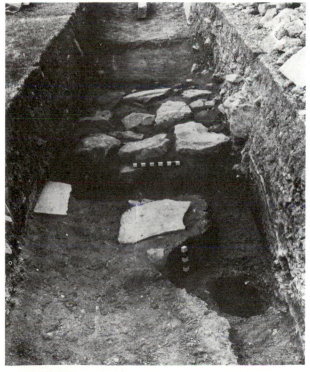

Pl. XXIIIc. Glastonbury Abbey, W cloister walk.
10th-century paving with post-hole below

Pl. XXIIID. Glastonbury Abbey, W cloister walk.
Bedding for 12th-century pavement with 10th-century
pavement below

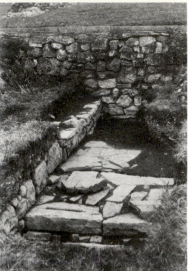

Pl. XXIVA. (*left*) Glastonbury Abbey, W cloister walk. 10th-century wall with 12th-century bedding piled against it

Pl. XXIVB. (*right*) Glastonbury Abbey, S of Refectory. 10th-century wall

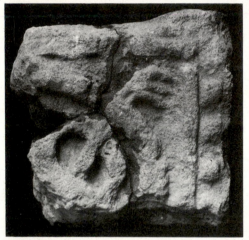

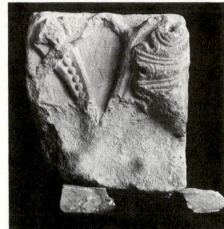

Pl. XXIVC. (*left*) Glastonbury Abbey, sculpture fragment of 10th century

Pl. XXIVD. (*right*) Glastonbury Abbey, sculpture fragment from Herlewin's church

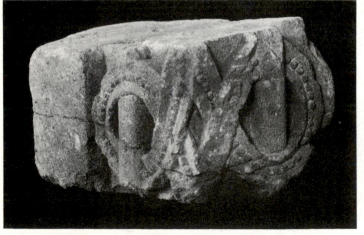

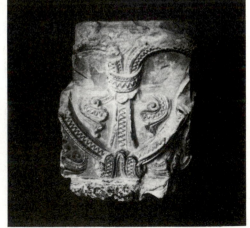

Pl. XXIVE. Glastonbury Abbey, sculpture fragment from Herlewin's church

Pl. XXIVF. Glastonbury Abbey, capital from cloister arcade of Henry of Blois